REFLECTIONS OF THE SPIRIT

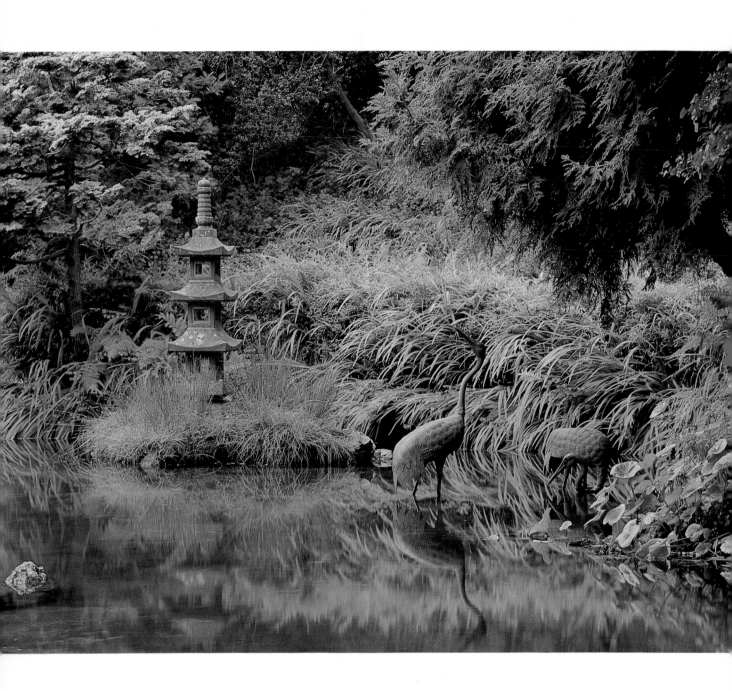

REFLECTIONS OF THE SPIRIT

JAPANESE GARDENS
IN AMERICA

TEXT AND PHOTOGRAPHS BY MAGGIE OSTER

DUTTON STUDIO BOOKS NEW YORK

DUTTON STUDIO BOOKS

Published by the Penguin Group
Penguin Books USA Inc.,
375 Hudson Street,
New York, New York, 10014, U.S.A.

Penguin Books Ltd,
27 Wrights Lane,
London W8 5TZ, England

Penguin Books Australia Ltd,
Ringwood, Victoria, Australia

Penguin Books Canada Ltd,
2801 John Street,
Markham, Ontario,
Canada L3R 1B4

Penguin Books (N.Z.) Ltd,
182–190 Wairau Road,
Auckland 10, New Zealand

Penguin Books Ltd, Registered Offices:
Harmondsworth, Middlesex, England

First published by Dutton Studio Books, an imprint of
Penguin Books USA Inc.

First printing, May, 1993
10 9 8 7 6 5 4 3 2 1

Copyright © 1993 by Quarto Inc.
All rights reserved.

Library of Congress Catalog Card Number: 92-73355
ISBN 0-525-93566-5 (cloth) – ISBN 0-525-48618-6 (paperback)

REFLECTIONS OF THE SPIRIT
A Running Heads Book,
Quarto Inc., The Old Brewery,
6 Blundell Street, London N7 9BH

Editor: Thomas G. Fiffer
Designer: Yasuo Kubota
Creative Director: Linda Winters
Production Associate: Belinda Hellinger

Set in Goudy Oldstyle
Typeset by Typesetting at Wilton, Inc.
Color separations by Vimnice Printing Press Co., Ltd.
Printed and bound in Hong Kong by
Leefung–Asco Printers Limited

ACKNOWLEDGMENTS

Write me down
As one who loved poetry,
And persimmons.

SHIKI

For John, Kurt and Sueann

This project was born out of discussions with Claire Sawyers, director of Scott Arboretum of Swarthmore College, about Japanese gardens and American interpretations. For sharing her knowledge of and insights on both, as well as encouraging me to write this book, I am grateful.

Images of the many Japanese-influenced gardens shall remain in my head and heart forever, filling me with their quiet energy. I wish all could have been depicted. Many people have graciously helped me and made gardens available, but I am most indebted to Judy Zuk, president, Brooklyn Botanic Garden; Richard Brown, director, The Bloedel Reserve; Stephen Morrell, curator, The John P. Humes Japanese Stroll Garden; Dr. Kenneth Yasuda; Mr. Raymond T. Entenmann; Mr. and Mrs. R. B. Caldwell; Mr. and Mrs. David Gibson; Mr. and Mrs. Fred Wiedemann; Mr. and Mrs. Edward M. Meehan; and Mr. and Mrs. Charles Uppinghouse.

For his vision of this project, I am grateful to editor Cyril Nelson; for his sensibilities in conveying that vision in the design, Yasuo Kubota; and for his patience, skill and supportive spirit, Tom Fiffer. To them and the others who played a role in production, including Mary Forsell, Josey Ballenger, Danielle Di Spaltro, and Linda Winters: my sincere thanks for their extra effort on my behalf and deep appreciation. There are not words in form or quantity to thank Marta Hallett. May her belief in my work come to fruition.

For technical assistance, the loan of equipment in crisis situations and general support of my photography, my thanks to everyone at Schuhmann's.

My gratitude to Richard Langdon for being crazy enough to drive to Chicago in a blizzard and to accompany me in subzero weather while I photographed.

For the friends who understand and accept me and my passions, who have listened and laughed and cried, thank you. John Grammer, Kurt Hampe and Sueann Townsend have been especially important. May each of us always be able to express our talents, be whomever we want to be with each other, know that we are loved no matter what and someday return home.

My parents remain a constant in my life, providing support in many different ways; their spirit gently surrounds me. I thank them for nurturing my affinity with nature and for both the metaphysical beliefs they taught me as well as the ones they allowed me to have.

Una salus victis nullam sperare salutem.

Aeneid, VIRGIL

CONTENTS

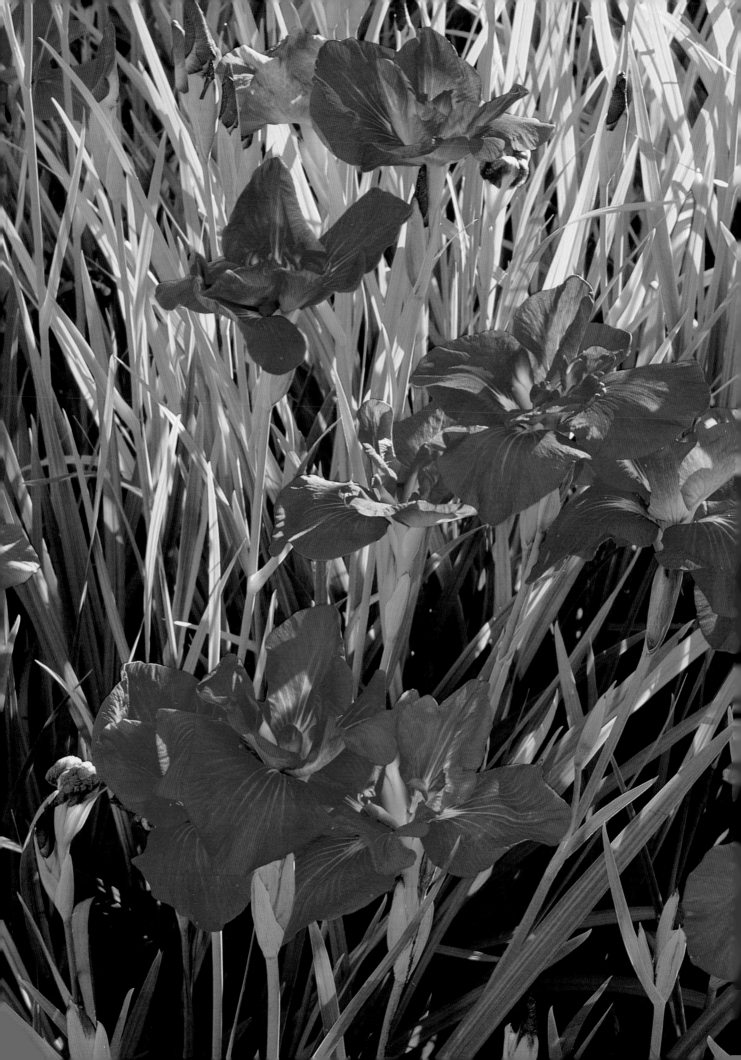

INTRODUCTION

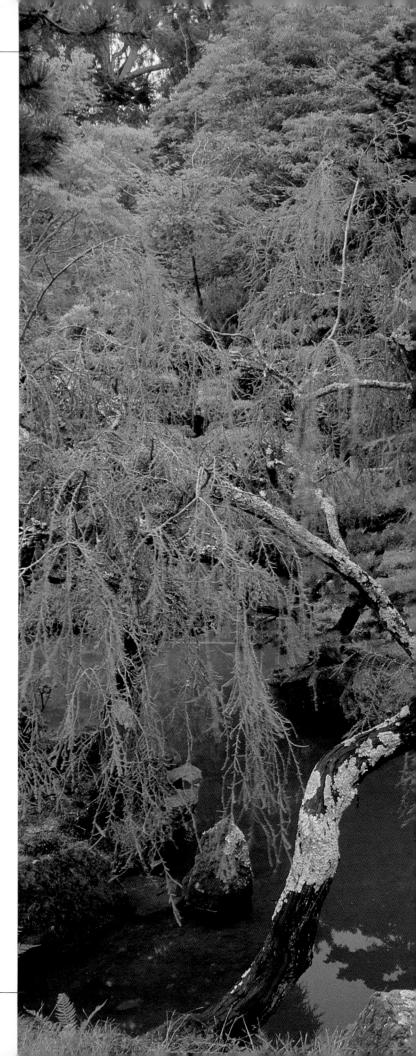

SERENITY

lies at the heart of every Japanese garden. As an artistic expression of the essence of nature, Japanese gardens draw upon the natural world's tranquil beauty to create an oasis for meditation and contemplation in a discordant society. Having evolved over the past thirteen hundred years and strongly influenced by both Shintoism and Zen Buddhism, these gardens, more than any other kind, are particularly conducive to restoring the inner calm and the peace of mind and spirit needed to face life's inevitable vicissitudes.

Only a relatively small number of us will ever be able to visit and spend time in the gardens of Japan. How, then, can we draw upon this source of restorative inspiration and solace? Throughout the Western world, and especially in the United States, there is a wealth of public gardens that recreate the Japanese style and provide a venue for experiencing this type of garden. These gardens also yield design ideas that have adapted Japanese concepts to Western climates and landscapes, which we can take home and assimilate into our own gardens.

Reflecting on the oneness of man and nature is a form of meditation on the passage to self-illumination. Japanese Tea Garden, Golden Gate Park, San Francisco, California.

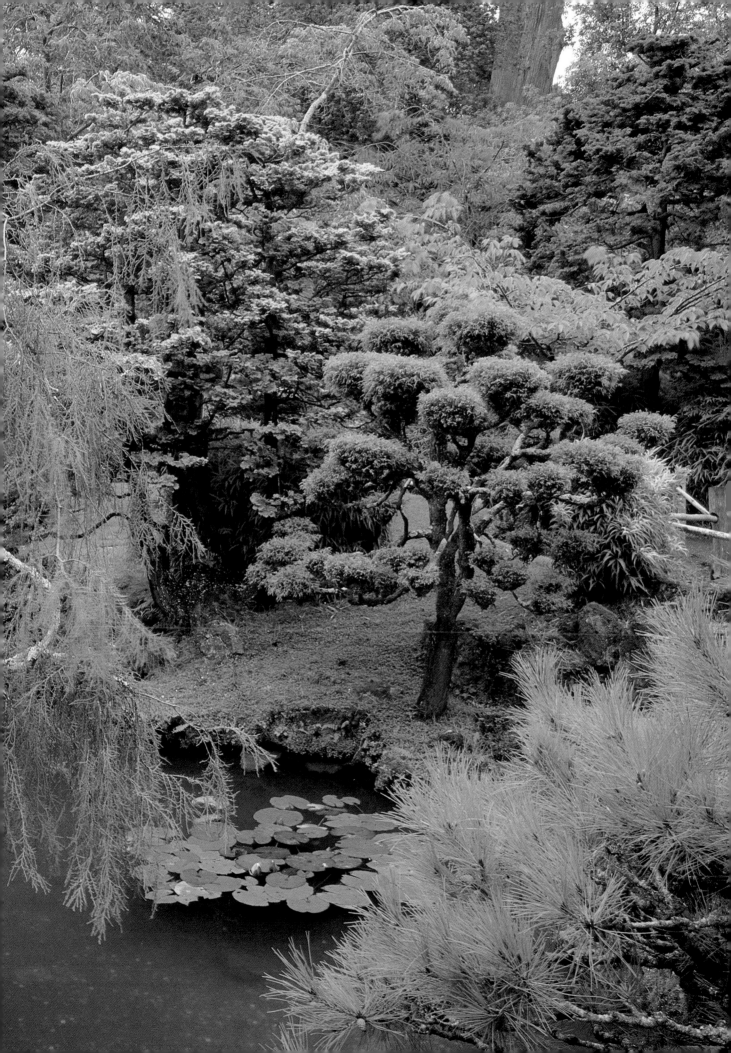

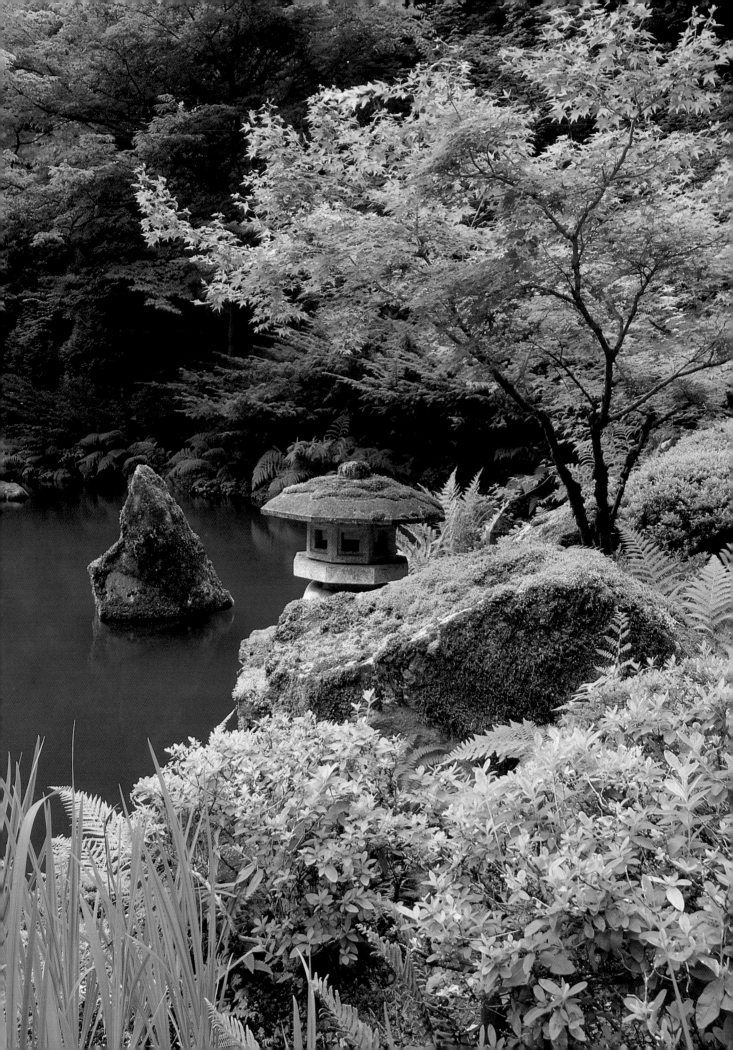

To create a Japanese-influenced garden successfully requires extended contemplation of both gardens and nature, as well as thoughtful consideration of the principles and elements involved. It is also necessary for one's mind and heart to learn to perceive the world differently from the way most of us brought up in the West do. A well-designed Japanese garden will suit the size of one's house, the property, and the natural surroundings, as well as the temperament and desires of the owner. Its elegant simplicity belies the complexity of cultural, aesthetic and spiritual elements that contribute to its successful balance and harmony.

To begin, it is useful to look first at the strong connection between the metaphysical beliefs of the Japanese people and their daily existence. Each day is undertaken as a rite in itself, respecting each person and the spirit perceived in all things, both animate and inanimate. Everything is believed to have a spiritual connotation exemplified through form, dimension and placement in relationship to each other. Through taking care of the garden, doing chores that might seem difficult or tedious, a person can become totally absorbed in nature. Tending the garden affords a period of silent contemplation and the opportunity to ponder one's role in the universe. A core belief in Japanese culture is that people must live in accord with nature, honoring its beauty and harmony. By showing respect and reverence for nature, a per-son does the same for himself or herself, with the outer world reflecting the world within.

The role of Shintoism, the original religion of Japan based on the veneration of nature spirits and ancestors, is apparent in the earliest garden mentioned in Japanese history. A holy shrine near the seacoast in Ise, this garden testifies to the inherent Japanese preference for simplicity and the search for wholeness through identification with the universe. Plain, unpainted wooden structures stand among a grand, ancient forest beside a small river. The buildings complement rather than compete with nature, and visitors become aware of their spiritual oneness with the earth. Early Shinto shrines also often included an area of white sand, establishing a precedent for later Zen gardens.

The religion of Buddhism was brought to Japan from China and Korea during the seventh century, along with highly developed ideas of architecture and garden design. During the Nara period (*circa* 710–794), members of the Japanese nobility commissioned Chinese-style lake and island gardens for the grounds of their palaces and villas. Although many gardens were created, none still exist. There are, however, references to these gardens in Japanese art, literature and poetry. Their main characteristics were the use of hills, lakes or ponds, islands, bridges and plantings of trees and shrubs—all aspects still found today in Japanese gardens.

In the Heian period (*circa* 794–1185), the Japanese capital was moved from Nara to Heian-kyo, today called Kyoto. The Japanese continued to employ ideas from Chinese architecture and gardening, but added more and more of their own style and symbolism. Their natural landscape, with its mountains, streams and waterfalls, rocky coastline and varied trees, shrubs and flowers also influenced the design of these gardens.

The estates of the Heian nobles had both small courtyard-type gardens around outbuildings and a large garden in front of the main building that included an area covered with white gravel. These gardens were composed of a pond or lake fed by a stream, with hills behind and islands, and each element reflected honored myths and spiritual beliefs as well as artistic considerations. These were bright, colorful pleasure gardens, evocative of paradise, that created a "picture" to be viewed mainly from a primary structure, from pavilions extending out over the water or from boats.

The Heian understanding of aesthetics, refinement and love of natural beauty has strongly influenced all Japanese culture through the ages. It has also established the acceptability of garden-making for those with power and prestige, both aristocrats and clergy.

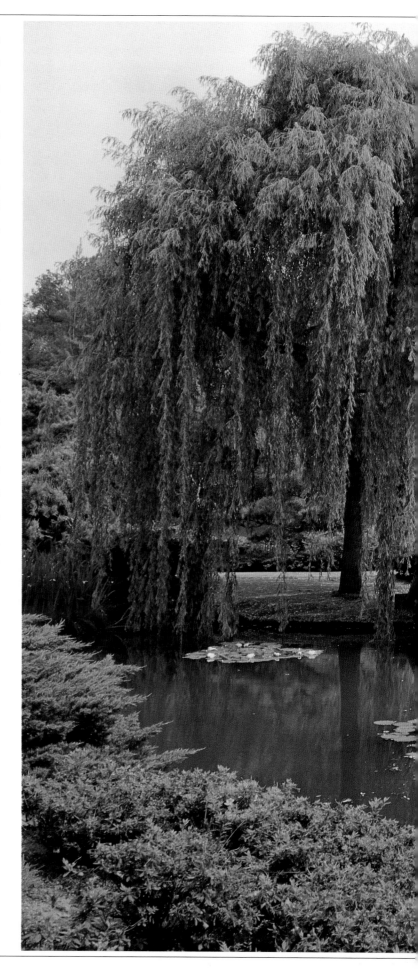

The dominion of the bright, beautiful Chinese-influenced Heian garden is still seen in Japanese gardens today. Huntington Botanical Gardens, San Marino, California.

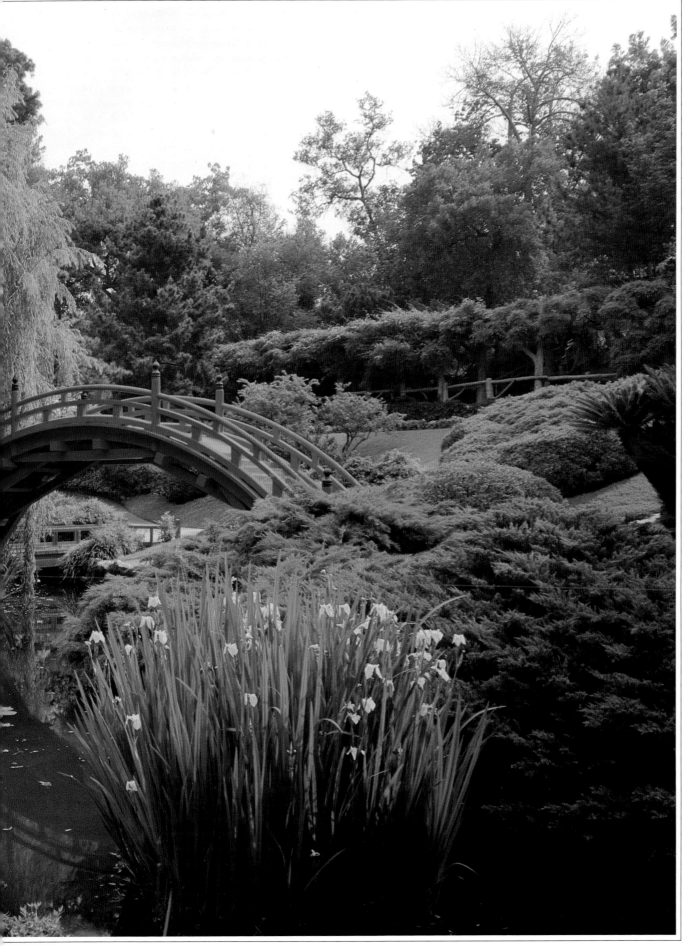

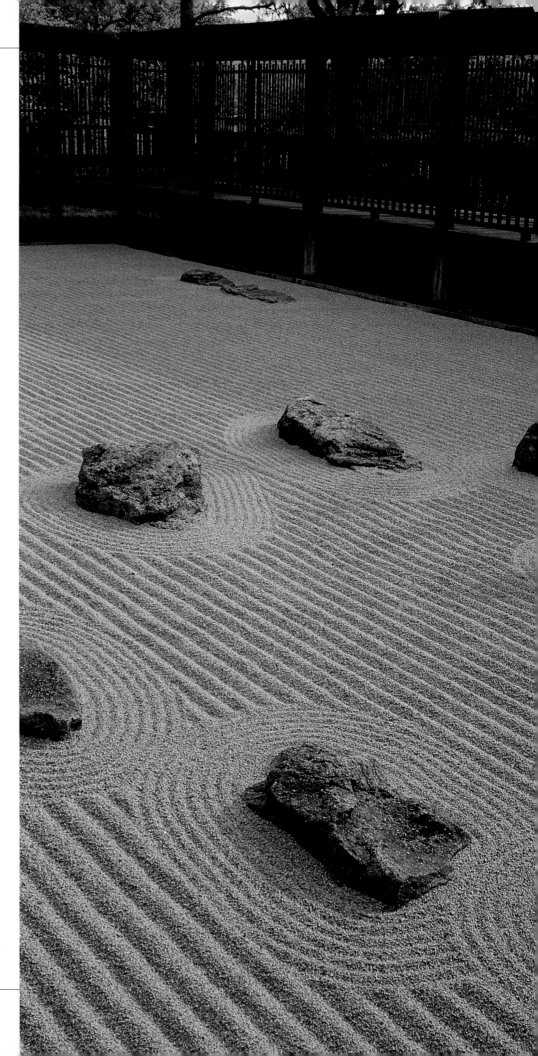

Abstract dry landscapes
composed of raked gravel
and large stones are a legacy
of the Zen approach to
contemplation through art
and nature. Fort Worth
Botanic Garden Center,
Fort Worth, Texas.

During the Kamakura period (*circa* 1185–1392) the capital remained in Kyoto, but the powerful shogun resided three hundred miles away in Kamakura. At this time an era of asceticism, attributable to the advance of the warrior class, the Zen sect of Buddhism and the black-and-white landscape paintings of the Chinese Sung dynasty, began to have an impact on Japanese culture.

Records and what extant gardens remain from this period show a diversity of form, including pleasure gardens designed by aristocrats and temple gardens created by ecclesiastics. However spartan, the early military leaders were not adverse to spending money on temples and adjacent gardens; their goal was to interpret nature subjectively. Creating a garden held the same religious significance as building a church in the West, with the Zen monks considered professional garden makers.

Notable from this time is Saiho-ji, or the Moss Temple, a stroll garden of moss and trees around a lake and islands. It has stonework representing the trinity of Buddhist figures, a "turtle island" set in a "pool" of moss and a large dry cascade of flat-topped stones, a style that greatly affected later garden design. This garden marks a change from the expansive Heian gardens designed for entertainment to a garden with a Zen feeling of repose and tranquillity that makes one aware of the attunement of personal spirit with the essence of all things.

Much of the depiction of rock in the Sung dynasty paintings is of the bold, soaring and precipitous mountains of China. In the temple garden of Tenryu-ji near Kyoto, several Sung-style rock arrangements remain. Each of these rock works is a highly symbolic abstraction and clearly the work of man, fashioned as art.

In the Muromachi period (*circa* 1392–1568), a new dynasty of shoguns came to power. In *The World of the Japanese Garden*, Loraine Kuck writes, "...inspiration and technique reached maturity together, producing gardens which for sheer beauty and artistry have never been excelled in any period or in any country." Traditional large-scale landscape gardens of this era include the ones built by shoguns surrounding the Gold and Silver Pavilions. Most intriguing at the latter are two large piles of white sand, one a flat-topped cone, the other simply wide and flat. No records of the time discuss their origin or rationale, although much meaning has since been assigned to them.

Lesser nobility built smaller picture gardens overlooked by the main room of the house. Many small temple gardens were also built during this period and left a legacy of art and refinement in the expression of the Zen philosophy of contemplation leading to enlightenment. To be viewed from a veranda or platform, these gardens consisted of an enclosed space using a minimum of evergreen plants and stones to imply or suggest nature.

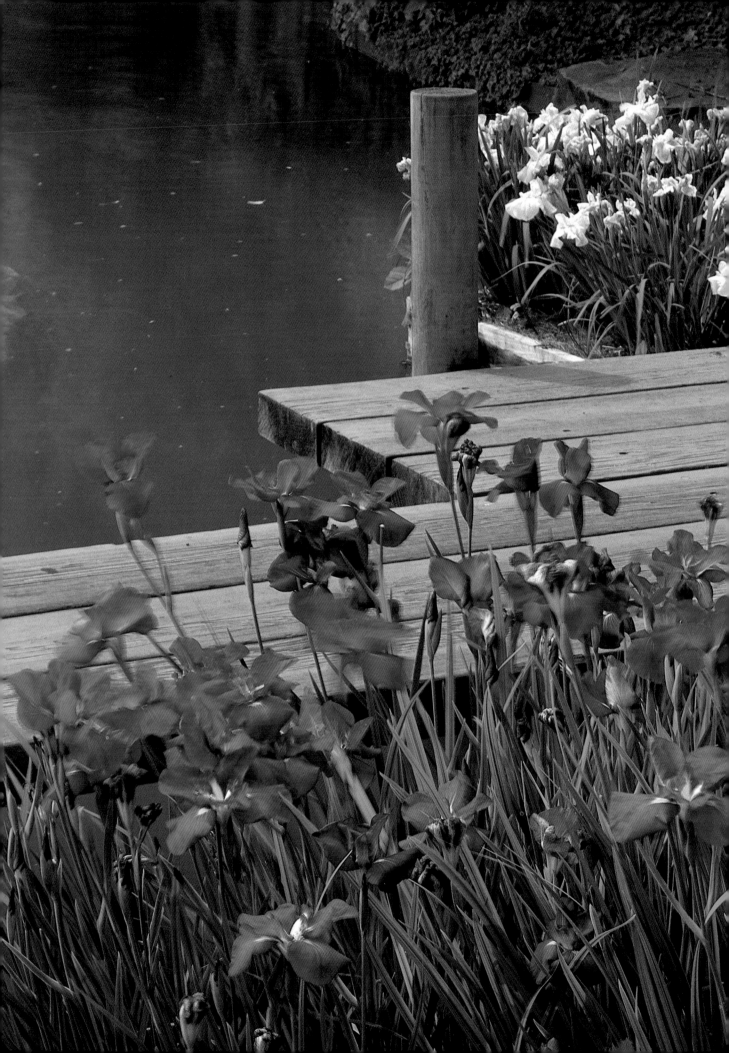

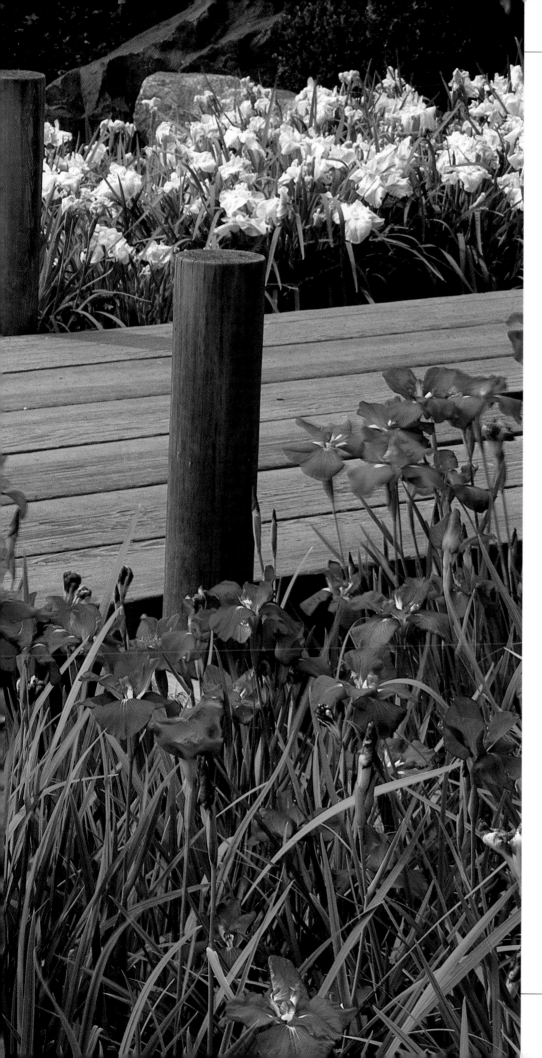

The fleeting purple and pastel colors of Japanese iris (*Iris kaempferi*) appeal for the beauty they bring to a zigzag *yatsuhashi* bridge with its successive series of views across the water. Missouri Botanical Garden, St. Louis, Missouri.

Daisen-in, a small temple in a monastery near Kyoto, gives the impression of vast mountains, cascades and a river gorge in a relatively small space with the use of sand, stones and small trees and shrubs. It is essentially a three-dimensional monochromatic landscape painting.

Other gardens went a step beyond the impression of a landscape to a purer form of abstraction, using rocks and sand almost exclusively. The first of these, at Ryoan-ji temple, embodies both harmony and mystery. An area about the size of a tennis court, it is covered with coarse white gravel raked into lines and set with fifteen stones in five groups. This is a garden to be studied over time, interpreted on many levels and ultimately to be felt.

In the succeeding Momoyama period (*circa* 1568–1615), architectural design changed dramatically, and buildings were erected on a much grander scale. In a divergence from the minimalist style inspired by Zen Buddhism, the gardens of those in power during this time reflected their wealth in a zealous display of elements that utilized previous garden forms and styles.

Concurrently, men who respected the simplicity of the Buddhist philosophy developed the tea ceremony and surrounding garden as one means of attaining serenity, harmony and a higher consciousness of existence through ritual as well as experiencing and discussing beauty and art. The tea garden was usually simple and small, with a stepping-stone path and evergreen plants creating an atmosphere resembling a mountain trail leading to the teahouse. A stone lantern lit the way, and a stone water basin provided symbolic purification before the tea ceremony.

The Edo period (*circa* 1615–1867) saw the center of government moved to Edo, later known as Tokyo, with its lowlands and marshy topography. Large lakes and gently mounded islands gave a horizontal, open look to the large stroll gardens of the nobility. An urban middle class that had begun developing in earlier periods was by now creating small, refined courtyard gardens, many of which drew heavily on the elements of the tea garden.

Throughout the centuries, Japanese garden styles have changed and grown with individual tastes and spiritual influences. A common theme does connect the various styles: the unity of man and nature inextricably interwoven with aesthetics, metaphysical beliefs and landscape. For Westerners to understand fully the cultural and environmental differences that separate them from the Japanese is nearly impossible. Still, Westerners can do as the Japanese did when they adapted what they had learned from the Chinese — create gardens reflecting their own culture and times. The Western mind and heart are drawn to the Japanese garden because the desire for peace and serenity, for a quiet place of at least momentary solitude and solace, is universal.

Even in deepest winter, the Japanese garden reveals its beauty with the patterns and textures created by the snow on plants and structures. Chicago Botanic Garden, Glencoe, Illinois.

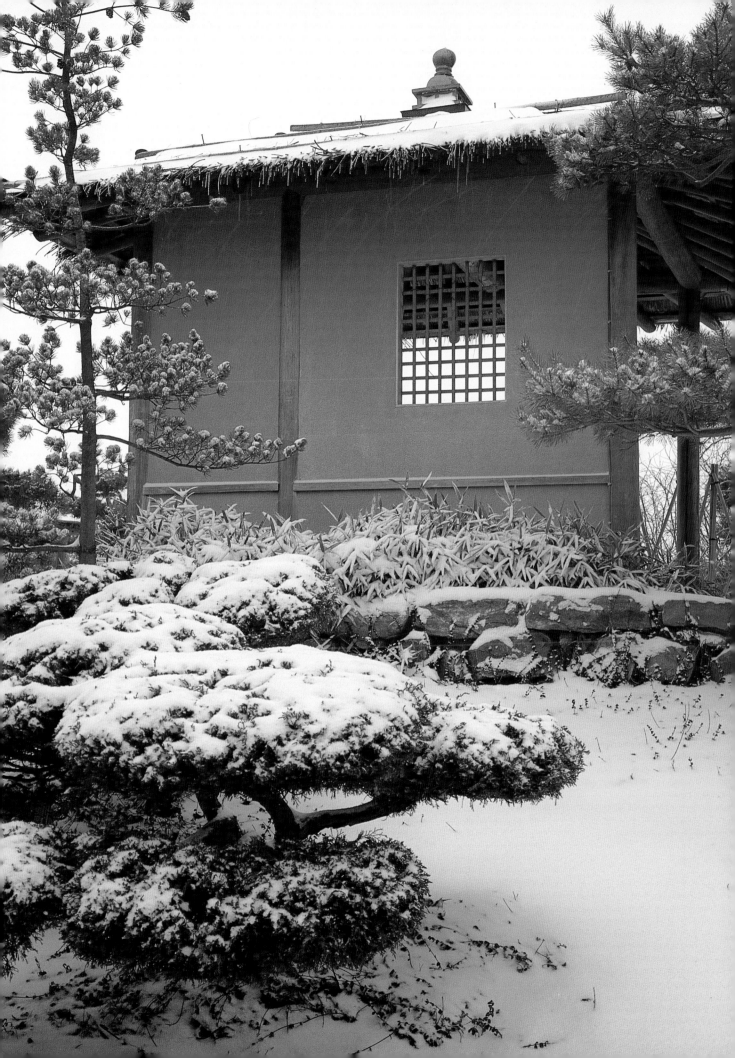

ESSENTIALS

庭
園

CREATING

a peaceful, harmonious Japanese garden of quiet refinement requires a sophisticated blend of imagination, skill and patience as well as consistent maintenance over time. It also demands an astute awareness of the principles and elements of Japanese garden design and the interrelationship of all aspects of the earth, including man. In creating gardens that embody the Japanese concept of adapting the harmonies of natural design to our own landscape, we have the opportunity to heighten our understanding of the world around us and in us.

To the Japanese, the garden is an extension of the self. Through meditation they have identified values important to them, and they have expressed these truths symbolically in the design of their gardens. Taking time for meditation and inner reflection may seem self-indulgent in a world torn by crisis and conflict, yet it is one of the most responsible things one can do. When we are confused or uncentered, we project our inner turmoil into the world around us. When at peace with ourselves, we see things more clearly and act more effectively. Like regular meditation, creating a Japanese garden not only restores our inner harmony and vital energy, but also enables us to experience the peace we seek.

When you begin to design your Japanese garden, you will have all the freedom in the world to fantasize about how you want to express yourself through it. By taking into account the geography and plants of your area, your personality and the layout of your home and garden, you will be able to develop a design plan that not only suits your wants and needs but also complements your home and life-style. As you read about Japanese gardens in these chapters, look at the photographs and visit public gardens, various elements of the gardens will attract you. You may use these in your garden without fully accepting or understanding the philosophy behind them, but you must respect that philosophy. Few Westerners reflect upon the universe while beholding a rock, but most of us can appreciate a rock's beauty by itself and how it is placed in a garden.

A hillside planting of many shapes and textures, with a meandering stream and small waterfall drawing the eye to a *torii*, requires meticulous maintenance. Japanese Tea Garden, Golden Gate Park, San Francisco, California.

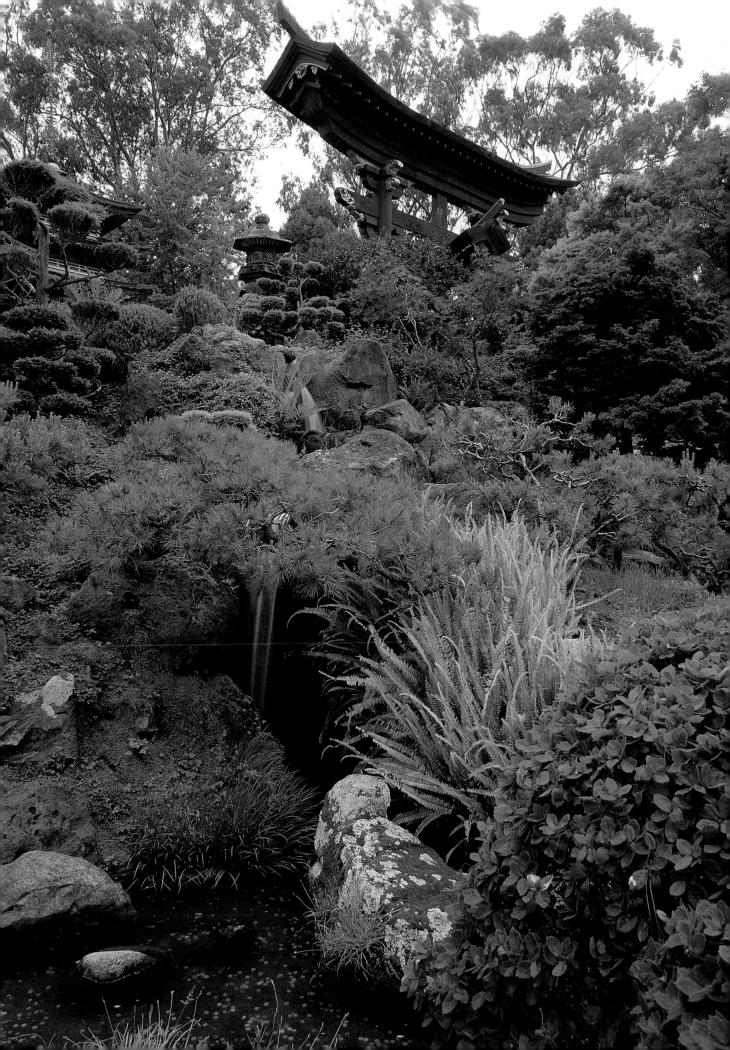

A long narrow yard with a natural swale, established trees and a vista to a lake provides the framework for the structural and ornamental components incorporated into this garden. Private garden, Dallas, Texas, designed by King's Creek Nursery.

In conjunction with experiencing the pleasures of observation and reflection, you must consider practical matters, such as space, money, weather and maintenance. Fortunately, a garden in the Japanese spirit can be built in very little space and will blend well with contemporary housing's trend of large glass doors and windows that frame highly visible outdoor living areas. Also, Japanese gardens are attractive all through the year because of their reliance on evergreen plants and stone. They can be designed to occupy an out-of-the-way part of the yard or a problem area, such as a very shady spot, a site with poor soil or a long, narrow side yard.

Think, too, about the elements used in establishing a Japanese-style garden. Most important are rocks, both large stones and gravel, water—real or suggested, and plants. Paths, steps, bridges, fences, walls, gates, ornaments and structures are secondary but important elements. Each is discussed in detail in Elements.

With these basic components you can create your own unique Japanese garden. You must, however, keep in mind the underlying philosophy of Japanese garden design, which emphasizes harmony and unity. Knowledge of the basic aesthetics of Japanese garden design, described in the Principles chapter, and an awareness of the different Japanese garden styles will enable you to create a garden that both respects Japanese philosophy and expresses yourself.

As you study the details of garden principles, styles and elements, ask yourself a few key questions, such as the following:

• What style of Japanese garden suits both my life-style and my particular garden site?

• Would a pond or working waterfall be appropriate and possible?

• Can I acquire all necessary elements from sources in my area?

• Is there a view I wish to include and is doing so feasible?

In addition, spend some time acquiring general gardening information about your area as well as the microclimate of your particular garden site. You should take into account soil type and topography, plants that do well in your area, the climate within your garden site, the amount of sun or shade affecting the site and the intended function of your garden.

Soil type is determined by the size of the particles that make up the soil's composition and the amount of organic matter it contains. Sandy soil consists mainly of large particles, and it drains quickly and easily. A disadvantage of fast drainage is drought and loss of nutrients that are held in solution around the soil particles. Clay soil consists of small particles packed closely together, and it does not drain quickly. Its density makes it very sticky. The soil that fosters the best plant growth, called loam, contains a balanced combination of sand, silt and clay particles, and is rich in organic material. Any soil type can be improved by adding organic matter.

Plants need nutrients just as people do. The nutrient level of a soil can be determined with kits available at garden centers or by submitting a soil sample for analysis to a soil-testing laboratory. Recommendations for adding fertilizers come with the kits or lab analyses. As important as soil type and nutrients is the alkalinity or acidity, or pH, of the soil. This, too, can be tested with kits or by a laboratory, and you can follow recommendations for altering levels to meet the needs of the plants chosen.

The topography of your site will surely influence your choice of garden style. You can, however, modify conditions to some extent to make them suitable for a different style. Land that slopes can be leveled, or mounds can be made on a flat lot. A hole can be dug for a pond or a recirculating stream can be formed. If there are existing rock formations, you can either design your garden around them, move them to another area of the garden or remove them altogether. Almost anything is possible, depending on the energy and expense you are willing to commit to changing the physical features of your yard.

Every region has its average minimum and maximum temperatures, prevailing winds and rainfall. In addition, each garden site has conditions that influence its microclimate, including exposure to sunlight, direction and force of winds, existing structures and plants and proximity to water.

Heavy shade, as that from a planting of bamboo, creates an environment that precludes the use of any underplanting but the most shade tolerant of plants, such as ferns. Swiss Pines, Malvern, Pennsylvania.

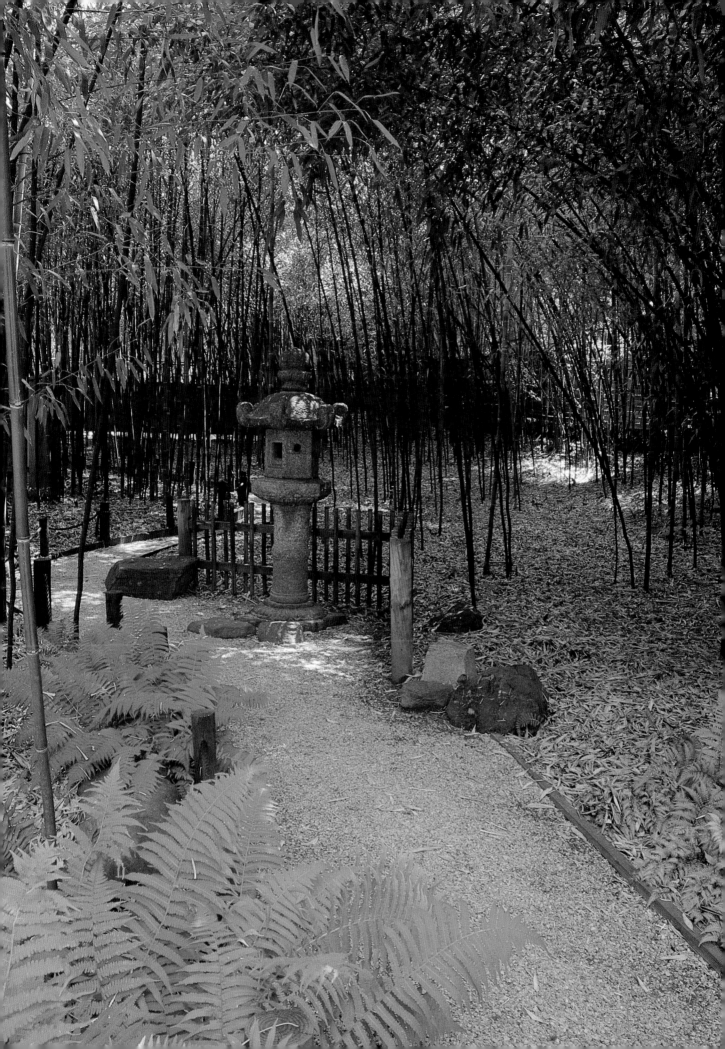

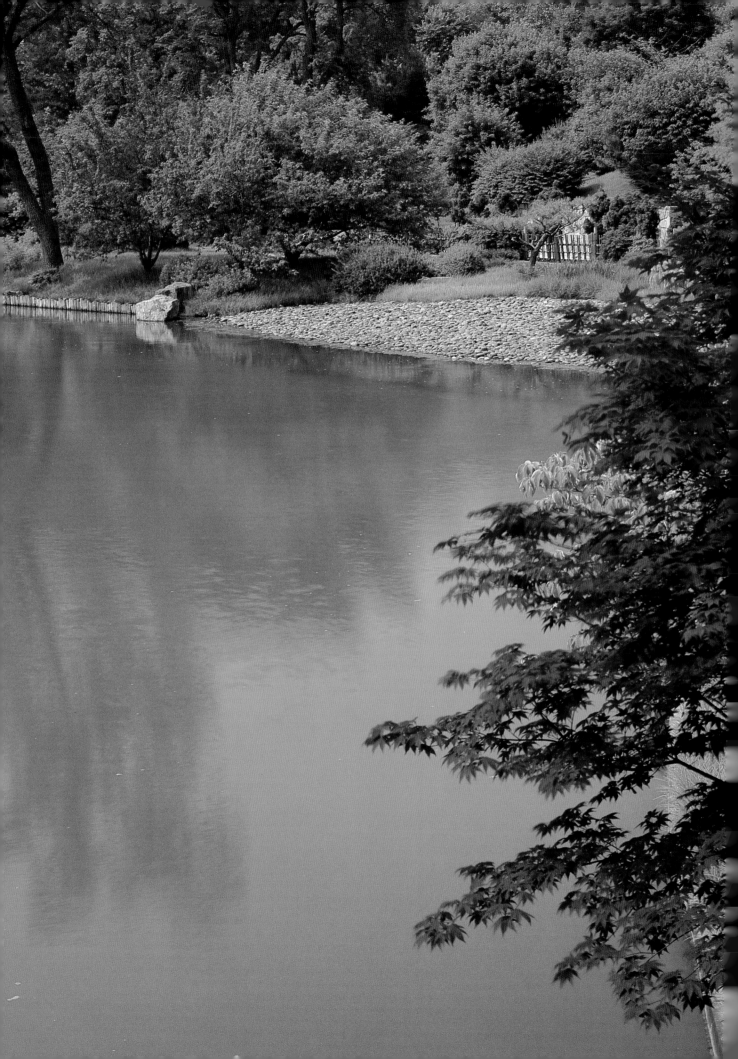

The hardiness of the plants you choose for your garden is determined mainly by their ability to withstand minimum winter temperatures. These temperatures can vary even within the small space of the average garden. Not only does dense, cold air collect in valleys, but it is also trapped in microclimates such as low-lying areas or at the base of north-facing walls or hedges. Areas near paved surfaces and sunny south- and west-facing walls retain the most heat, which is absorbed during the day and radiated back into the atmosphere during the night. Water also absorbs a lot of heat, albeit slowly. Large bodies of water tend to lessen seasonal, rather than daily, temperature fluctuations in surrounding areas. A pond in your garden can influence the temperature in your microclimate.

Other factors, including soil, moisture and wind, affect plant hardiness in conjunction with cold temperatures. In choosing the plants for your Japanese garden, make sure they can withstand your conditions, or be willing to take special measures to protect them, such as winter mulching or wrapping.

The amount of sunlight is another factor that determines what plants can be grown in a particular area. Certain plants are suited

not only to survive but also to thrive in specific conditions. Most sun-loving plants need at least six hours of full sun each day, which is most readily available in a south-facing area. Plants adapted to light shade need about four to six hours of sun each day, which is usually afforded in areas by east- or west-facing walls, fences or buildings or under open trees. Shade classified as dense, heavy or full usually describes any area that receives less than four hours of sun a day. This may be under thickly branched trees or on the north side of a wall, fence or building. The shade on a northern exposure varies somewhat with the season and angle of the sun.

The amount of sun or shade also affects soil and air temperatures. Shade can reduce both air and ground temperatures and increase the level of humidity found in the microclimate of your garden site. A south-facing exposure receives the most sunlight, resulting in a warmer, drier microclimate.

Prevailing winds also have a significant effect on the chill factor and the ability of plants to survive the winter. Wind causes plant leaves to lose moisture, making them susceptible to desiccation. Areas that are more likely to have an inordinate amount of wind include shorelines and hilltops.

A four-acre (1.6 hectare) lake is large enough to affect the microclimate of the surrounding area, moderating both summer and winter temperatures. Missouri Botanical Garden, St. Louis, Missouri.

Dry, hot southerly winds can also affect your garden by drying out plants and soil in the summer. Knowing the direction from which the prevailing wind blows affords you the opportunity to choose plants accordingly, or to incorporate defenses into your design concept.

Soil moisture also influences plant selection. As mentioned, soil type affects drainage and is one aspect to consider. Another is natural rainfall. Most plants grow best with an average of 1 inch (2.5 cm.) of water each week during the growing season. Due to water shortages in many areas, supplementing rainfall is not the option it once was. It is better to choose plants that require less water, or plan on using a mulch that helps retain soil moisture.

In making a careful study of your own garden needs and how your design will meet them, do not forget to consider which existing features you wish to retain. Is there a vegetable garden you want to keep, a play area with a sandbox or swing set, a stone retaining wall or certain trees or shrubs?

A mild, moist climate allows the extensive use of moss and a choice of many different evergreen plants. Japanese Garden, Portland, Oregon.

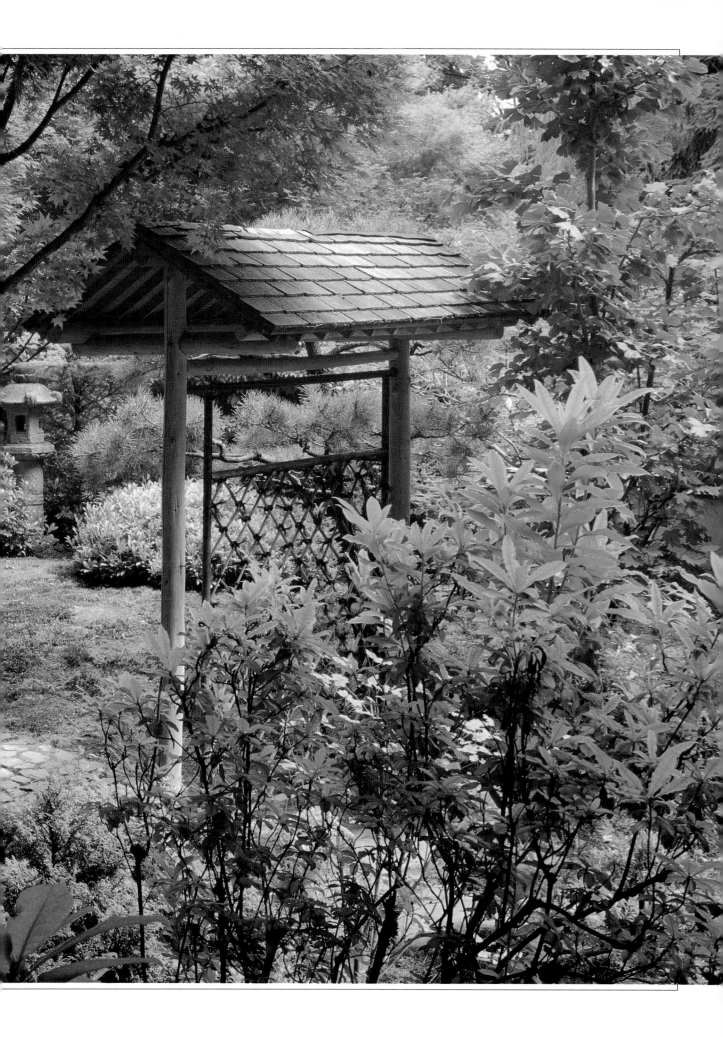

To blend a Japanese-influenced garden into your yard, assess your needs, whether they be recreation, entertainment or meditation, and choose a style that serves them. Also, determine who may need access to your site now and in the future, such as garbage collection or maintenance services. In addition, try to envision your future needs and the possible expansion or contraction of the garden. Although you cannot foresee all the possibilities, forethought can alleviate potential problems in the future.

You should now have a better understanding of the natural, structural and personal parameters of your particular site that will affect the choices to be made in designing your garden. This, combined with a study of natural phenomena in your area and Japanese garden principles, styles and elements will provide you with the framework either to design a garden personally in the Japanese manner or to work with a design professional to create one.

If designing your own garden is your goal, you are ready to sit down with pencil, graph paper and tracing paper and start to plan your garden site. A step-by-step process follows to help guide you in this endeavor.

If your intended garden site is small and relatively flat, or you have some garden design experience and technical expertise, begin by drawing a measured outline of your house, including the location of all doors and windows, and the existing features of your garden, using an appropriate working scale, on a sheet of graph paper. Be sure to mark the scale of measure on your graph sheet and include all outbuildings, driveways, walks, walls, fences and other garden features. Draw in existing trees, including such details as the girth of the tree trunks, the span of overhanging foliage and, if possible, existing shade patterns at midsummer. Also, note the contours, or slope, of the land.

Mark the direction of north and indicate the prevailing winds with arrows. Note, if you can, the locations of any underground power, water and sewage lines. This information can usually be obtained from your power company or municipality. A professional survey of your property will include it.

If you test your soil for pH and nutrient levels, then improve it with organic matter and fertilizer, the plants you choose will have the greatest possible chance of success. Ornamental grasses are among the most adaptable of plants, withstanding a wide range of soil types and providing beauty almost year-round. Planting Fields Arboretum, Oyster Bay, New York.

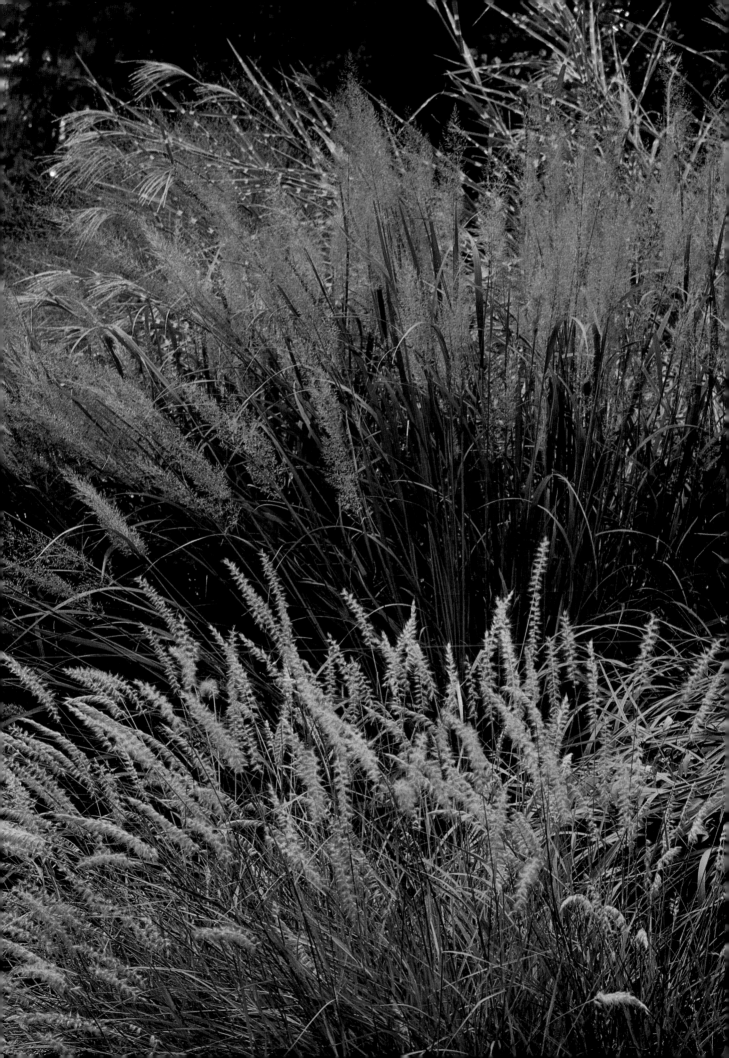

In planning the garden, it
is important to know the
estimated time of the first
and last frost as well as the
average minimum winter
temperature for the area.
Such information helps
you choose plants that will
do well in your garden.
Still, unusual weather, such
as an early snow, can put
plants under stress. Private
garden, Palmyra, Indiana.

If you are planning a larger garden, or the space you have chosen has a number of different elevations, or you have no design experience or technical knowledge, obtain a survey of your property from a professional surveyor. The cost of the survey will depend on the size and features of your property, but the expense will be small relative to the investment in your garden. It will also save you a good deal of time, making it well worth the extra money.

On a separate sheet of graph paper, draw an enlargement of your intended garden site, or make an enlarged copy of the relevant portion of your survey. Tape a piece of tracing paper over the top.

Art and graphics supply stores often carry inexpensive templates of plant shapes and other garden elements. Purchase one of these or use different household objects of varying sizes, noting their size in scale, to help develop the best design for your garden. Try different configurations until you find an arrangement that suits you *and* embraces Japanese design principles.

Once you have settled on an arrangement, make a final copy on a sheet of tracing paper for use as your working drawing. You are now ready to apply your plan to your garden site and express yourself by creating your own Japanese-influenced garden.

基本

THE Japanese consider gardens a major art form, and, as such, certain design principles apply to them. These principles are the key to creating beautiful havens of serenity and peace. At the core is the principle of *in* and *yo*, the Japanese terms for the Chinese *yin* and *yang*. This concept of the male, or positive, and the female, or negative, is one not of antagonism but rather of wholeness. It is a concept manifested in many different ways, and, when balanced in the Japanese manner, it is what gives these gardens their sense of harmony and unity.

Balance is integral to a Japanese garden, but not the balance of centering and symmetry traditional in the West and in the formal Western garden. Rather, it is the balance of asymmetry, as in nature. Philosophically, the Eastern preference for asymmetry is founded in the Taoist and Zen teachings that focus on the process of attaining perfection rather than on the state of perfection itself. Aesthetically, in terms of the garden, this translates to appreciating its beauty as much for what is absent as for what is present.

Practically speaking, asymmetrical composition and odd-numbered components in a grouping are favored. The overall design and the groupings within are balanced asymmetrically along the lines of a scalene triangle in which the three sides all have different lengths. A series of interlocking scalene triangles carries on this pattern and relates different groupings to one another, with attention given to all three dimensions. If the grouping is to be viewed from more than one angle, the designer attempts to make it appear balanced in the Japanese sense—from every viewpoint.

The concept of balance applies to any aspect of *in* and *yo*. For example, there is the duality of cycles. By observing the cycles of nature, we know ourselves; by observing our own cycles, we know nature. We all have peak periods during the day when our energy flows most strongly and a lag time when our energies diminish. We also experience cyclical patterns by observing nature. We watch an orchard blossom in spring and bear fruit in summer. In autumn and winter we see leaves fall to the ground and slowly disintegrate, enriching the soil to bring energy to the trees in spring. These cyclical processes are a necessary part of life and contribute to its completeness.

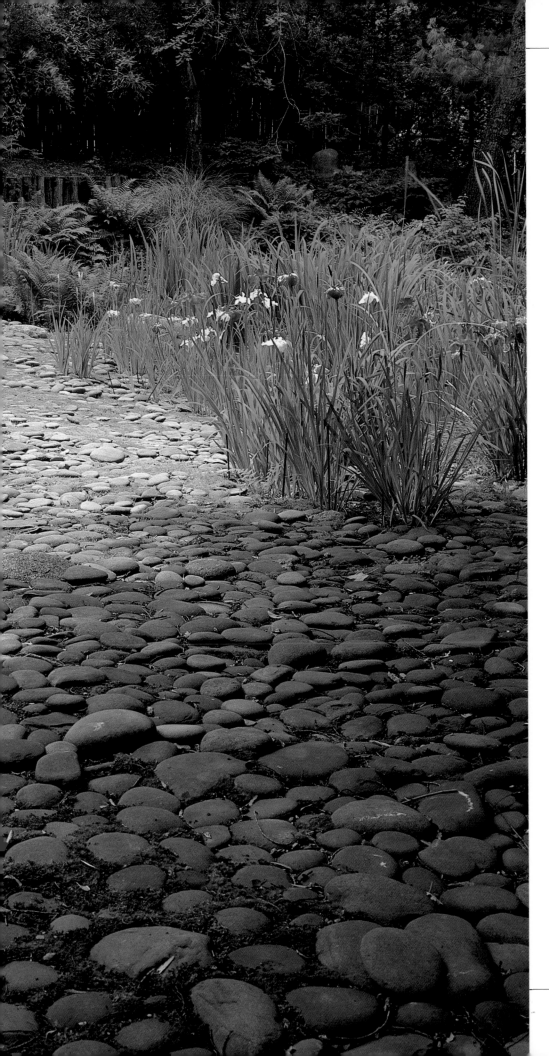

The perspective and scale
of a great ocean and wave-
worn coastline are reduced
to their essence in this
simplified expanse of beach
with smooth river stones
along the shore of a small
pond. The John P. Humes
Japanese Stroll Garden,
Mill Neck, New York.

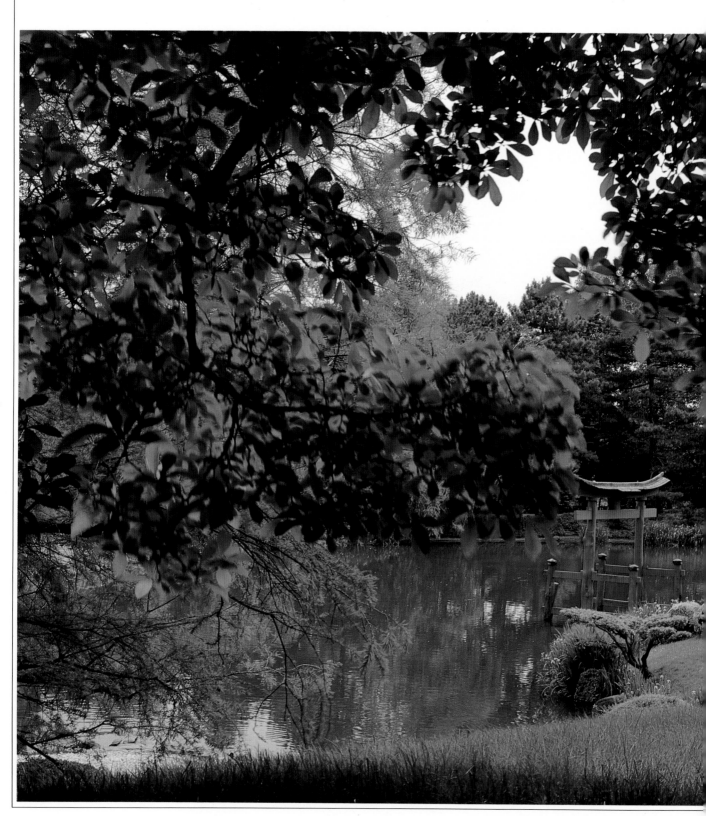

Viewing points within a garden that offer overhead protection and a sense of enclosure, such as a canopy of large old trees, are essential to creating a feeling of security and peace in a garden. Brooklyn Botanic Garden, Brooklyn, New York.

Another aspect of the unity of *in* and *yo* in a Japanese garden is the complementary attitude of its ornamental elements and plantings: light and dark, coarse and fine textures, space and form, horizontal and vertical, the obvious and the mysterious, hard and soft surfaces. Each opposes the other, but rather than creating discord, they achieve harmony and unity when they are in balance, asymmetrical though they may be.

Other than plants, water and rock are the two elements most commonly used to unify the Japanese garden with the universe. Water, in either a pond, stream or stone basin, unites the garden with the sky through its reflection. The sky's reflection reminds viewers of their participation in the universe even while they are secluded in a quiet, private domain. It also reminds them that they are not alone but connected to a greater whole. The sound of water tumbling over stones in a stream or waterfall or dripping from a bamboo pipe lets listeners know they are alive and united to the cosmos.

Rocks give a garden a sense of stability, strength and connectedness. Stones used for pathways flow through the garden, taking the visitor not only on a physical journey through the garden space but also on visual and auditory journeys. Eyes follow the stones around the garden. The sound of feet walking on a path of stones or of a rake drawn across gravel provides another connection with the earth.

Another way that balance and unification come into play is through integrating architecture and landscape. When at all possible, have the house and garden designed simultaneously as a unified whole that relates styles and materials. When this is not possible, the garden can be blended with a house through transitional devices, such as similar materials or shapes, that serve to connect the two.

One of the least understood, most esoteric and often ignored aspects of harmony and unity is the ancient Eastern concept of geomancy, the adaptation of man's dwellings and gardens to harmonize with the cosmic forces of nature. Most important was orientation to the four directions, but natural landscape features were also considered. Changes could be made in the landscape to make buildings or gardens propitious to the site. This science is difficult to apply today, but the best way to take it into consideration is to try to relate the aesthetic, philosophical and practical qualities of your site, as well as its personality, with its surroundings and the community.

Another Japanese principle of design is naturalism or simplification, the reduction of the complexity of nature. For example, a designer of a small garden site can represent a vista of majestic mountain ranges along a vast seacoast by strategically placing rocks and a carefully raked gravel pattern indicative of water with waves lapping at the shoreline. Simplification enables Japanese garden designers to focus on the most important details, making construction possible in any size of garden and enabling us to enjoy more with less.

In a garden designed with the principle of simplification, the viewer becomes an active participant. Only a few details of a much larger picture are provided, challenging the viewer to imagine the missing pieces through contemplation of the existing scene. On a daily basis, depending on the viewer's mood, interpretation of the scene can differ. Whatever is imagined, this active process heightens the viewer's awareness that he or she is a part of the garden and, hence, a part of the universe.

A microcosm of the natural world, this small area at the intersection of two paths has a unity of purpose and spirit. Woodland provides a background of borrowed scenery, the bamboo fence defines the space and the moss unifies the area. The rocks are large but not out of scale, and there is a balance between vertical and horizontal, hardness and softness. The John P. Humes Japanese Stroll Garden, Mill Neck, New York.

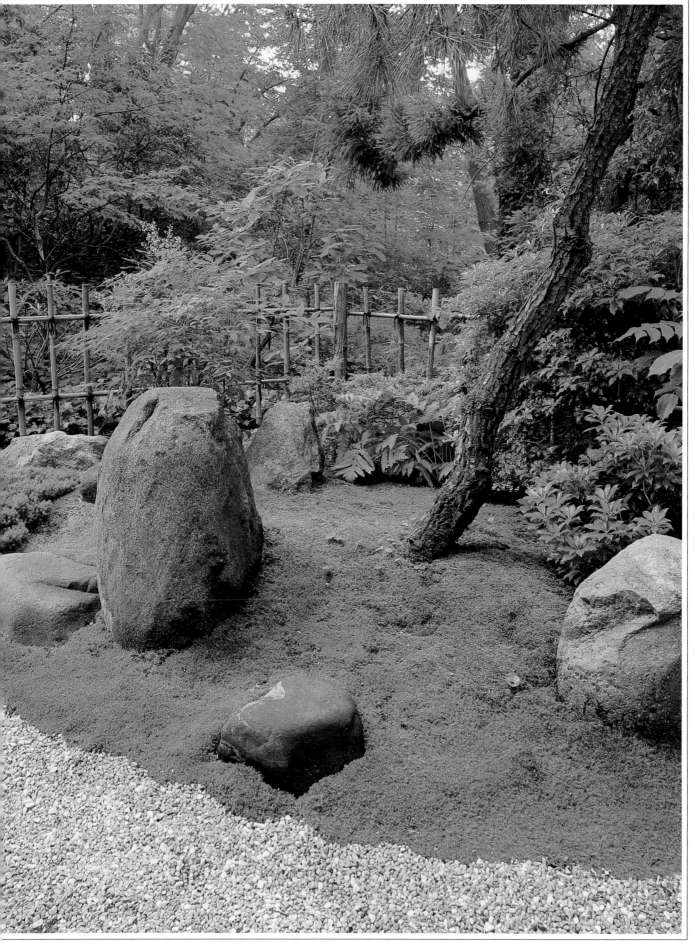

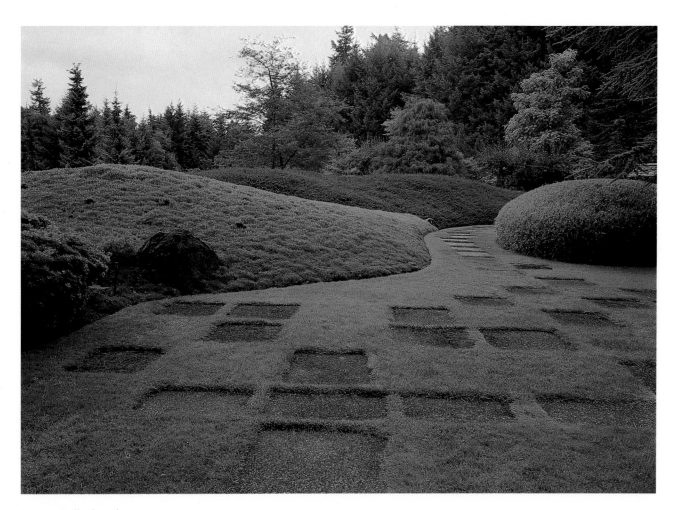

Geometrically shaped step-
ping stones, asymmetrically
arranged in an irregular
pattern, counterbalance
the lush, sensuous mounds
and trimmed shrubs.
Bloedel Reserve, Bain-
bridge Island, Washington.

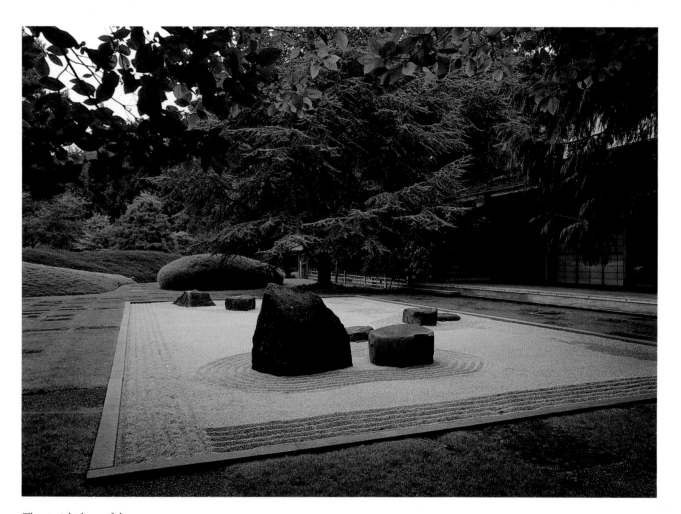

The straight lines of the
dry landscape repeat those
of the guest house and the
stepping stones, while the
rounded shapes of the
stones echo the softness of
the natural surroundings.
Bloedel Reserve, Bain-
bridge Island, Washington.

A simple redwood fence, constructed in the style of a traditional bamboo one, provides an unaffected enclosure, with the gate and stepping stones beckoning one into the garden beyond. Mounds of earth and closely trimmed shrubs further the sense of enclosure and mystery by obscuring the path ahead. The distant woodland creates a feeling of depth and distance, making the garden seem larger than it actually is. Bloedel Reserve, Bainbridge Island, Washington.

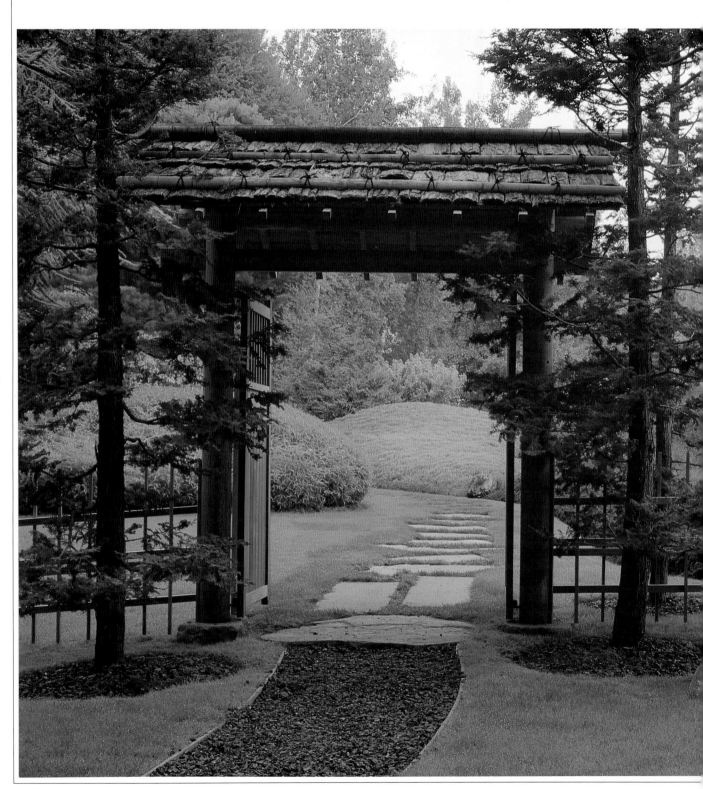

The design principle of framing, involving enclosure and borrowed scenery, is a process of selecting existing elements or adding new ones to a garden site to create both a sense of sanctuary and a oneness with the world. For the Japanese this concept goes as far back as early Shinto shrines, which had areas roped off to keep them sacred. Whether you live in a suburban neighborhood or the penthouse of an urban apartment building, or you are isolated in the country, your garden space and home can come together into a single entity that is at once separate yet part of your surroundings. Enclosure embraces your space, creating a sense of security and comfort.

Outer enclosure uses background plantings of trees and shrubs and either natural or artificially constructed hills as well as walls or fences that are existent or added. Where appropriate, use what already exists and add what is necessary to complete the enclosure.

The feeling of serenity will be diminished if the space overhead is too open and unprotected. A few large trees with thick foliage at the top and far-reaching branches will create a natural canopy that protects the viewer from feeling too exposed. Another form of overhead enclosure is the wide eaves present on some homes or the roof of a veranda. Both also contribute to the framing of a scene.

While framing the garden site through the use of enclosure sets the stage or creates a mood, the selective and skillful inclusion of the surrounding landscape can enhance the beauty of the garden site without compromising the sense of privacy. Borrowed scenery, or *shakkei*, "landscape that is captured alive," provides a sense of balance and continuity, a connection with the outside world. What you can borrow depends on where you live. It can be mountains, hills, trees (or just their tops), the ocean, lakes or even beautiful structures. While some existing structures may detract from the beauty and harmony of your garden, others may have a unifying effect. Whatever you borrow, be sure that it complements the design and intended effect of your garden. Focus on the addition of an attractive, harmonious dimension that will not sacrifice the garden's privacy or sense of enclosure.

In an urban or suburban setting, trees and fences belonging to adjacent yards must either be incorporated into your garden or blocked from view. It is usually simpler to allow larger trees, fences and other structures to become a part of your total design concept than to try to eliminate them. Plantings can be situated to blend with the surrounding landscape. If your neighbors are willing, perhaps you can implement a cooperative design.

The design principle of framing has established the garden's boundaries. You now know where the limits are and have created a safe place within which you can freely express yourself.

Manipulation of perspective and scale alters the perception of depth, distance and size of both the garden and its components. The smaller the area, the more inclined you will be to manipulate depth and distance. In Japanese garden design three areas are used in manipulating perspective: foreground, middle ground and background.

Perception of depth and distance are manipulated by placing larger objects in the foreground. To make a garden space seem larger, the larger trees, shrubs and stones must be placed in the foreground and the smaller objects placed in the background. Bolder textures and brighter colors in the foreground and finer textures and more subdued colors in the background will enhance the effect.

If your garden site is large enough to have either a path or a stream, taper it so it appears to narrow as it recedes from your vantage point. You can further enhance the illusion of distance by partially obstructing the middle ground, which interrupts the visual link betweeen foreground and background, making the background seem disconnected and even farther away. You do not want to block the middle ground from sight but instead add something to it to catch the viewer's eye and enhance the perception of depth and distance.

To create a sense of diminished space, simply reverse the previously described tactics. Place the larger components in the background and the smaller objects in the foreground.

The Japanese frequently employ the principle of surprise, or *miegakure*, to stimulate the imagination. In gardens with stroll paths they typically curve the path or place plants or objects to hide what is behind or beyond. This invites the spectator to continue walking to discover what is around the bend or on the other side of that tall clump of bamboo. The route by which an object or planting is approached, or by which groups are joined together, adds to the overall effect and helps us realize the full potential of what is being viewed. This principle reinforces the concept of process, with the path to discovery at least as important as the discovery itself. The placement of the stones, the objects along the way, all enhance your passage through the garden and bring a fuller appreciation of the journey as well as the destination.

Beds of fern and iris along this angular bridge obscure the middle ground, disconnecting the foreground and the background. This enhances the depth of the garden and also piques the curiousity of the visitor to explore, to see what is beyond. Japanese Garden, Portland, Oregon.

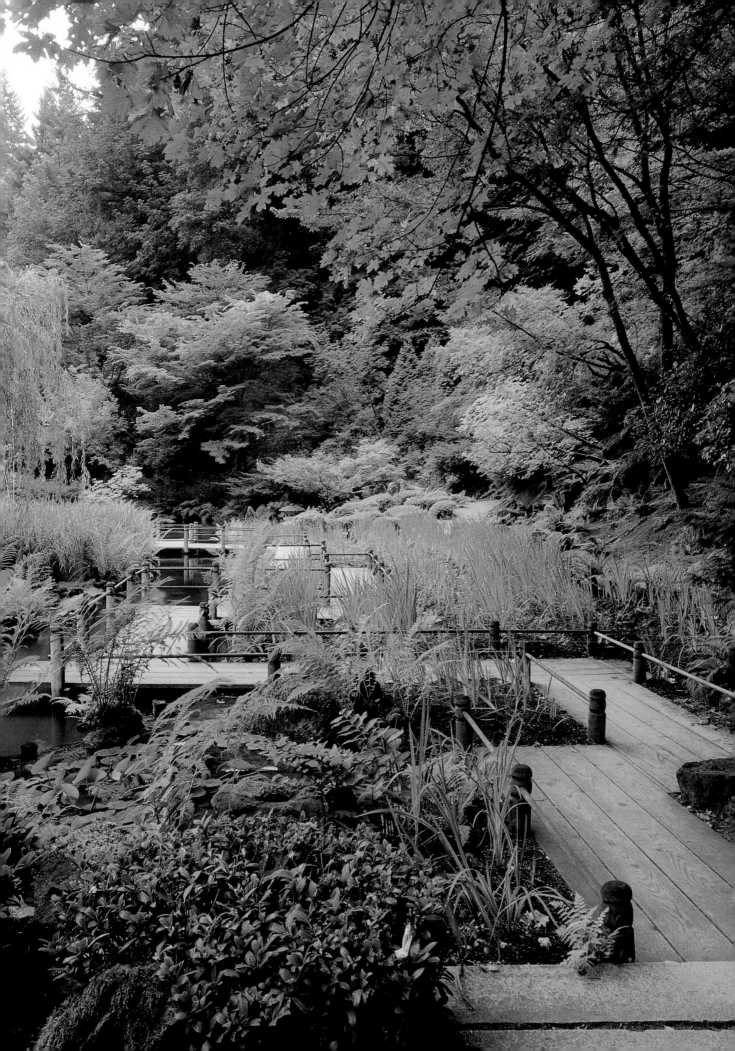

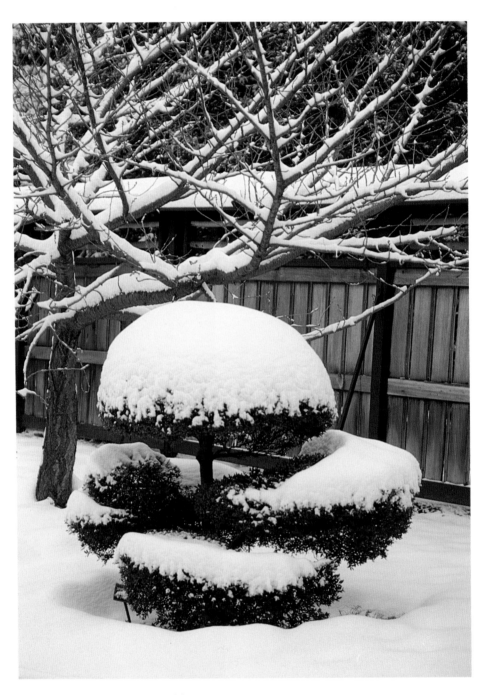

A small garden area conjures the image of a snow-covered mountain scene. The fence and "snow-blossomed" trees provide enclosure. The juxtaposition of the airy lightness of the tree branches with the solid mass of the finely clipped evergreen exemplify the wholeness of *in* and *yo*. Brooklyn Botanic Garden, Brooklyn, New York.

Background trees give a feeling of enclosure and provide borrowed scenery even in the winter, while the choice of plants and structures up the hill gives the garden depth. Plantings are different on each side of the bridge and stream, yet balance is achieved. Brooklyn Botanic Garden, Brooklyn, New York.

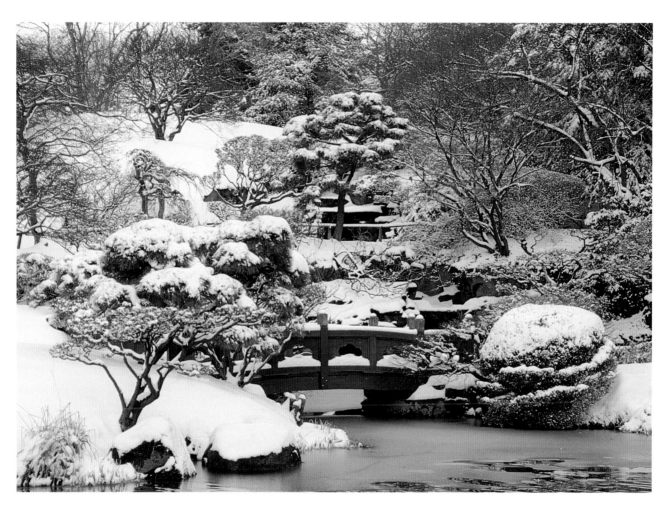

Straight lines and perfect geometric shapes are seldom employed in Japanese design, but when used they are set against very naturalistic elements or used as symbols, such as plants sheared to intimate clouds. To generate a sense of spaciousness, horizontal lines dominate and vertical counterpoints create contrast. Bridges, ponds or other elements are set to be viewed on the diagonal, creating a sense of enlarged space. Line and mass, constructed mainly from evergreen plants and rock, are used in the garden rather than color. These have an immutability that transcends seasons and gives the garden a timeless quality that is integral to its tranquillity.

A Japanese garden is ultimately about the knowledge, expression and reflection of feelings, to which we gain access through our senses. A successful garden offers a sensory experience, evoking physical responses to what we see, hear, smell and touch. Given the Eastern belief that our senses are the pathways to our inner beings, our spirits, this means that the garden touches us emotionally. It is imperative then that what we sense in our gardens be in harmony and relate feelings of connectedness and a sense of unity, to provide a place of serenity and peace.

Spending time in your garden should be an opportunity for self-renewal and peaceful contemplation. As the Zen monks used their gardens for meditation, you can use yours to escape from the chaos and concerns of the world and unite the disparate thoughts in your head and elements in your life, so that you can once more face the world with a balanced wholeness.

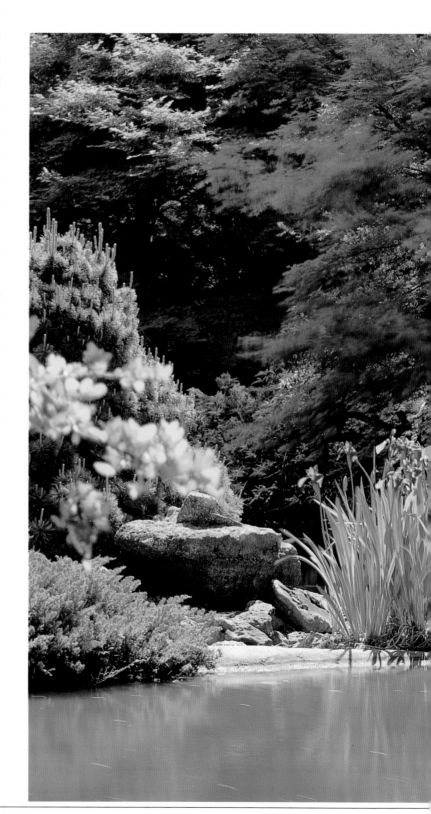

A placid pond reflects the world around it—the rocks, the plants, the sky—and suggests the unity and harmony of the universe. The solidity of the large horizontal stone contrasts with the fluidity of the vertical iris leaves. Fort Worth Botanic Garden Center, Fort Worth, Texas.

STYLES

丘池

M A N Y garden styles and variations are part of Japanese design philosophy. Westerners have the opportunity to create variations on Japanese themes by reflecting their own landscape. Established styles do not have to be followed strictly, for when they are rigidly copied, the designer's inner self is lost. Personal interpretation of styles can result in a beautiful garden and also reflect the self you wish to express.

The five traditional Japanese garden styles are presented in this and the following four chapters. Adapting these styles to your requirements and incorporating yourself into the design of your garden should be your main focus. Mix elements from different styles as appropriate in adapting your garden to its site as well as to your needs and wants.

The hill and pond garden, or *tsukiyami*, is the foundation on which all other Japanese garden styles are based. The concept was brought to Japan from China and its colonial outpost of Korea in the seventh century. For the next five centuries, through the Nara and Heian periods, hill and pond gardens were the predominant style.

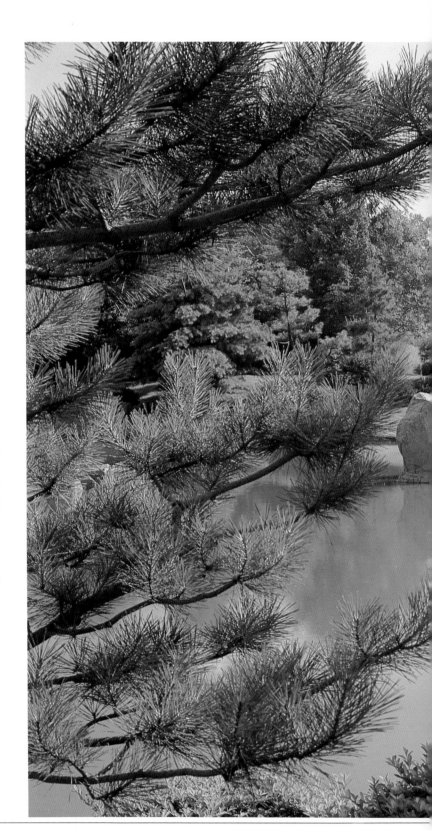

Over the centuries Japanese gardens have come to incorporate many styles and influences, but expanses of water, bridges, islands and plantings of evergreen and deciduous trees are their hallmark. Missouri Botanical Garden, St. Louis, Missouri.

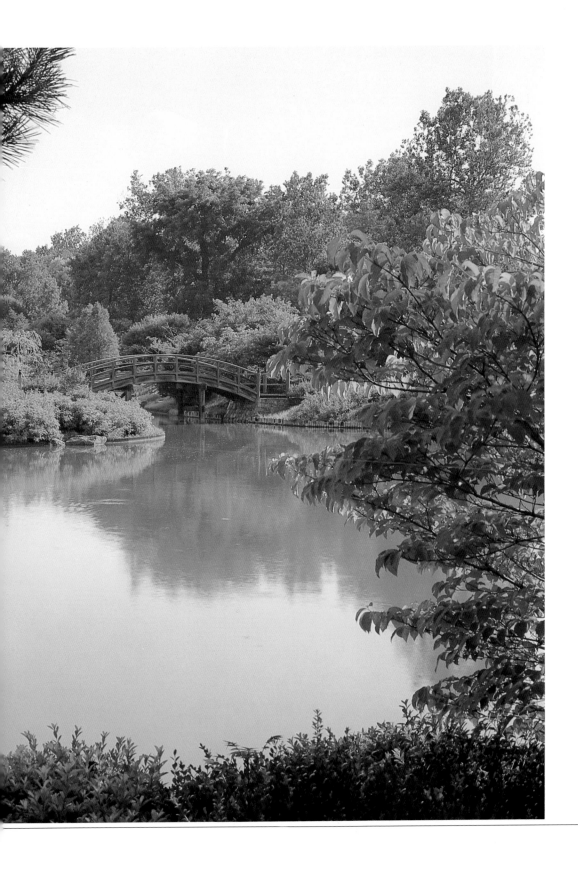

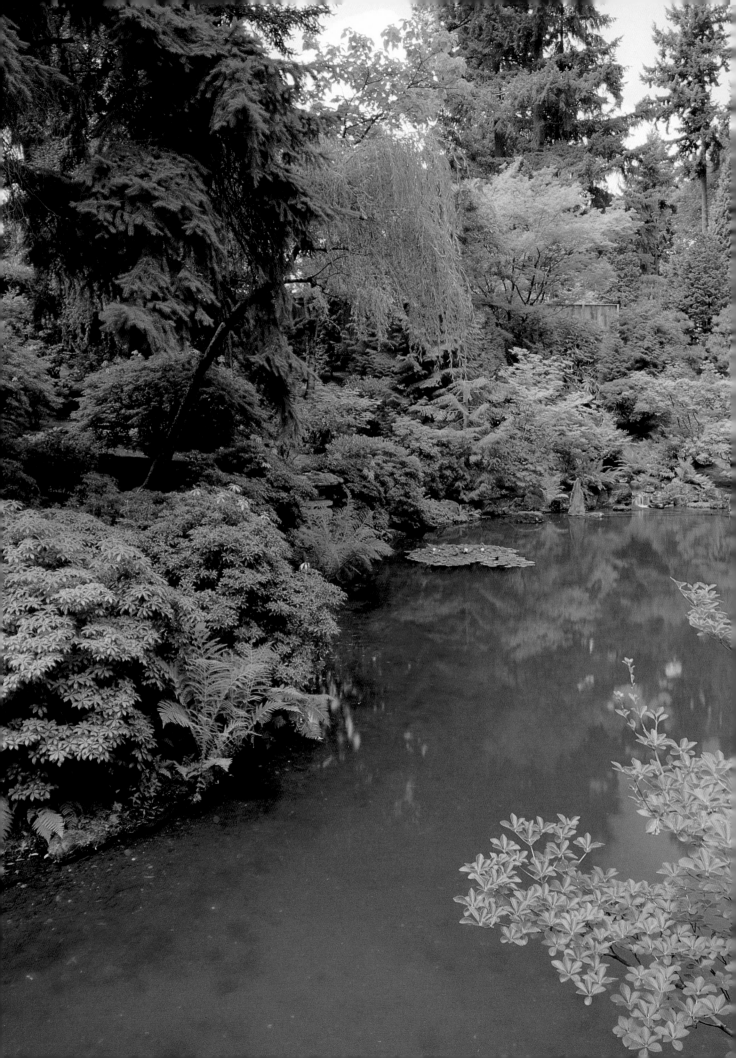

The emperor and and members of the nobility built compounds of multiple structures with small courtyard-type gardens around the various lesser buildings and a larger garden in front of the main building. These primary gardens were almost always built on the south side with a pond stretching from east to west. The pond was fed by a stream entering from the east, symbolically bringing in purity, and leaving from the west, taking away impurities. Often the stream would have one or more cascades or waterfalls. Viewing pavilions extending out over the pond or lake were linked to the main building via covered walkways.

A large island was connected to the mainland by two bridges. One was usually arched, often red in the Chinese style, for pleasure boats to pass under, and another would be low and flat. Smaller, single rock islands were also popular. On the far side of the pond would be a single hill or a series of hills. A path might extend around the garden, but it was basically decorative, as this garden was essentially a composition to be enjoyed from the viewing pavilions and the main building.

The placement of stones along the shore and in the water of a man-made pond gives it a sense of naturalness. Japanese Garden, Portland, Oregon.

A variety of plants were used, including pines, cherries, apricots, plums, wisteria, kerria, deutzia, tree peony (*Paeonia suffruticosa*), many genera of bamboo, maples, azaleas, pieris, weeping willows, iris, chrysanthemum and wildflowers such as violets and balloon flowers (*Platycodon grandiflorus*). Trees and shrubs were sometimes trained to give the impression of being old and windswept.

Although few gardens exist from this era, two written records of the time afford us details of these pleasure gardens. One is a novel, *The Tale of Genji*. Written by a lady of the court known as Murasaki, it offers descriptions of various gardens. The *Sakuteiki*, or *Treatise on Garden Making*, reveals the Japanese awareness of nature and design principles, with two key instructions being to study past masters and nature.

Of the many hill and pond style gardens that have been built in the West, perhaps the most notable example is at Brooklyn Botanic Garden in Brooklyn, New York. Although a pathway is available for walking around part of it, this is a garden to be viewed mainly from the pavilion extending out over the lake.

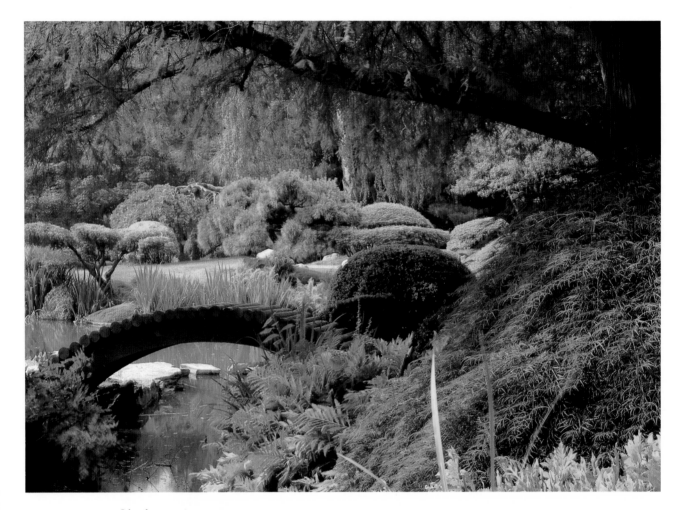

Islands, sometimes accessible by bridges, are a key characteristic of Japanese hill and pond gardens. In their earliest manifestation, islands symbolized paradise and immortality. Brooklyn Botanic Garden, Brooklyn, New York.

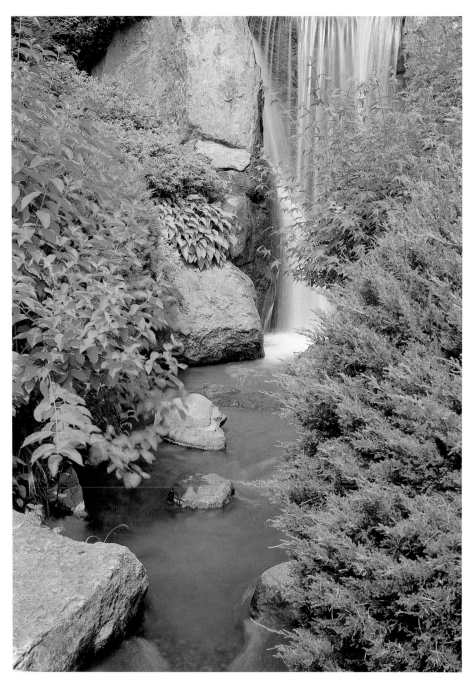

stones along this stream

before it enters a lake.

The movement and melody
Missouri Botanical Garden,

of the finely veiled water-
St. Louis, Missouri.

fall offset the weight of the

For many years after gardens were begun in Japan, the Japanese word for garden was *shima*, or island. There is much Japanese folklore and tradition surrounding the concept of islands, mountains and rock, which is not surprising given Japan's natural landscape.

Horai-jima, Horaisan or Mt. Horai, from Chinese Taoist lore, was a mountainous island paradise of eternal youth. Some legends tell of its being turtle-shaped or inhabited by turtles and cranes, symbols of longevity. Others tell of giant turtles bearing three such islands on their backs and cranes flying the immortals to and from the islands.

Building turtle and crane islands became an early part of Japanese garden design. Turtle islands were usually low mounds with stones for the head and feet. Crane islands were either simply a large vertical stone or a low island planted with a tall pine tree.

Islands in gardens were also thought to lure the gods into visiting the owners. A single rock island might suggest a ship seeking the mystical island of Horai, while a string of five rocks could imply boats moored at night.

Of Hindu origin and adapted by Buddhism, a sacred mountain called Sumeru, Shumisen or Shumitsen, was at the center of the universe supporting the heavens and surrounded by eight mountain ranges. This concept, as well as the natural terrain, gave rise to the use of hills in the garden.

Other aspects of Buddhist philosophy influenced the development of hill and pond gardens. The deity Amida lived in a celestial lake garden, and this belief inspired garden designers to use its imagery. The duality of *in* and *yo* played its role, too, with the complementary forms of hill and pond.

A common form for this style of garden is an artificial lake, pond or pool, preferably with a natural or recirculating stream and waterfall, and "hills" behind. If there is an island, you can build or purchase a wooden bridge or create something new, such as the red steel bridges at Dow Gardens in Midland, Michigan, or have none at all.

A wide range of plants can be used in the hill and pond garden, including many flowering trees and shrubs as well as perennial flowers. Even so, the principle of simplification must not be abandoned; it is better to repeat just a few different kinds of plants.

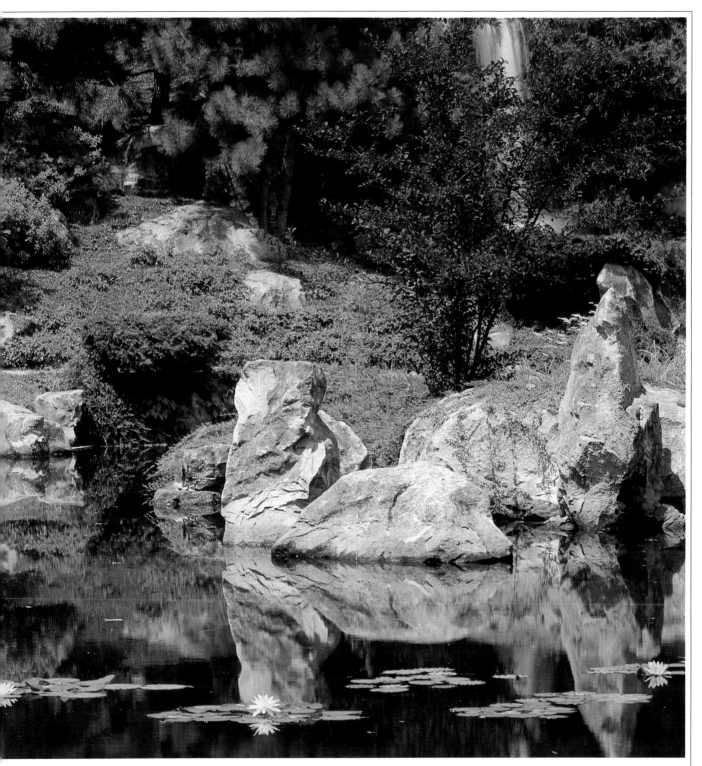

The massive stones near the point where the waterfall and stream enter the pond readily convey the sense of a mountain lake. The reflection of the stones in the water and their repetition up the hillside emphasizes the immutability of nature. Private garden, Bloomington, Indiana, designed by Kenneth Yasuda.

In the hill and pond garden, rocks and stones establish the pond in its environment. Surrounding a man-made pond with various rocks gives it a natural look. The most common place to set rocks is where the stream meets the pond and along the edge to cover the lip, be it natural, concrete or a plastic liner. Small stones scattered along the edge leading into the grass and away from the pond's shoreline add to its natural appearance. Smaller stones pressed into large, flat shore areas of the pond give a stylized beach effect. A large rock placed in the pond creates the image of an island, possibly that of the traditional turtle or crane.

Although originally designed on a large scale for nobility, the hill and pond style adapts readily to smaller spaces, particularly through manipulation of perspective. Western homes, with their large glass doors and windows visually connecting the house to the garden, lend themselves to gardens providing an idealized picture of nature.

Imagine viewing your garden from a room in the house or a patio and focusing your eyes on a pond and hills and their natural beauty. This experience would give you strength and reaffirm your connection with the earth, nurturing you and giving you the courage to continue your journey. Such are the lessons learned in the hill and pond garden.

Left: An expanse of water, two large rock islands and a hillside planted with evergreens invokes with simplicity and unity a vision of ocean and mountainous coastline. Denver Botanic Gardens, Denver, Colorado.

Right: The three massive stone islands representing paradise glow in the afternoon twilight of a winter's day, calling us to pause and appreciate the universe. Missouri Botanical Garden, St. Louis, Missouri.

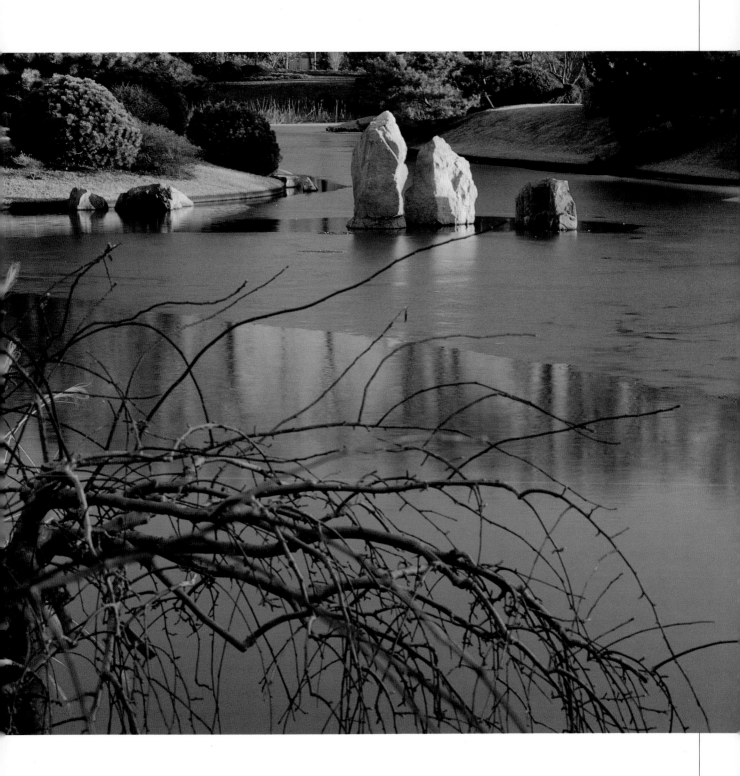

中庭

SINCE the time of the early Shinto shrines, with their sacred roped-off areas, the small garden has been considered part of the Japanese culture. As the centuries have passed, a number of different ways to create gardens of the spirit in small spaces have evolved. Whether one has a true courtyard or an area of limited size, a courtyard garden affords a sense of connection to the natural world.

During the Nara and Heian periods, from the eighth to twelfth centuries, the individual apartments at the villas the nobility had small, open courts called *tsubo*. They were planted in many different fashions. Some descriptions recount informal plantings of artemisia or bush clover (*Lespedeza bicolor*) surrounded by white gravel or clumps of low-growing bamboo set amid a ground cover of moss. Others, such as those described in Murasaki's *The Tale of Genji*, are much more elaborate.

In temple grounds, near the priests' residences and sub-temples, there were small gardens. Some of these gardens were located at the entrances and were meant to be walked through, but most of them were supposed to be viewed from a room or veranda as part of meditation. With the influence of Zen and the Chinese Sung style of painting, these small gardens became more and more simple and abstract, and they often used only fine gravel, stones and moss.

Until this time gardens were mainly the province of the nobility or priests. However, as the middle class, especially merchants and artists, prospered and grew in number, the small spaces around their urban dwellings also began to be landscaped. These spaces might be found at the entrance to a home; a long, narrow walkway from the street or from one building to another; an area between buildings; or a walled-off area at the rear of a building. Often the function of these areas was to provide light and ventilation. They were small, sometimes no more than 8 to 10 feet (2.4 m to 3 m) long and 4 feet (1.2 m) wide. As with the smaller temple gardens, some of these courtyard gardens of the middle class, called *tsuboniwa*, were to be walked through, but most were for viewing from inside the home or from a veranda.

The interplay of the differing sizes, shapes, colors and textures of the stones with the bamboo fence and plants connotes the inherent diversity of nature, yet the simplicity of their use and the setting create a unifying effect. Private garden, Dallas, Texas, designed by Raymond T. Entenmann.

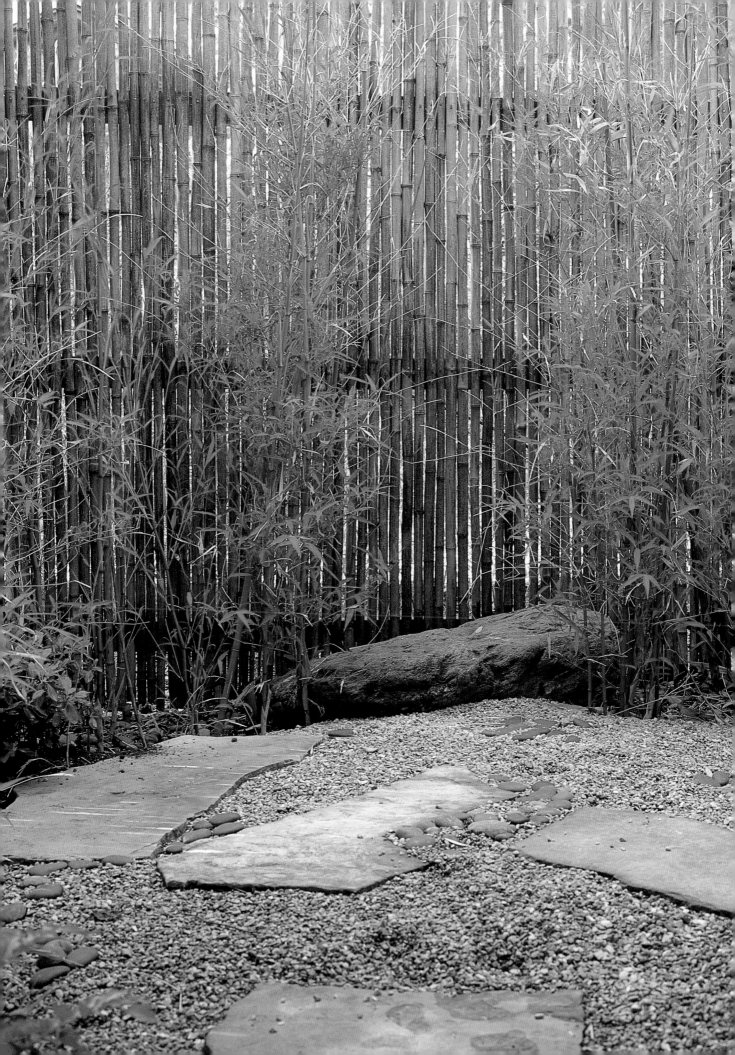

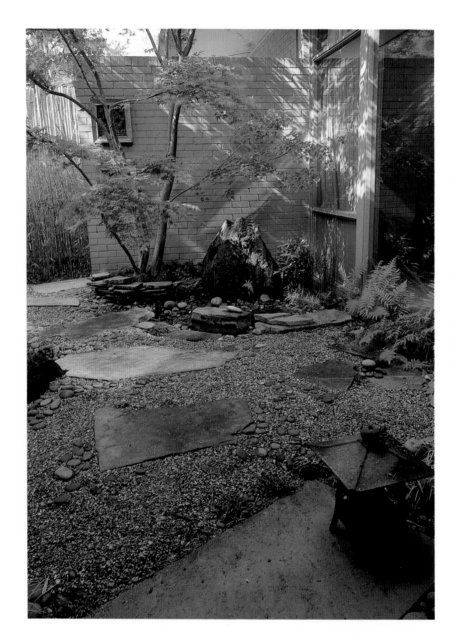

Located off a dining room and bedroom, the stepping stones in this courtyard allow one to journey spiritually through the garden lit by the lantern to contemplate the "mountain stream and ocean" in the far corner. Private garden, Dallas, Texas, designed by Raymond T. Entenmann.

It was during the late 1500s and 1600s that the tea ceremony, including the tea garden, became popular. This ritual influenced the entire Japanese culture. It became fashionable to include the tea garden elements of stepping stones, a lantern and a water basin in the courtyard garden, even though it was only to be observed and did not lead directly to a teahouse.

Given this heritage, the courtyard garden today obviously can take many forms. It is a style that allows a great deal of freedom of expression, but its design principles are the same as those of much larger gardens. Present-day architecture and home styles provide a number of opportunities for including courtyard-type gardens as part of the landscape. Look around your yard for areas that are already enclosed or possibly could be. These spaces may be located off bedrooms or dining rooms or at entrances. Also consider balconies, narrow sideyards or town house backyards. A courtyard garden can even be indoors, perhaps as part of a large foyer or an enclosed porch.

Besides the design principles that apply to all Japanese gardens, there are additional key factors to keep in mind when designing a courtyard garden.

A courtyard garden should allude to being part of a much larger landscape. This may be accomplished with borrowed scenery or by including tall plants that extend up beyond what one sees when looking straight into the garden. A tree or bamboo with its top above the fence creates this feeling. Tall plants also pick up the wind more readily, bringing movement and sound to the courtyard.

It is imperative that elements in the courtyard garden not be reduced in size, as this only accentuates the garden's smallness. Use lanterns, rocks, stone basins or other elements that are proportionate on a human scale. This will also emphasize the above precept by implying that there is more garden beyond the courtyard.

In this idealized evocation of nature, be it an indoor or outdoor courtyard, with or without plants, the integration of each element with the others is also of utmost importance. There should be no jarring notes, and careful attention should be given to even the smallest detail.

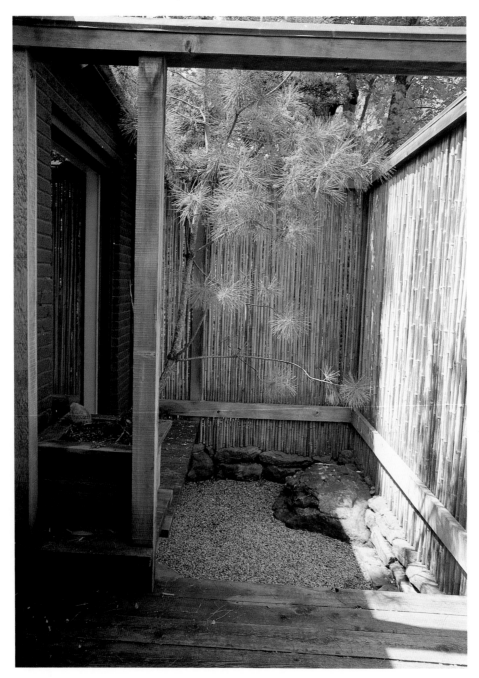

In the narrow space between a deck and bamboo fence, an area of gravel and stone becomes a contemplative dry garden with the borrowed scenery of large trees behind it and the overhead enclosure from a container-grown pine. Private garden, Dallas, Texas, designed by Raymond T. Entenmann.

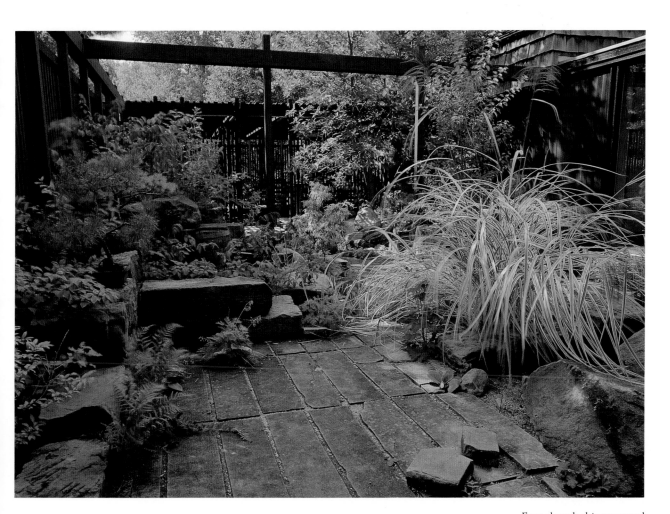

Even though this courtyard
has the Western exuberant
use of plants, the strong
framework of stone main-
tains the essence of the
Japanese style. Dawes
Arboretum, Newark, Ohio.

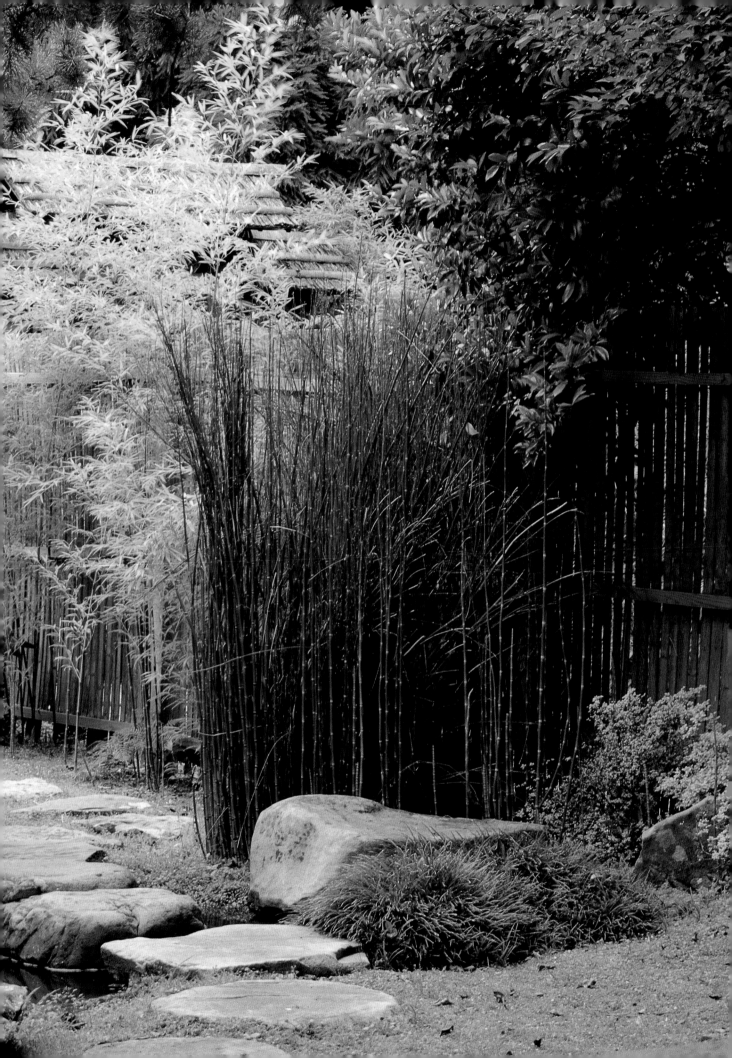

Because courtyard gardens are so intimately connected to the buildings, the harmony of the materials within the gardens themselves and in relation to the architecture is particularly important. If the walls or paving are not in keeping with Japanese design or aesthetics, consider adding or changing materials. For instance, you may want to cover a portion of the wall with bamboo or replace brick paving with stone.

The courtyard should be visually accessible, either through large windows or glass doors, from a patio, from a narrow porch or from seating. Although there are exceptions, such as an entrance garden or a garden that is part of a passageway, this is generally a garden to be viewed rather than walked through. Stepping stones are often included in a courtyard garden, but are only there to provide the illusion of movement. While sitting quietly, the viewer can take a journey in the mind without ever setting foot in the garden.

Empty space is essential to the success of any style of Japanese garden, but especially important in the courtyard garden. A crowded courtyard garden will suffocate the viewer, while one with only a minimal amount of elements gives the viewer a sense of a much larger area. For most of us, this means drawing a plan, then removing at least half the elements.

Unless of relatively large size, most courtyards tend to be rather shady; therefore the plants selected should be able to survive with low light. Glossy-leaved evergreens, such as holly, reflect the light and bring a feeling of energy to the garden year-round. Ferns and bamboos are other traditional plants for courtyards. The only color in a courtyard garden is usually provided by potted flowering plants brought in for brief periods of time. Deciduous plants can be used if they have qualities that make them interesting in all seasons, such as an unusual bark or branching pattern. If there is enough light, ornamental grasses are effective for most of the year.

Left: Bamboo rustling in the wind brings sound and movement to a long, narrow walkway. Plantings, fence and use of stones are kept simple so that the space imparts a feeling of tranquillity. Atlanta Botanical Garden, Atlanta, Georgia. Right: Within a small space, this courtyard includes all the elements of a tea garden, which have traditionally been appropriated by the courtyard garden. Cheekwood Tennessee Botanical Gardens and Fine Arts Center, Nashville, Tennessee.

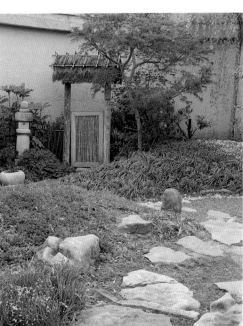

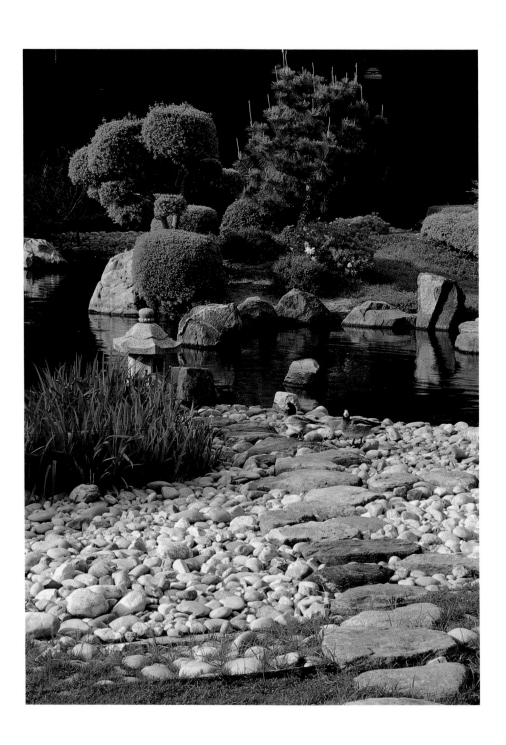

Customarily, the ground is covered with moss or some type of gravel or pebbles, but other plants or materials can be used as long as they keep with the aesthetics of the garden. The use of low-growing evergreens, such as creeping junipers (*Juniperus* spp.) or European ginger (*Asarum europaeum*), allow the garden to be attractive even in winter. Or use old cobblestones, broken pieces of slate or other available paving. No matter how the courtyard garden is designed or what materials are used, meticulous maintenance and grooming is essential.

Although there is a great deal of latitude in designing a courtyard garden, the element of water has the greatest power to determine the feeling conveyed by the garden. Whether trickling down a small waterfall or placid in a basin, water brings a sense of liveliness and vibrancy, and establishes a connection to the natural world. Another way to bring this about, and a traditional way of preparing for guests, is to sprinkle the garden with water.

This courtyard affords restful views of a tranquil pond with a rocky shore, hill-like mounds and dramatically shaped plants. Gulf States Paper Corporation, Tuscaloosa, Alabama.

On a large scale, the headquarters of the Gulf States Paper Corporation in Tuscaloosa, Alabama, illustrates the possibilities of combining architecture and natural landscape with a highly stylized courtyard garden.

Few public Japanese-style gardens in the West have courtyards, but there are still many ideas to be garnered when visiting them. Study and take notes on the arrangement of lanterns, water basins and small rock groupings and the surrounding plants that are particularly appealing to you. There are endless variations on stepping stones and paving materials; perhaps a segment at a garden will catch your eye. Because enclosure and integration of materials are so important in a courtyard, look closely at wall and fencing materials and designs. These efforts will result in a courtyard garden that pleases the senses and soothes the spirit during all seasons.

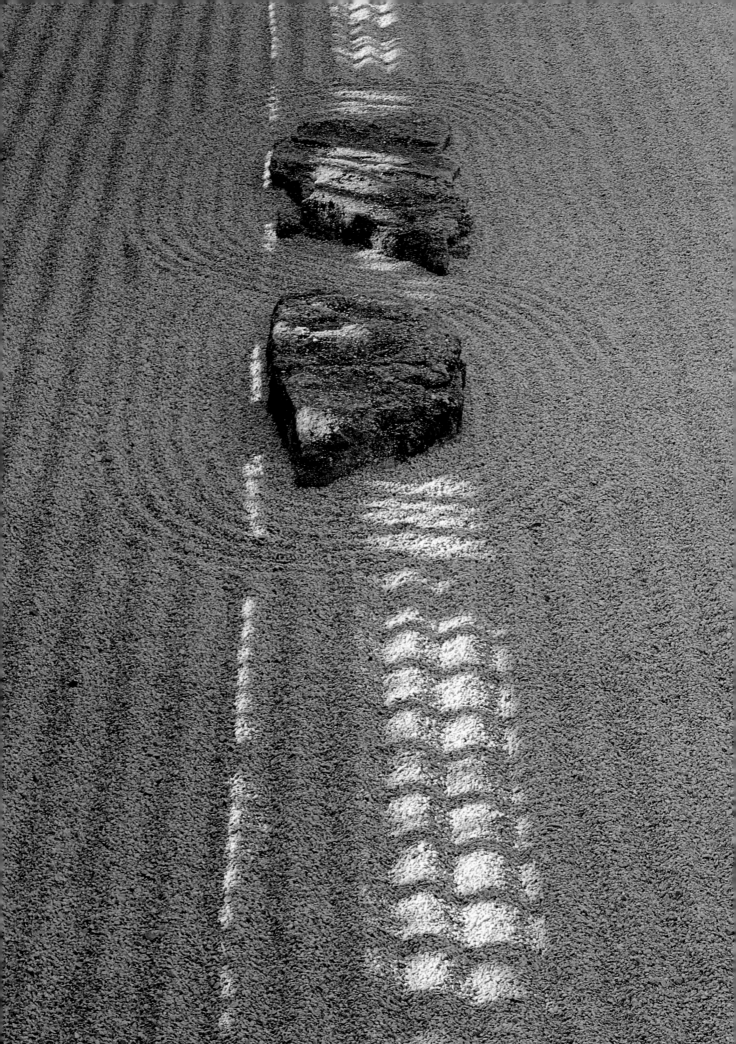

ZEN

Buddhism is so intricately linked with Japanese thought, culture and perception that there is hardly a garden in Japan that does not reflect at least some aspect of Zen teachings. Yet it is the dry landscape garden, *karesansui*, with the emphasis on the element of stone, that is most closely linked to the Zen way of looking at life, nature and art.

The Ch'an sect of Buddhism, founded in China in 520, became a dominant force in Japan by the thirteenth century, where it was called Zen, from the Sanskrit word for meditation. The Zen monks were involved with painting, poetry, garden making and scholarly pursuits. Their art reflected spiritual insight and was marked by a subtle fineness down to the smallest detail. Zen also appealed to the powerful military because of its focus on self-reliance, discipline, simplicity and restraint.

Gardens were created for contemplation during meditation, which was to bring a person intuitively in touch with the inner self—the enlightenment that is within each of us and unites us with the world. These gardens were not meant to be a picturesque or otherworldly vision but rather an aesthetic, sensory, subjective expression of the experience of the connection between a human being and the physical world.

Much has been made of the symbolism in these gardens, which actually emphasized the use of traditional materials in a new way that focused on the Zen sense of timelessness, inner essence and the dynamic harmony in all things. The Japanese term *yugen* is most befitting here, with its quality of mystery, or the evocation of feeling by what is not said or seen. To look at the paintings of the time is another way to see in the Zen way. The Japanese monochromatic ink paintings on silk or white paper conveyed entire landscapes with an economy of brush strokes. What painters did with ink, garden designers did with rock, working with them in terms of harmonic balance, movement and rhythm.

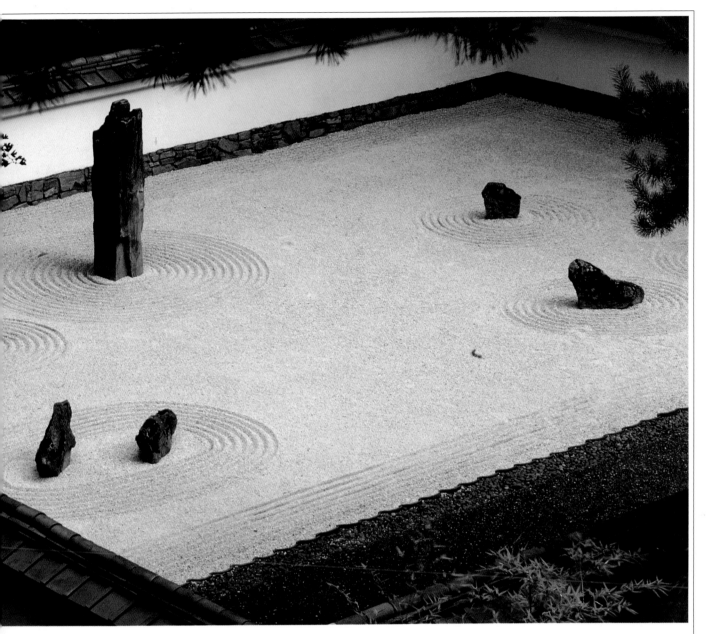

Stark and extremely modern looking, the dry landscape, or flat garden, is the epitome of simplification of form. The stones in this dry garden relate to a Japanese myth of Buddha sacrificing himself to seven starving tiger cubs, symbolizing the infinite compassion of the Buddha for all forms of life. Japanese Garden, Portland, Oregon.

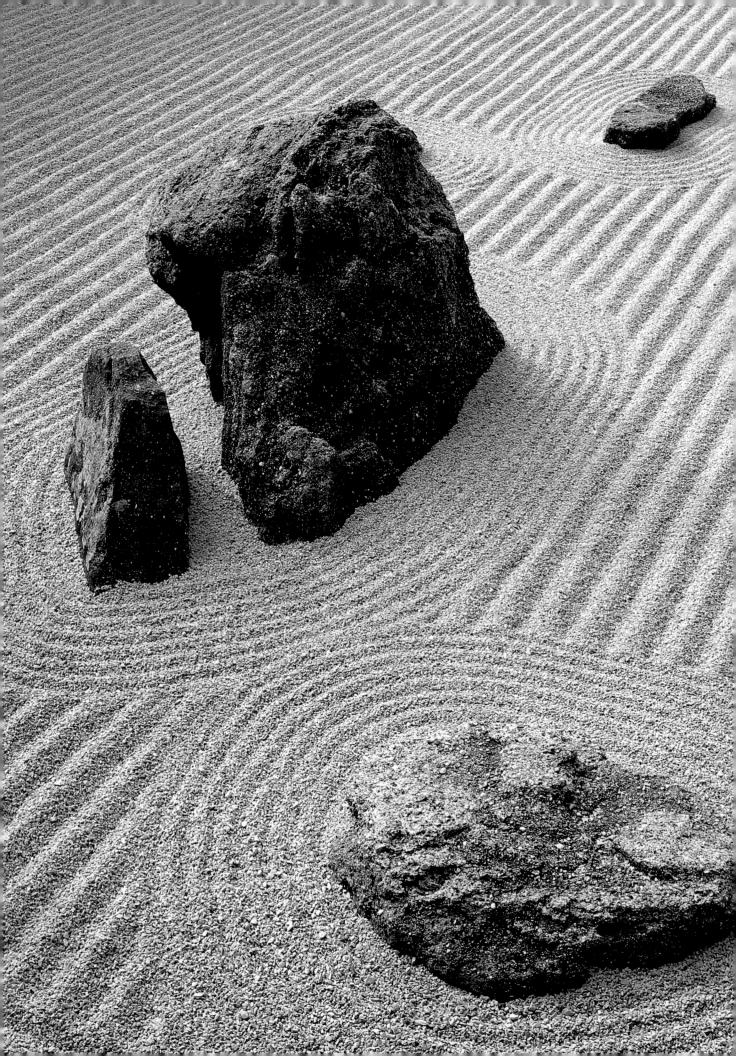

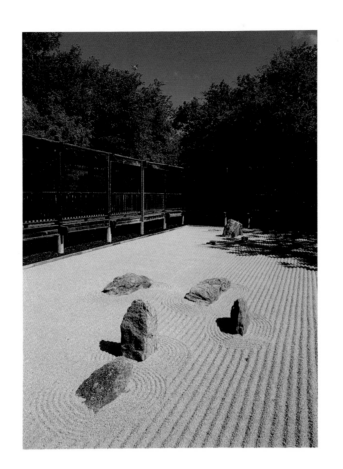

The long straight lines
raked into the gravel of a
dry garden usually indicate
calm water, while the con-
centric circles imply a sense
of movement. The raised
and covered veranda sur-
rounding this garden allows
it to be contemplated even
when raining, which some
say is when it is most beau-
tiful. Fort Worth Botanic
Garden Center, Fort
Worth, Texas.

Given the early Japanese acceptance of rock as a place in which sacred spirits dwell and roped-off areas of white gravel to mark holy sites, these elements naturally began to appear as part of the religious activities and garden landscape of the day.

The earliest dry landscape garden still in existence in Japan is Saiho-ji, built in the late twelfth century. Amid tall trees, a spectacular full-size cascade of large stones conjures up the image of a tumultuous waterfall, yet no water has ever spilled over it. Stonework continues down the hillside, suggesting a stream with moss "pools," including one with a stone turtle island. Rather than the gravel used in later gardens, luxuriant moss is juxtaposed with the boulders. The dominant use of flat-topped, straight-sided stones with powerful lines ties in closely with the concurrent painting style.

Ginkaku-ji, or the Temple of the Silver Pavilion, and Tenryu-ji are other gardens with significant stonework. At Daisen-in, built in the early 1500s, the parallel of stone in the garden to ink on the canvas is most apparent. Vast mountain ranges, thundering waterfalls and a turbulent river are built within a long, narrow space using only rocks and gravel punctuated by a few plants. To varying degrees, these and other gardens of the time use reduction in scale.

A large stone, bearing the name Iyo, from the Island of Shikoku, represents the finest in decorative Japanese art with its varied and banded colors of green, black and grey. Japanese Garden, Portland, Oregon.

Although each of these gardens is more or less an abstraction of nature, there is still a recognizable landscape. In an exquisite harmony of elements, the garden at Ryoan-ji, built about 1490, took the art to a different level, one where there is purer use of form and even greater *yugen*. The tennis court-size space, surrounded by a natural-colored wall and viewing veranda, has fifteen stones placed in five groups in a bed of raked gravel. The only plant material in the garden is moss growing at the base of the stones.

Another type of minimalist landscape is achieved with island plantings of low-growing plants within an area of raked gravel. The forms used are often those of a circle and a gourd. These have been interpreted as a lighthearted representation of a sake cup and gourd, and also as symbols of enlightenment and happiness.

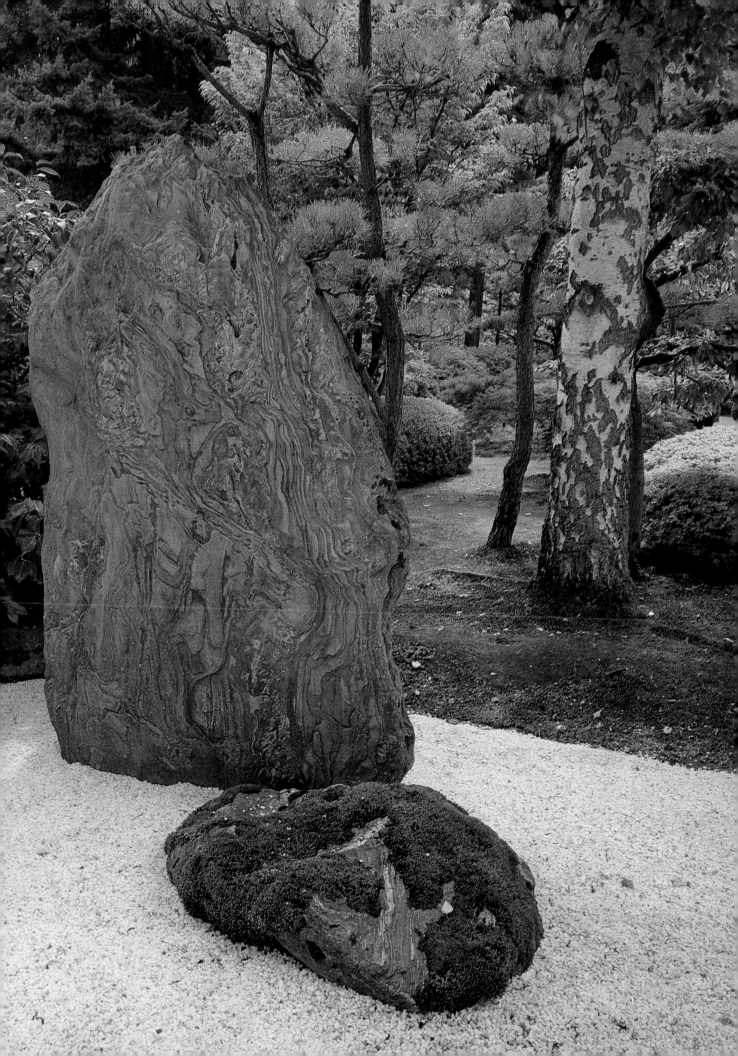

Many public gardens in the West have dry landscape gardens in the style of Ryoanji. A number are small, providing ideas for creating a garden of this style in a limited space. Of particular interest is that most of these are free-form in shape rather than rectangular, illustrating how this kind of garden can be created in a variety of settings.

Three large dry gardens in the traditional rectangular form are particularly powerful. Even on the hottest, most humid day, to enter the pavilion surrounding the dry landscape garden at the Fort Worth Botanical Garden Center is to transcend space and time and feel only truth and beauty. In the Japanese Garden in Portland, Oregon, one can look through the opening in the evergreens on the hillside above or sit in repose within the walls of the dry garden and absorb the calming energy. At Bloedel Reserve on Bainbridge Island, Washington, the dry garden is unusual in that it is not set apart from the surrounding landscape by walls but instead by small hillocks with the forest in the distance.

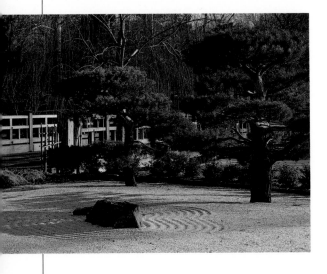

Today, just as hundreds of years ago, rocks are a medium for artistic expression. Dry landscape or stone gardens have many applications in Western landscapes, particularly in areas where water resources are increasingly limited. If one does not want actual water in the garden, the stone garden is a logical alternative. Streams, waterfalls, cascades and ponds are all possible with the artful and judicious use of rock and gravel. Because the stonework can be full-size or reduced in scale, the dry landscape can suit many different sites. The highly abstract type is especially suited to modern architecture.

Making a stone garden requires a finely tuned aesthetic sense and knowledge of the design principles. Skill and patience are necessary in selecting and placing the rocks in the garden.

In the golden twilight of a winter's day, the shadows cast across a dry garden create patterns within patterns. Missouri Botanical Gardens, St. Louis, Missouri.

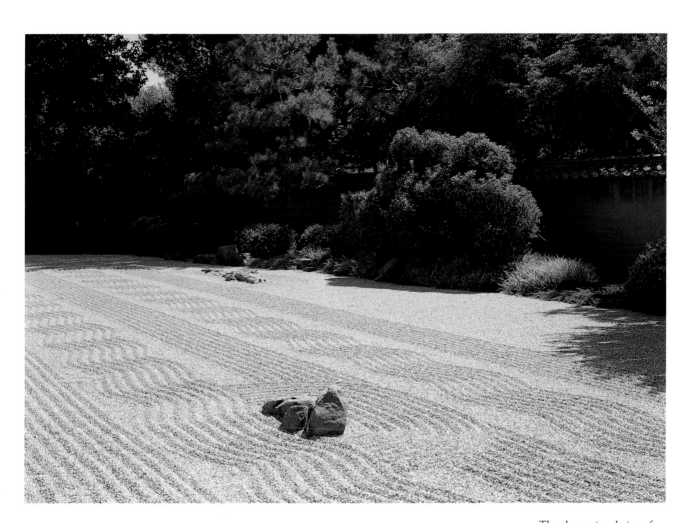

The alternating design of
straight and wavy raked
gravel represents a flowing
stream. Huntington Botan-
ical Gardens, San Marino,
California.

A light snowfall both
obscures and emphasizes
the lines of raked gravel,
creating a form of mini-
malist art. Chicago Botanic
Garden, Glencoe, Illinois.

Gravel raked in wavy lines, following the irregular rocky edges of this area, replicates an abstraction of an ocean and shore at a highly reduced scale. Cheekwood, Tennessee Botanical Gardens and Fine Arts Center, Nashville, Tennessee.

The principle of depth perspective is employed differently when the dry garden is a narrow area running parallel to the viewing site. David Slawson, in *Secret Teachings in the Art of Japanese Gardens*, suggests the use of single-depth perspective, which "reduces the effort required to view the garden [and] frees up the viewer's senses and imagination to savor the more suggestive subtleties of form, texture, and tonality."

If plants are at all used, they should be few in number, simple in line and preferably evergreen. Many of the later gardens in this style in Japan used clipped plants instead of rocks, which is another possibility today. For the low island plantings, use something ground-hugging and fine-textured, such as moss or certain thymes.

Maintenance of stone gardens depends somewhat on the amount and type of plant material used. As with any Japanese garden,

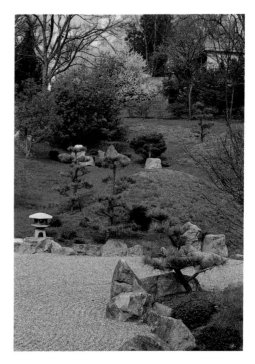

meticulous care is inherent to its success. The stone garden with gravel needs to be raked often to maintain its pattern and to remove leaves and debris. Use a regular steel garden rake or make a wooden rake from a short board cut with zigzag teeth and attached to a handle. Place a porous fabric or plastic mulch under the layer of gravel to prevent weed growth. If plants are set among stones, pay close attention to watering as stones absorb heat and quickly dry out the surrounding soil.

For those who use their stone garden as a tool for meditation as well as those who enjoy its simplicity and beauty, the dry landscape offers a unique outlet for expression. Appreciating line and form, seeing beyond the obvious and subjectively extracting the essential quality of nature will lead you on a journey of awareness.

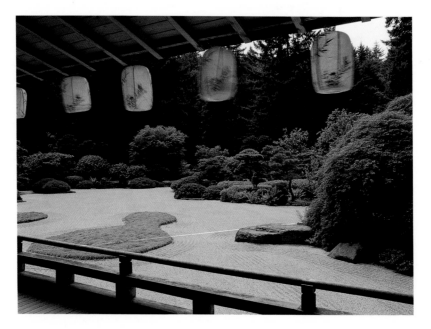

Less austere than most dry gardens, this irregularly shaped area includes raked gravel, woolly thyme (*Thymus pseudolanuginosis*) and a magnificent one-hundred-year-old Japanese lace-leaf maple (*Acer palmatum* 'Dissectum Atropurpureum'). Evergreen and decidous plantings, as well as the borrowed scenery of a conifer forest, enclose the area. The island shapes convey two meanings: One is that of a *sake* cup and bottle, or gourd, encouraging one to be cheerful and forget troubles. The other is that the perfectly round shape means enlightenment and perfection while the gourd shape suggests happiness. Japanese Garden, Portland, Oregon.

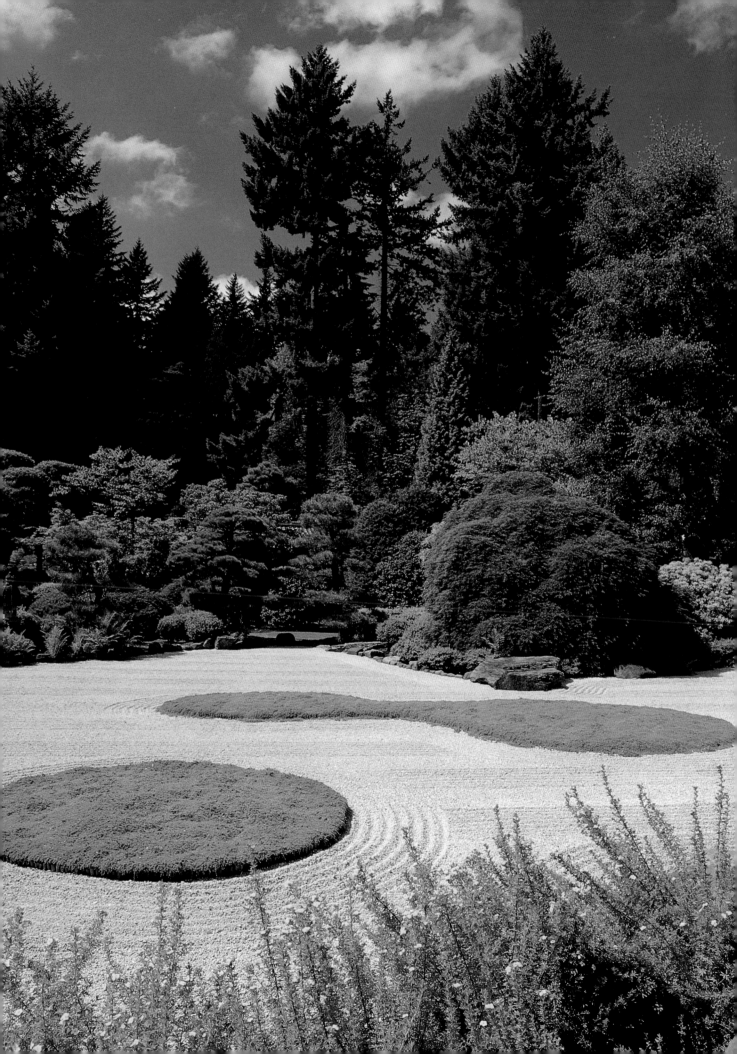

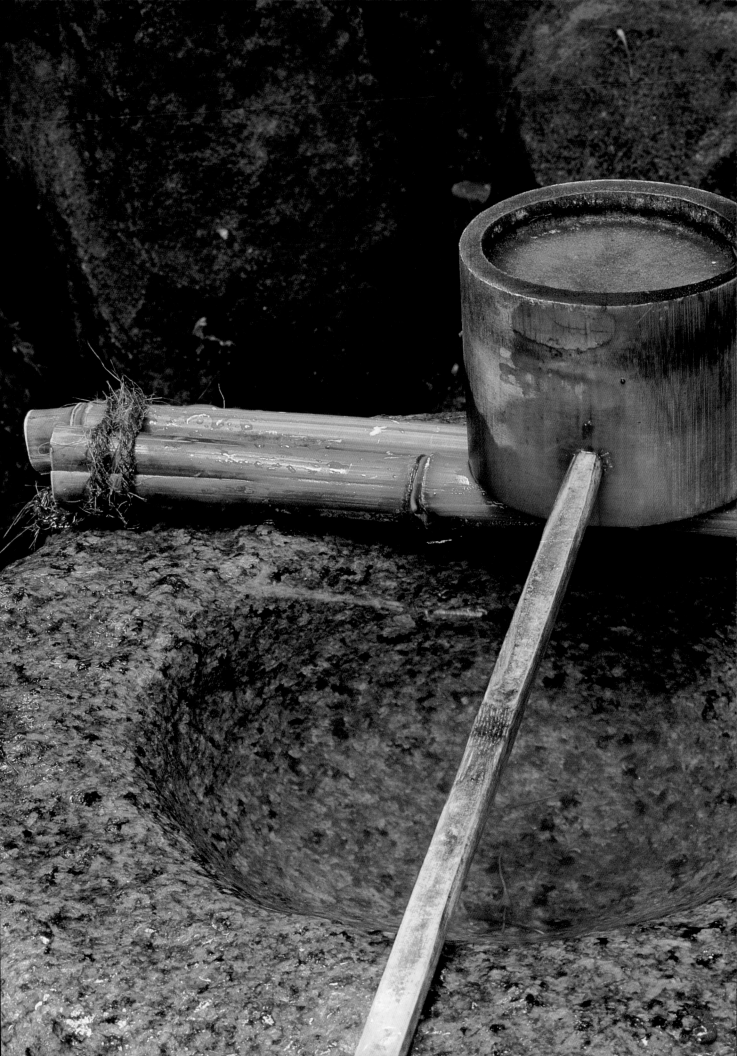

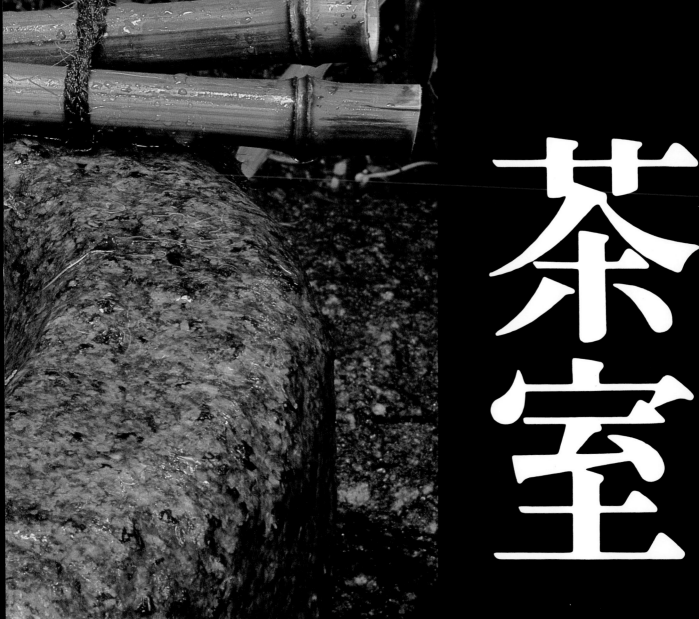

茶室

T H E Zen view of contemplation as an active rather than a passive process has led the Japanese to develop various "ways" of self-illumination. The ritual of the tea ceremony is one of the most prominent. Formalized five centuries ago, the tea ceremony epitomizes rite, simple love of nature, appreciation of aesthetics and idealized social conduct. It permeated Japanese culture and had a profound effect on gardens, large and small.

Since most Westerners will never participate in a tea ceremony or experience the culture that developed it, how can we include the features of these gardens that fascinate us—lanterns, water basins and stepping stones —in our own gardens without being banal? Awareness of the functions of and reasoning behind the tea garden and its elements provides us with a palette and brushes to create Japanese-style tea gardens that are appropriate for ourselves and our living spaces but also respectful of Japanese traditions. Because the tea garden is a microcosm of the relationship of man and nature, we are once again called upon to look within ourselves as well as to study our own natural environment.

The winding path to the teahouse is meant to encourage one to leave behind the cares and worries of the world. Missouri Botanical Gardens, St. Louis, Missouri.

Native to China, the leaves of the shrubby evergreen tea plant (*Thea sinensis*) were used as a drink first by Chinese and then Japanese monks to help them remain alert during meditation. Elements of the early religious ritual set the stage for the later secular one, including a wall alcove shrine honoring Bodhirharma, founder of Zen, and the whisking of the powdered tea with boiling water before passing a communal cup from monk to monk.

Tea was also used by members of the court and the warrior class. Records indicate that the third shogun, Yoshimitsu (1358–1409), served it at gatherings of poets, artists and scholars at the Gold Pavilion. Under shogun Yoshimasa (1435–1490), the rite of tea drinking evolved to the point of having a separate building set aside for the activity, which still stands at Ginkaku-ji. It is a small space with a wall alcove, or *tokonoma*, now decorated with art, calligraphy or flowers. Men designated as tea masters conducted the ceremony and became arbiters of taste, refinement and manners. Yoshimasa's tea master, Shuko, held that the virtues of the tea ceremony were urbanity, courtesy, purity and imperturbability. Others have written that it imparted modesty or humbleness, restraint and sensibility, while uplifting the spirit.

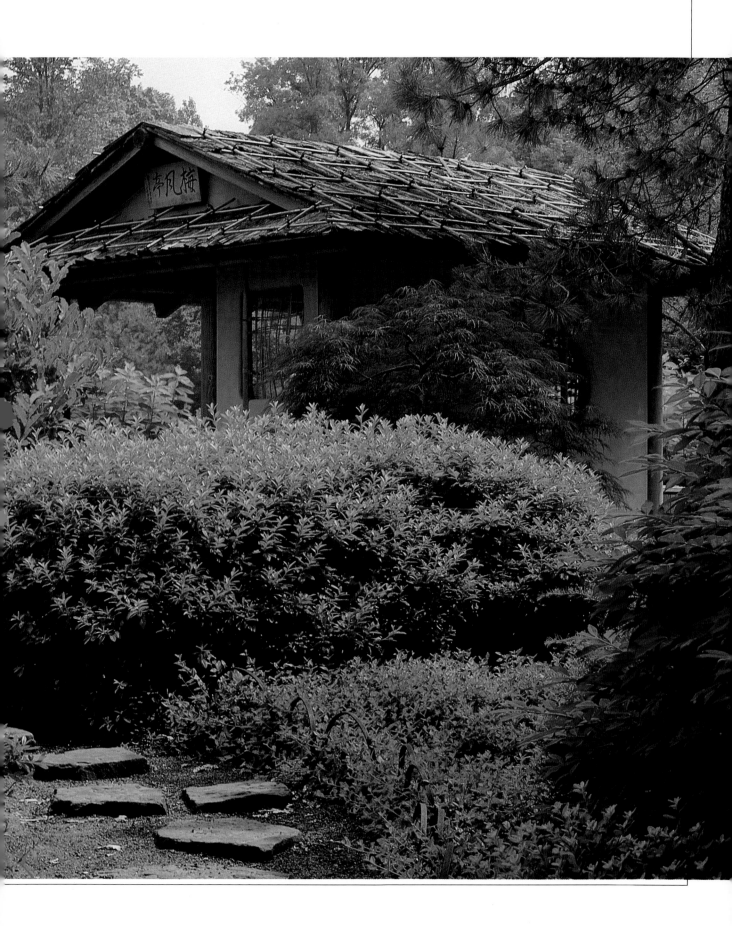

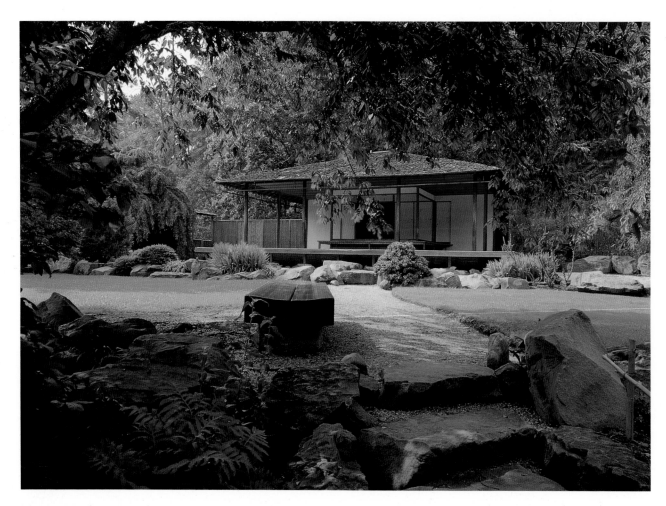

The creation of a separate
building for the tea cere-
mony removes participants
from distractions. This
teahouse was a gift of the
Japanese government from
its exhibit at the 1965 New
York World's Fair. Birming-
ham Botanical Gardens,
Birmingham, Alabama.

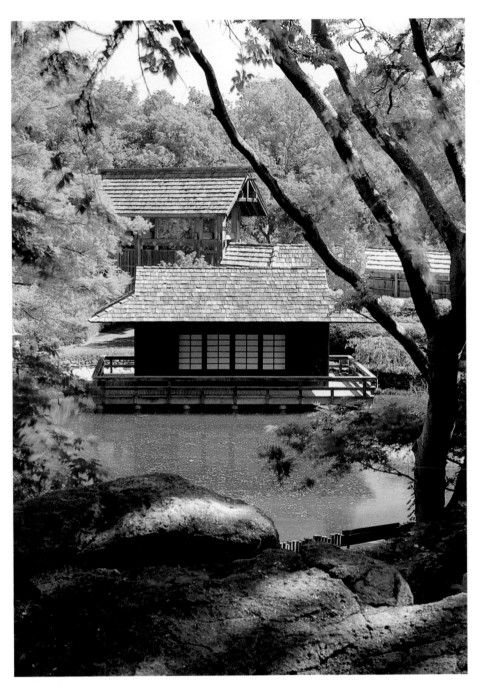

The setting for a teahouse

should be subtle and restful,

relying on the simple beauty

of the natural world. Fort

Worth Botanic Gardens

Center, Fort Worth, Texas.

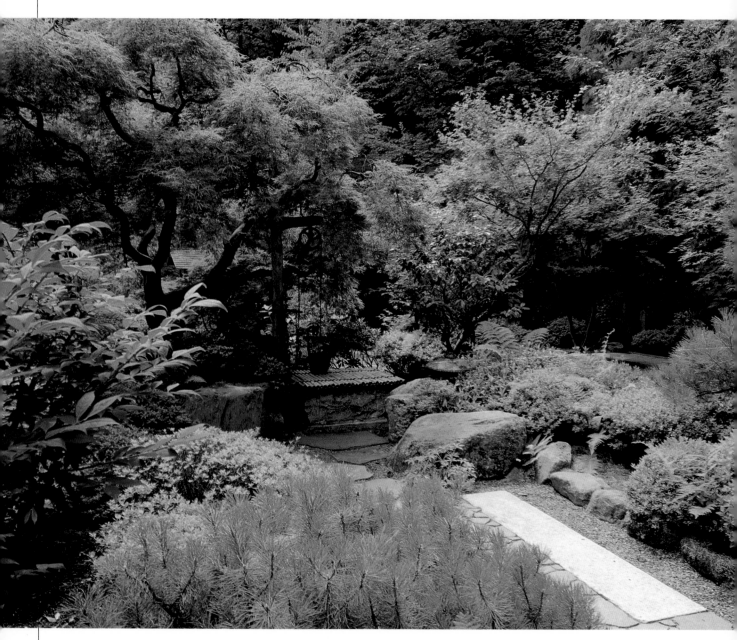

Along the path to the tea-
house, a well provides the
tea master with water for
the ceremony. Japanese
Garden, Portland, Oregon.

A simple narrow rectangular area is transformed into the traditional outer garden with a "dewy path" by incorporating simple plantings and a twisting, pace-slowing path. Atlanta Botanical Garden, Atlanta, Georgia.

In the 1500s, the tea ritual and tea garden, or *chaniwa*, became more formalized. Two of the most famous tea masters, Sen no Rikyu (1522–1591) and Kobori Enshu (1579–1647), added and elaborated upon its elements. The teahouse itself was to be of rustic wood, rough plaster and uncut stone, and have a thatched roof with tea bowls of earthenware. For the ceremony, no more than five men gathered in a waiting area, then they walked slowly through a small garden, symbolically leaving worldly cares behind, stopping for a ritual washing of the hands and mouth at a water basin. In the tearoom, they first admired the art or flowers in the *tokonoma*. Tea was made and served to one person at a time, and the utensils and bowls admired. Sometimes a meal was served, after which minds and conversations turned to discussions of aesthetics.

The attributes relating to the tea garden were based on the poetic appeal of the solitary life in pursuit of beauty and wisdom while surrounded by nature. This was expressed in a highly refined and stylistic manner. The tea garden is essentially small and simple with an air of seclusion and tranquil wildness. Hedges, walls or fences give a sense of privacy and intimacy. Sometimes the garden is divided into two parts, with the outer garden having a bench where guests wait, perhaps with a lantern and an inner garden with a water basin lit by another lantern.

The most important element of the tea garden, and significant in terms of garden design, is the stepping-stone path. Although previous gardens had been walked in, the aspect of passage was the tea garden's reason for being. Sometimes the tea garden is called *roji*, which has variously been interpreted as a cottage path, cleared ground, dewy path, or way. The movement through a series of changing views represents a conscious effort to elicit a transformation in people. Within a relatively short distance, people are to let go of the outside world with its attendant cares, come in touch with the tranquillity and beauty of natural harmonies and be prepared for spiritual renewal.

Prior to this time, fine gravel was used for paths, or one simply walked on the moss. With the increased use of the path stepping stones became a necessity.

The rock stepping stones guide the way, pacing one through the garden. Small and close together, they slow the stride; broad and flat, they encourage one to pause, observe and become aware. Other rocks are unobtrusive, with only a few small ones placed in a natural way about the garden.

Entwined with the mystery of *yugen* in the tea garden is the Japanese understanding of *wabi* and *sabi*. *Wabi* is the quality of a rustic, yet refined, solitary beauty. *Sabi* is that trait, be it the green corrosion of bronze or the pattern of moss and lichen on wood and stone, that comes with weathering and age. Contemplating these characteristics at close range as one walks through the tea garden allows one's self to be deeply touched.

The plants used in the tea garden are chosen for their unobtrusive and subtle attributes. They are to be soothing, with plantings becoming more comforting as the teahouse is neared. Evergreens, ferns and mosses are preferred. The Japanese apricot, *Prunus mume*, is traditional with its brief, small flowers in early spring. American natives with the same quality include the witch hazels and serviceberries. Small-growing maples are also appropriate. There are never flowers in the tea garden, only a single specimen or *ikebana* arrangement in the teahouse.

As the tea ceremony became popular, a source of lighting in keeping with the quality of the garden and ceremony was necessary. The stone lanterns, originally from shrines, set out with a dish of oil and wicking or a candle, and with rice paper over the opening gave a lovely soft light appropriate to the size and mood of the tea garden.

Part of the emptying of the self prior to the tea ceremony, the ritual purification of heart and mind at a water basin had its heritage in early Shinto rites. The gravel around the base not only kept the area from becoming muddy but also represented the sea. Other stones were for kneeling and setting down objects being carried.

Lit by a stone lantern, this combination of stones and water basin, called *tsukubai*, meaning to bend or crouch, is a traditional tea garden arrangement. A stepping stone directly in front is for standing, while flat stones on each side are for setting down a water pitcher, hand lantern and belongings. Fresh water enters the basin from a bamboo flume and overflows into the pebble-covered area representing the sea. The John P. Humes Japanese Stroll Garden, Mill Neck, New York.

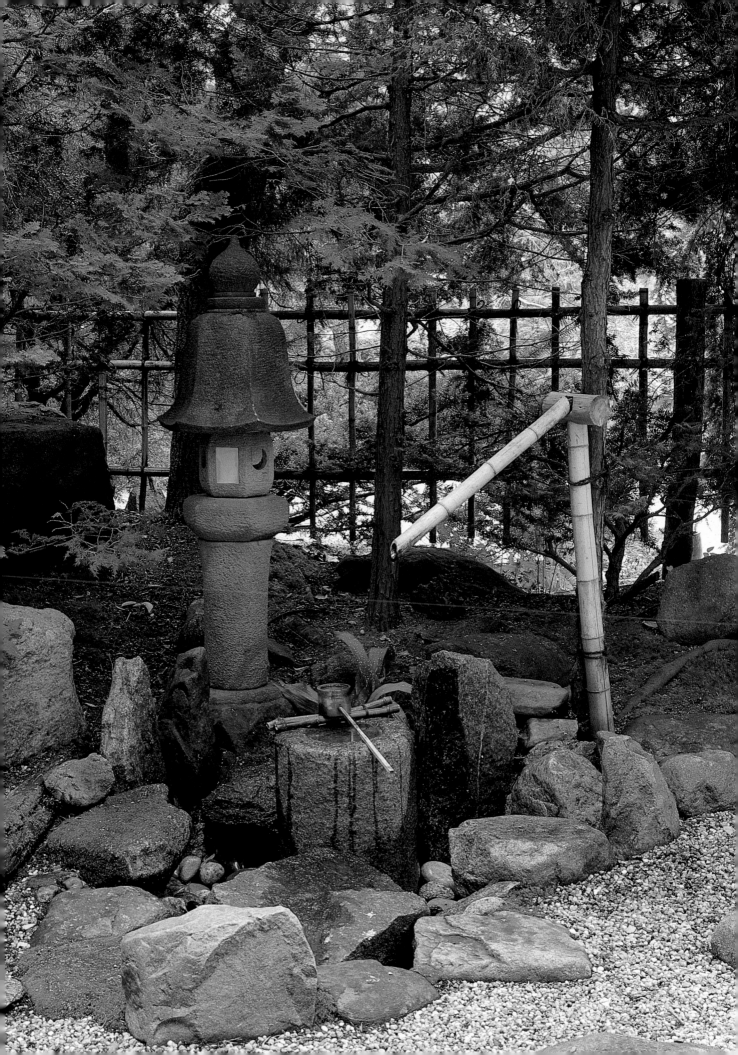

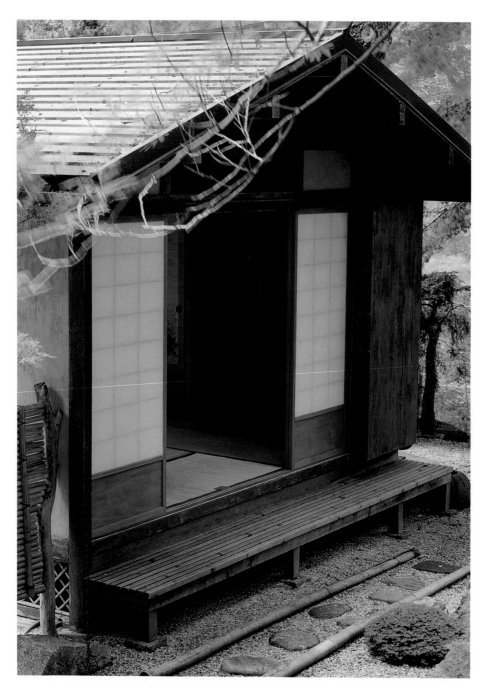

Whether in a tradition.
tea hut or a more simpl
shelter, the materials sh
convey a sense of age, r
ticity and naturalness a
well as a sense of ascetic
refinement and quiet pe
fulness. Left: The John
Humes Japanese Stroll
den, Mill Neck, New Yo
Right: Chicago Botani
Garden, Glencoe, Illino

One reason the elements of the tea garden became popular in Japan was the increasing number of people living in urban areas who missed the beauty of the countryside. Today, the same feelings draw us to the tea garden. With or without the tea ceremony, the garden itself, perhaps with a simple shelter, offers a respite of quiet pleasure for oneself or friends.

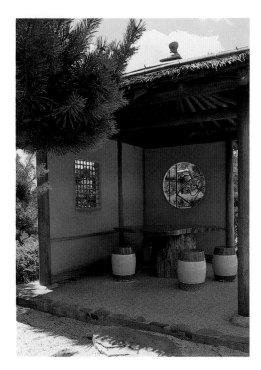

Ritual informs our lives with structure and stability. It honors past generations and manifests the unique traits of a people and their spiritual beliefs. Even without the ritual of the tea ceremony at the end of the *roji*, the transformative, cleansing journey that is possible within the secluded tea garden brings perspective to our lives and a heightened awareness of beauty and our connection with the earth. Basing a tea garden design on its venerable elements interpreted in terms of our own culture, environment and personal aesthetic will result in a garden that offers timeless renewal of the spirit.

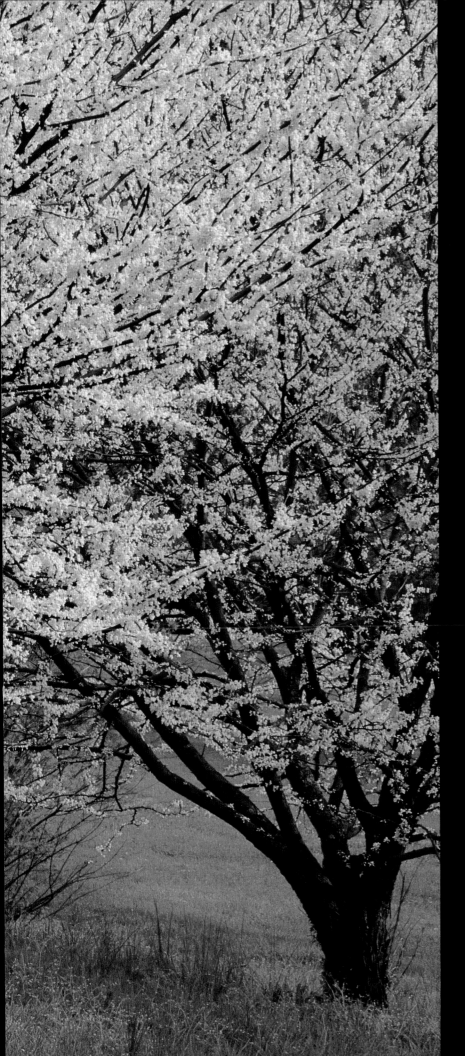

STROLL gardens as a distinct, recognizable entity came into existence during the Edo period (circa 1615–1867) in Japan. They were essentially a fusion of the hill and pond and tea garden styles, created as large-scale, splendid pleasure gardens of the nobility. Besides lanterns, water basins and at least one teahouse, they contained paths and bridges leading around lakes or ponds, which had convoluted shores and one or more islands. Streams and waterfalls led into or away from the lake or pond.

There is much to be appreciated beyond the physical grandiosity of these gardens. While the paths themselves are often works of art, it was the element of enticement and surprise, of drawing the visitor from one mesmerizing picture to another, that became polished and refined.

In the strictest sense, however, these were not the first stroll gardens in Japan. A twelfth-century garden in Kyoto, Sekisui-en, has a pond with winding shores and a path for walking along. Saiho-ji, from the fourteenth century, is also a garden with an irregularly shaped pond and paths circumnavigating its shores, islands and rocks, then leading to the upper garden with its notable dry stone-work. Although the pond at Ginkaku-ji, or Temple of the Silver Pavilion, is small, its shape is contorted, and the design of the garden seems to indicate that strolling through it was the main way to enjoy it. More than the others, Ginkaku-ji gives the sense of one vista unfurling after another.

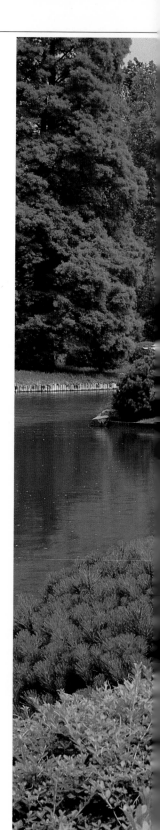

Large stroll gardens are often mostly monochromatic, relying on plantings of evergreen and deciduous trees and shrubs. The journey of discovery that awaits along the path allows for personal interpretation as scene after scene unfolds. Missouri Botanical Garden, St. Louis, Missouri.

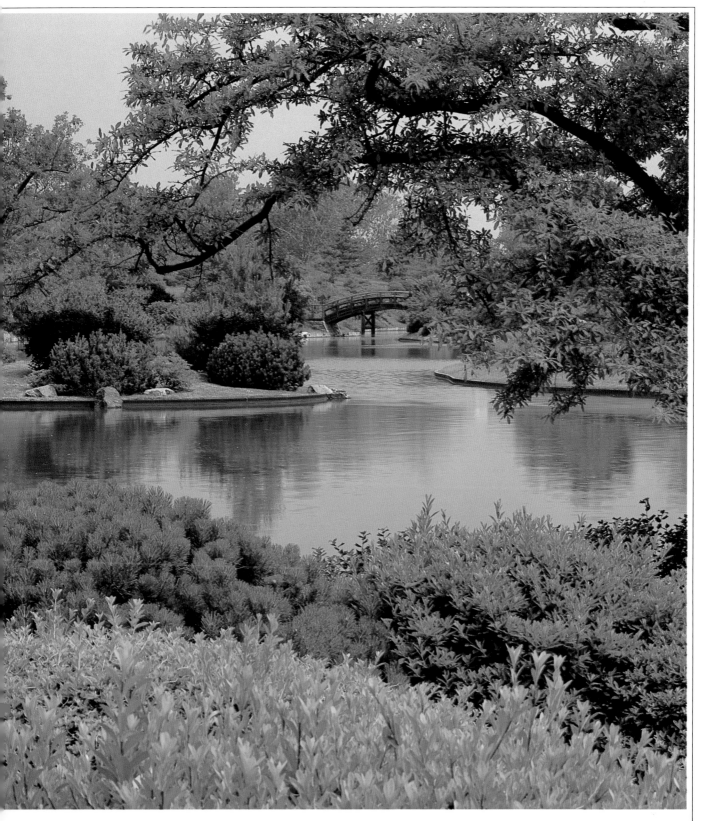

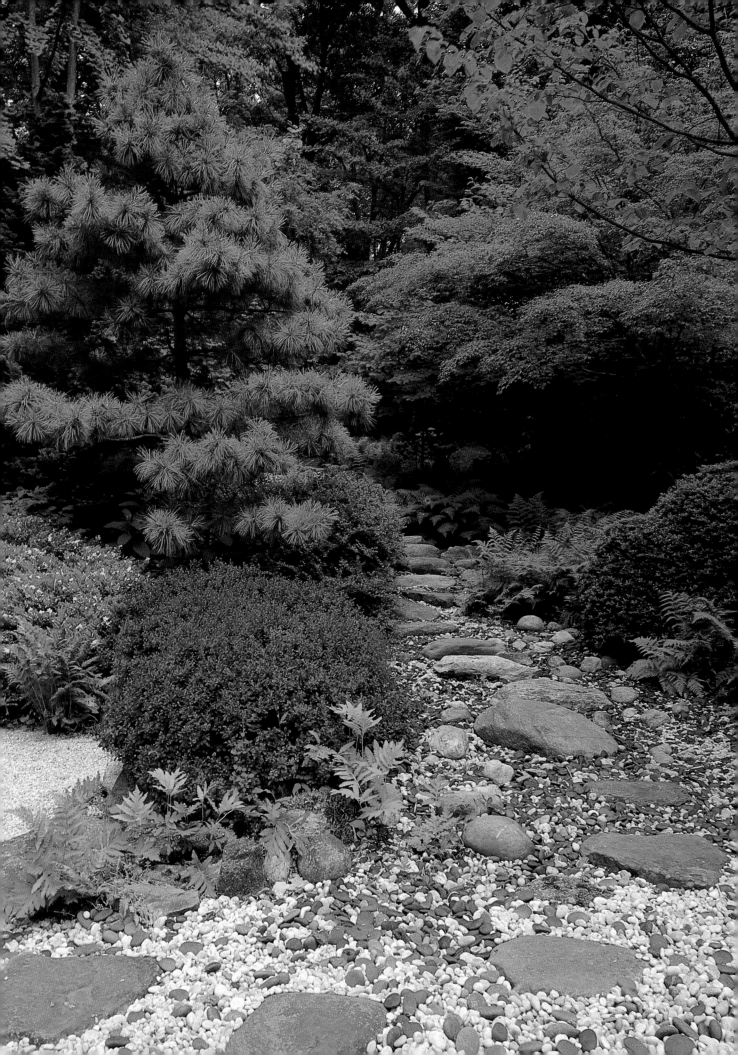

The advent of the stepping stone path, which came with the tea garden and was adapted to large stroll gardens, invited guests to investigate what was hidden just beyond the next bend. The John P. Humes Japanese Stroll Garden, Mill Neck, New York.

During the 1500s, the tea ceremony and its garden of passage and transformation became popular. Garden designers began striving to present a series of sequential visual experiences. Several outstanding examples of the seventeenth-century stroll gardens still exist in Japan today. The garden of Katsura Villa in Kyoto was the work of Toshihito (1579–1629), a brother of the emperor, and was elaborated on by his son, Toshitada (1619–1692). It is a magnificent example of how many diverse elements and a large space can be brought together into a harmonious whole of wooded rural solitude and tranquility. Toshihito was a great admirer of the Heian period and brought its sensibilities to Katsura, sometimes as directly as recreating scenes from literature of the time.

Although the area had previously been an estate, Katsura's present manifestation was begun about 1620. Its eleven acres (4.4 hectares) contain a large lake and island, sixteen bridges, a number of teahouses and pavilions, lookouts, two areas for sports, twenty-three stone lanterns, eight water basins and approximately 1,716 stepping stones. With the simple stepping stones of the tea garden now the focus of an imperial estate, a trend was set. Other innovations, including original designs for lanterns and water basins, the stone beach and the use of geometric formality reveal a willingness to experiment and synthesize instead of relying on the hackneyed.

Toshihito's brother, the Emperor Gomizunoö (1596–1680), built a country retirement estate near Shugaku-en that contributed new ideas to landscape design within the context of the stroll garden. The garden was built on a mountainside overlooking a valley and more mountains. It focused on the concept of borrowed scenery with an added twist. This garden incorporated borrowed scenery on a large scale yet still effectively included the man-made landscape of the hillside and lake.

Built about the same time as Katsura, Koraku-en was created on sixty-three acres (21.4 hectares) outside of Edo, now Tokyo, by Tokugawa Yorifusa (1603–1661), a vice-shogun. This garden included the requisite circuitous path and was best known for its literal reproductions of famous scenic areas in both Japan and China.

Significant rocks were scarcer and more costly from this time on, and fewer were being used in gardens. In their place, clipped shrubs received greater attention. The terrain around the city of Edo had a quality of openness, and lent a spreading horizontality to the gardens. This was repeated in the new style of low, "snow-viewing" lanterns and in the design of other gardens around the country.

Whether created by nobility or the military elite, there was a sense that the stroll garden pulled one along, becoming slowly and methodically revealed. To hide and reveal, or *miegakure*, is one way to manipulate perspective and scale. If only a portion of an object is visible, the rest must be imagined, and then an illusion of depth is created as well as a feeling that going a little farther will reveal all. A glimpse of the top of a lantern or pagoda, the sound of a waterfall, the sinuous path of a stream disappearing behind a rock all serve this purpose. Each of these and many more are called into service in the stroll garden, but it is the chart of the path that determines a stroll garden's success, ever calling with a new vista just around the bend.

Almost all the public Japanese-style gardens in the West are in the stroll garden style, with many also including dry landscape or stone gardens. In the United States, designers classically trained in Japan were the creative force behind most of these. Varying in origin, size, topography and accomplishment, they constitute a body of expression that is a wellspring for those who desire to experience and learn.

Distinctly set apart from the rest of the landscape, the Japanese garden at the Fort Worth Botanical Garden Center in Texas is very wooded, with an extensive series of ponds, streams, waterfalls and teahouses. Portland, Oregon's garden, part of a public park with many large native conifers, is quite hilly and includes a commanding view of the city below and Mount Hood in the distance.

Stroll gardens contain all the traditional components found in Japanese gardens, including waterfalls, pools, paths, borrowed scenery, rocks and plants with a variety of textures. Left: Japanese garden in Portland, Oregon. Right: Bellingrath Gardens, Theodore, Alabama.

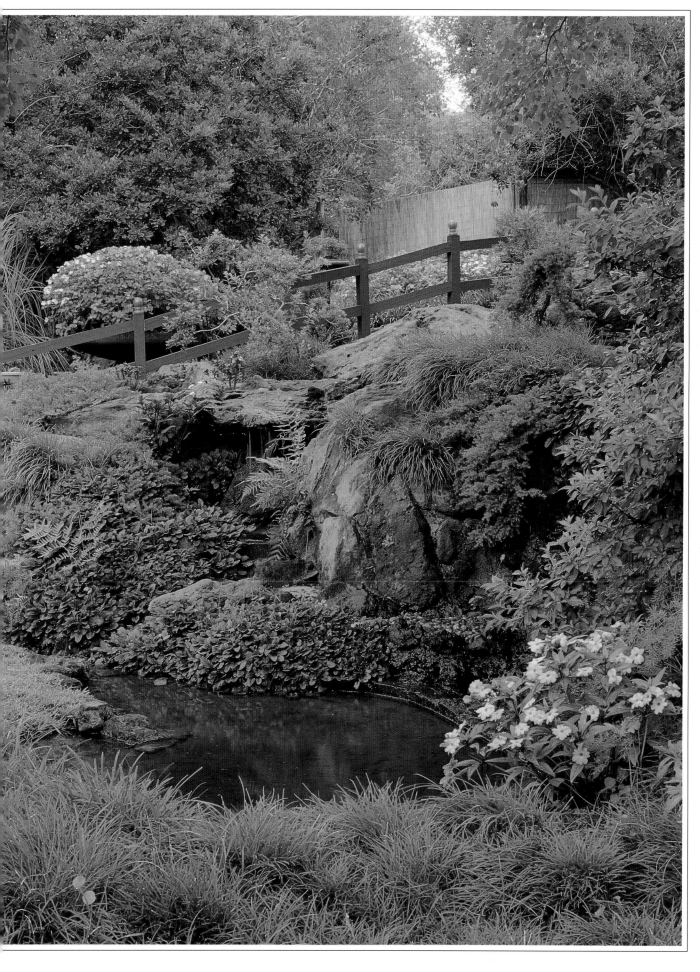

The John P. Humes Japanese Stroll Garden and the Japanese Tea Garden in Golden Gate Park both effectively utilize the hilly nature of their sites as well. The oldest Japanese garden open to the public and part of the California Midwinter Exposition of 1894, the Tea Garden is remarkable for its ability to absorb many elements and large numbers of people yet still convey a sense of tranquillity. At the opposite extreme in terms of quantity of visitors, the jewel-like Humes garden is a space of exquisite detail where the sense of passage has a profound fluidity.

Expansive gardens in St. Louis and Chicago are both part of a large botanic garden and are open and horizontal in character. The Japanese-style portion of the landscape at the Bloedel Reserve on Bainbridge Island, Washington, has been artfully blended with an English-style park and the towering conifers of the Northwest.

If you live some distance from a public stroll garden, allow as much time as possible when you plan a visit. If you are fortunate enough to live near one, visit often. Try to see the garden at different times of the day and in different seasons. Follow the path in one direction; then the next time go the opposite way. Take the time to sit and absorb only one or, at most, only a few different scenes.

Bring a sketchbook with you. Draw what catches your eye—be it a group of rocks, meandering stepping stones, an interplay of light and shadow or a branch arching over a path. Note the relationships of elements to one another and sketch forms and details quickly. The point is not to make an elaborate drawing but to learn to observe. Become conscious of your feelings and makes notes about them. Whether studying gardens, wilderness, animals, people, painting or sculpture in this manner, you will gain insight into the aesthetic relationship of different elements and subsequently their effect upon the senses.

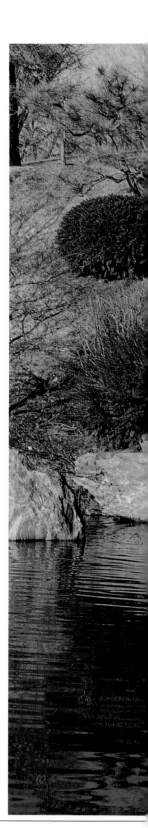

Left: A stylized dry stream bed and water basin bring the quality of water symbolically to a small garden. Sherman Library and Gardens, Corona del Mar, California.

Below: A large cascade constructed of three great boulders symbolizing heaven, earth and man brings music to the winter landscape. Missouri Botanical Garden, St. Louis, Missouri.

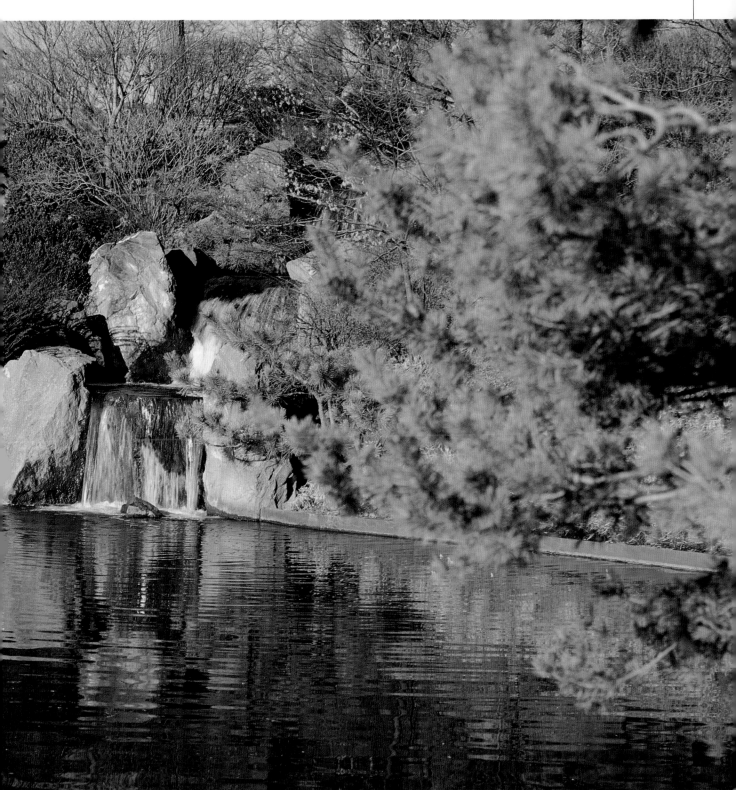

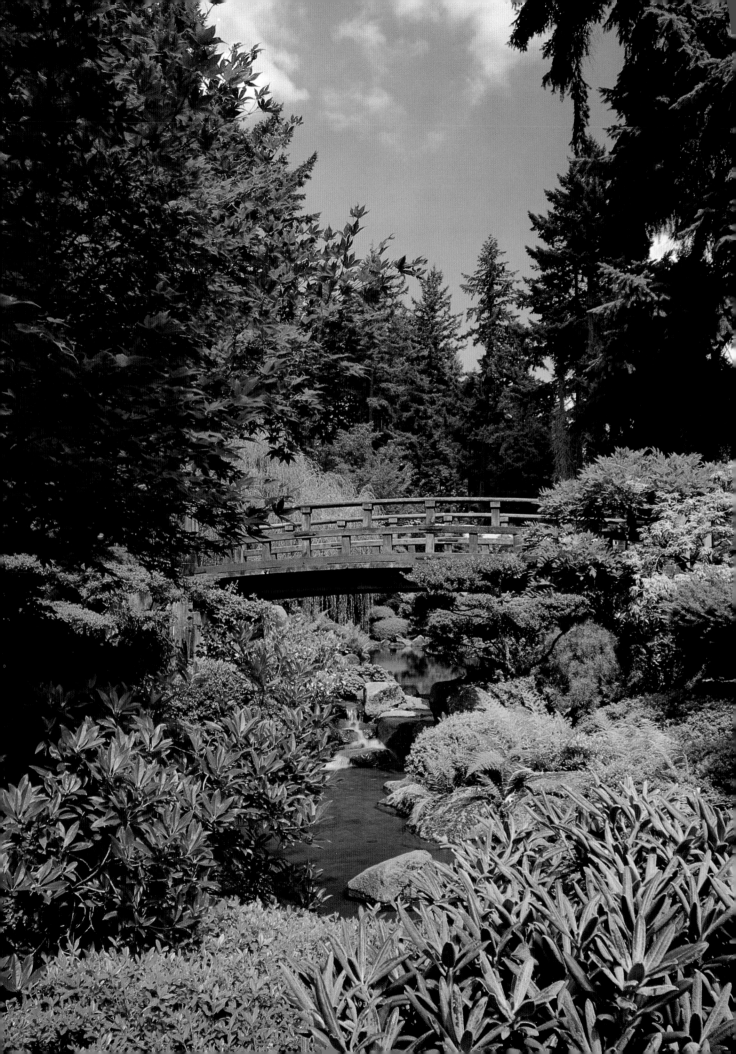

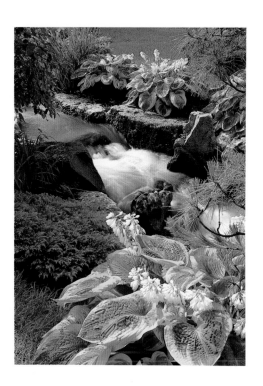

The sight and sound of
water, whether trickling or
cascading over and around
rocks, is essential to the
vibrancy of a Japanese gar-
den. Left: Japanese Garden,
Portland, Oregon. Above:
Missouri Botanical Garden,
St. Louis, Missouri.

In *Secret Teachings in the Art of Japanese Gardens*, David Slawson suggests looking at "everything and nothing, to simply relax and open your mind." As a garden design apprentice in Japan, Slawson was told to view gardens *bon-yari shite*, that is, "with detachment, without preconceptions, in a state of total receptivity."

Although very few people will ever be creating a stroll garden on the scale of a public garden, the many details of these gardens provide us with encounters that internalized along with the others in our lives can be used to create smaller gardens successfully. The concept of the stroll garden can be made applicable to limited space, whether it be a suburban backyard or a larger lot. A winding path, plantings that partially screen the view ahead, a small pond with undulating shore, all can be the framework that, when integrated on the basis of the Japanese design principles, yield a favorable aesthetic solution—a sense of cohesiveness and well-being—to your specific conditions.

A garden has the power to rest and enliven, to ease and to invigorate. As the scenes in the stroll garden unfold, the interrelationship of the mind and senses responding to each experience brings an intuitive awareness of the interrelationship of all things, a transmittal of profound truths that are beyond words, and can only be felt in the heart.

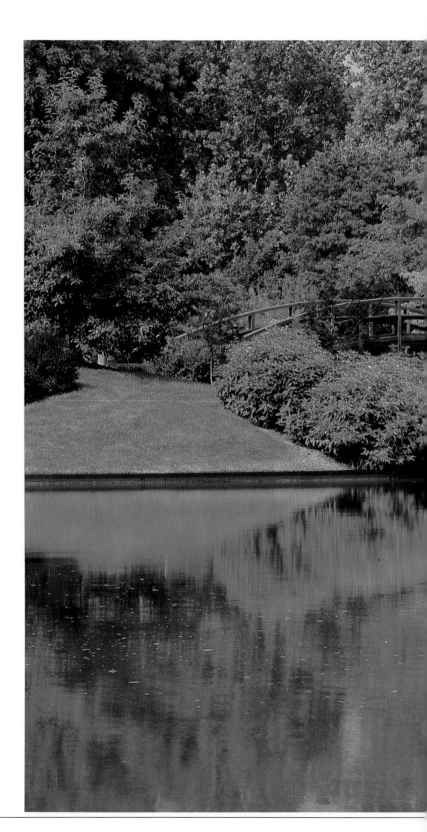

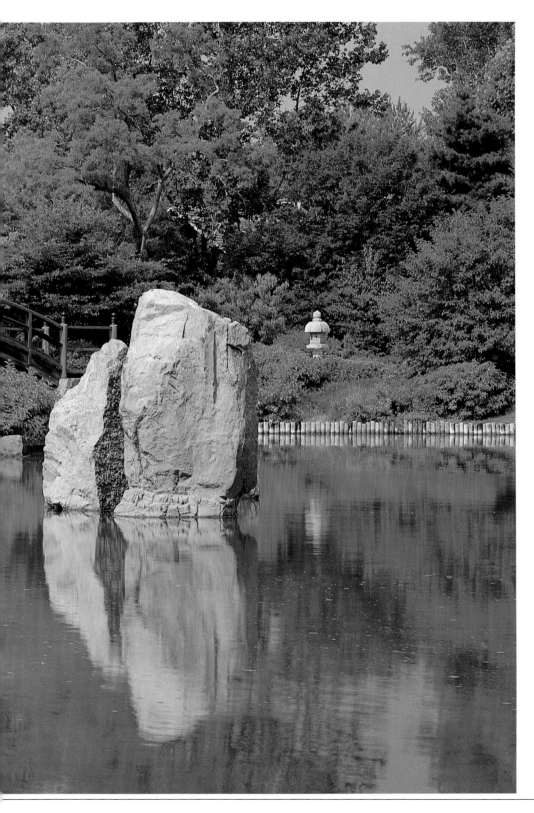

Three large boulders, one of which is partially obscured, comprise the symbolic center of this garden. They represent everlasting happiness and immortality. The lantern and bridge in the background lead to a teahouse island. Missouri Botanical Garden, St. Louis, Missouri.

ELEMENTS

ROCK AND STONE

岩石

FROM the earliest time, the people of Japan have had a deep and abiding affinity with rock. Omnipresent in their landscape and respected as the abodes of their deities, rocks are at once commonplace and sacred. Venerable and steadfast, rocks signify the durability befitting the dwelling place of the Shinto god of creation. The Japanese culture is not unique in having its cosmology pervaded with images from the natural world, but it is exceptional in the role that rock has come to play in the garden.

In theory a Japanese-style garden could be designed without rocks, but in truth that seems impossible. Rock in every imaginable form, size and configuration comes into play in a Japanese garden, and is even used to simulate water. Boulder or pebble, soaring or barely visible, alone or in composition, rough or carved into basin or lantern, rock and stone serve as a recurring medium of aesthetic expression.

As such, rocks have become a commodity. Whether bought and sold as works of art or common goods, the larger rocks play a dominant visual role in the Japanese garden. They are chosen for their shape, color, joints, angles and grain as well as for their energy and presence. Rare colors, grains and striations are highly valued, as is the patina of age from moss and lichen. Rocks are delineated as to geological character and place of origin, with granite, limestone, slate, schist and volcanic rock most often employed.

In the art of classical Japanese landscape gardening, certain individual rocks and rock compositions are given names. The fifteenth-century book, *Illustrations for Designing Mountain, Water, and Hillside Field Landscapes*, names forty-eight rocks. Some of the nomenclature is wonderfully poetic, such as Hovering Mist Rock or Flying Birds Rocks. Bridge-anchoring Rocks show a prosaic side, while others carry spiritual or cultural connotations, such as Mystic Kings Rocks and Never Aging Rock.

In essence, these rocks are metaphors for natural scenes, aspects of the culture or effects on the senses. Each has an artistic value in that the rocks connote a spatial configuration. The specific designation or inference of size, shape, projection and spacing collectively becomes a tool to use in garden design.

Since the Western world was opened up to Japanese gardens with Josiah Conder's *Landscape Gardening in Japan* in 1893, there has been much cogitation as to the use of rock in Japanese-style gardens. Some people have tried to follow literally the directives set forth in the *Sakuteiki*, an eleventh-century garden manual, and *Illustrations for Designing Mountain, Water, and Hillside Field Landscapes*, while others have merely put a few rocks about in the landscape.

In Japan, cranes are said to live a thousand years, and this large rock, submerged in a pond, is symbolic of a crane and long life. Symbolism aside, its subtle colors and markings, contrasted with the moss and fern, elicit an emotional response simply for its remarkable beauty. Japanese Garden, Portland, Oregon.

A large, complex "plant-
ing" of stones has been
meticulously designed to
contrast tall vertical rocks
with low vertical, flat and
reclining ones. The blending
of blue and brown stones,
with some containing both
colors, shows an attention
to detail that honors the
importance of rocks in the
Japanese landscape. Fort
Worth Botanic Garden
Center, Fort Worth, Texas.

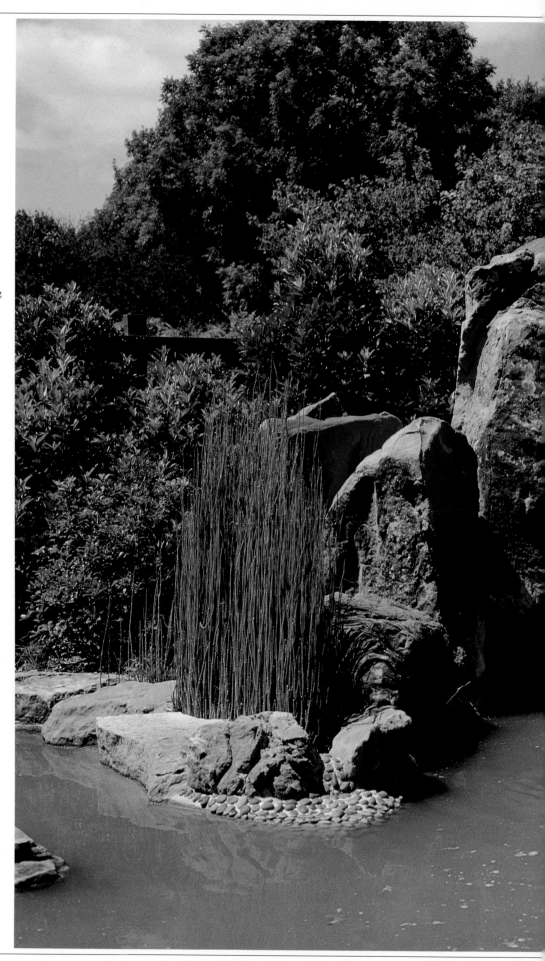

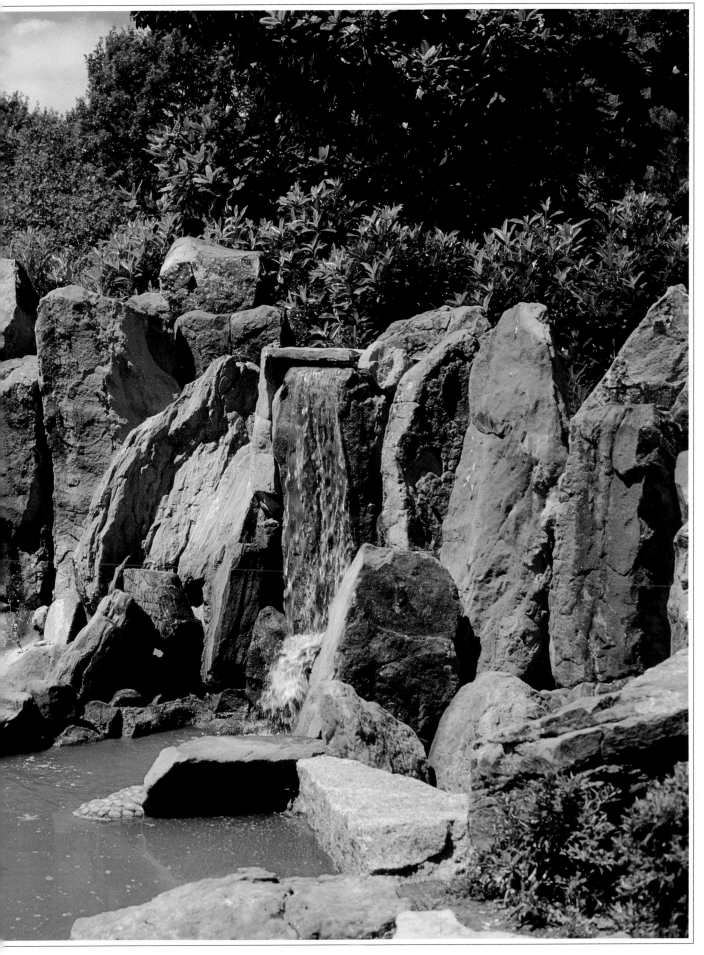

By studying both the old Japanese gardening manuals and present-day books, plus Japanese-style gardens themselves as well as nature and art, one can develop a sensitivity to the design principles behind the rock groupings. Effective garden design combines elements of the natural world integrated with human senses and values, with the ultimate meaning being the sensory effect of beauty. This can be accomplished anywhere by anyone.

In *Secret Teachings in the Art of Japanese Gardens*, David Slawson relates an anecdote about Kenneth Yasuda, professor and scholar of Japanese aesthetics at Indiana University and a landscape designer. In designing a certain garden, Yasuda decided to use rocks found on the site that were considered worthless. He chose the best shaped and most pleasing ones and placed them in arrangements using classical proportions. The beautiful result proved the point that, "The value of the work of art does not lie in the perceived value of the materials, but rather in the quality of the experience produced by materials woven into effective sensory relationships."

Whether a garden landscape is representational of natural scenery or more abstractly evocative of a mood or impression, there should be a sense that the rocks were placed by natural forces. This is accomplished by "planting" the rock to make it appear as if it "grew."

Japanese garden designers, while taking advantage of the natural topography, have never been adverse to manipulating the landscape. The same applies to rocks. Respect is shown for their natural geological origin, and rocks of only one type are used in any given area, with the form of the rock determining its placement. A rock found near the ocean can imply mountains, but such a leap requires a keenly observant designer to be aware of the natural landscape and identify placement correctly. In general, vertical, jagged, angular rocks allude to mountains, cascading streams and waterfalls; lower, rounded, smoother rocks give a sense of valleys with rivers and slower streams. The five principal shapes of stones used in gardens are tall vertical, short vertical, low flat, arched and the recumbent ox stone, which is long, low and curved with one end higher than the other. Helping stones are small and create a naturalistic effect.

Both the *Sakuteiki* and *Illustrations for Designing Mountain, Water, and Hillside Field Landscapes* emphasize the significance of placing a rock the same way in the garden as it was in nature; that is, once vertical, always vertical. This is easier to do when rocks are chosen at their origin than when they are purchased at garden centers or stone quarries. In the latter case, one must listen very carefully to what the rock is saying.

Establishing a sense of age and immutability, the moss on the stones surrounding a simple water basin and bamboo spout are painstakingly maintained with daily watering. The verdant result effects a transcendence of time and place. The John P. Humes Japanese Stroll Garden, Mill Neck, New York.

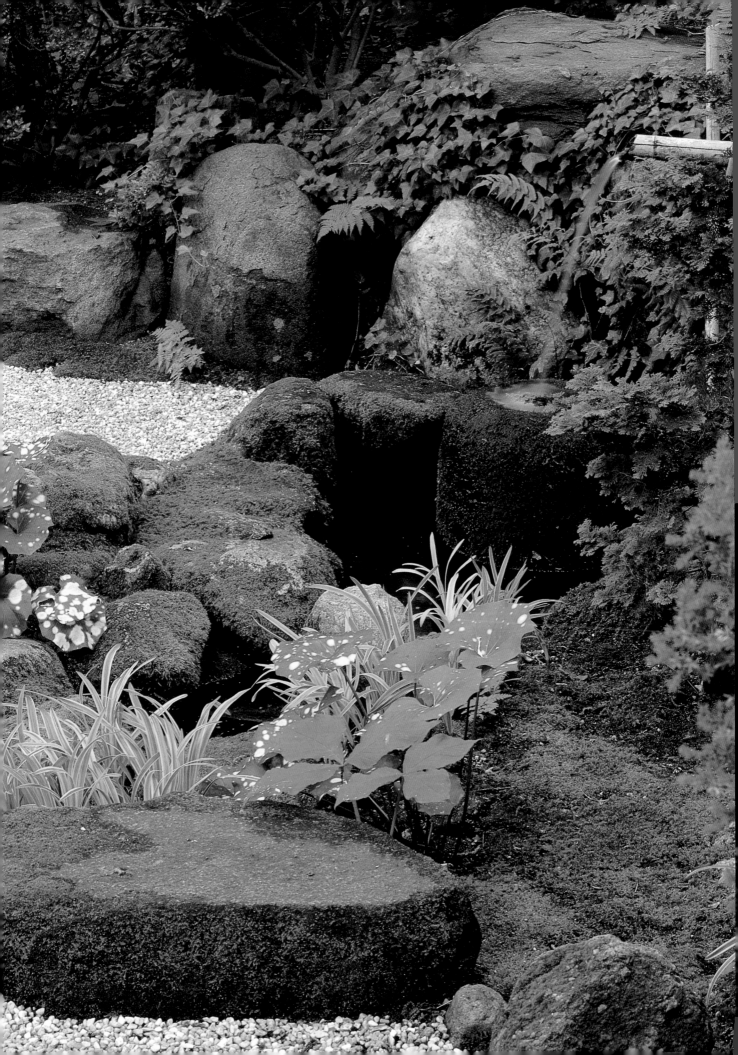

A mixture of river gravel, both large and small, with smooth, water-worn edges furnishes an easy walking surface and opposition to the lushness of the ferns, the bamboo and the large angular stone. The John P. Humes Japanese Stroll Garden, Mill Neck, New York.

Strategically placed stone steps, set in a textural foil of moss, cause the visitor to pause on the path to a teahouse and appreciate the larger stones, waterfall and plants. Private garden, Dallas, Texas, designed by Raymond T. Entenmann.

A teahouse surrounded by
a strip of smooth, round
blue-grey rock implies that
it is built above water, and
that the stepping stones
across these rocks keep the
visitor's feet "dry." Cheek-
wood, Tennessee Botanical
Gardens and Fine Arts
Center, Nashville, Tennessee.

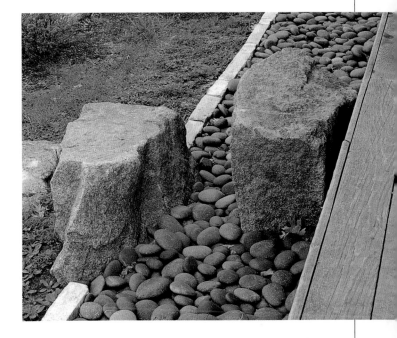

Even a small area becomes
significant with the carefully
composed textures and
colors of rough tree bark
encrusted with lichen and
moss, velvety moss carpet,
angular yet smooth-edged
boulders and tiny-leaved
plants. The John P. Humes
Japanese Stroll Garden,
Mill Neck, New York.

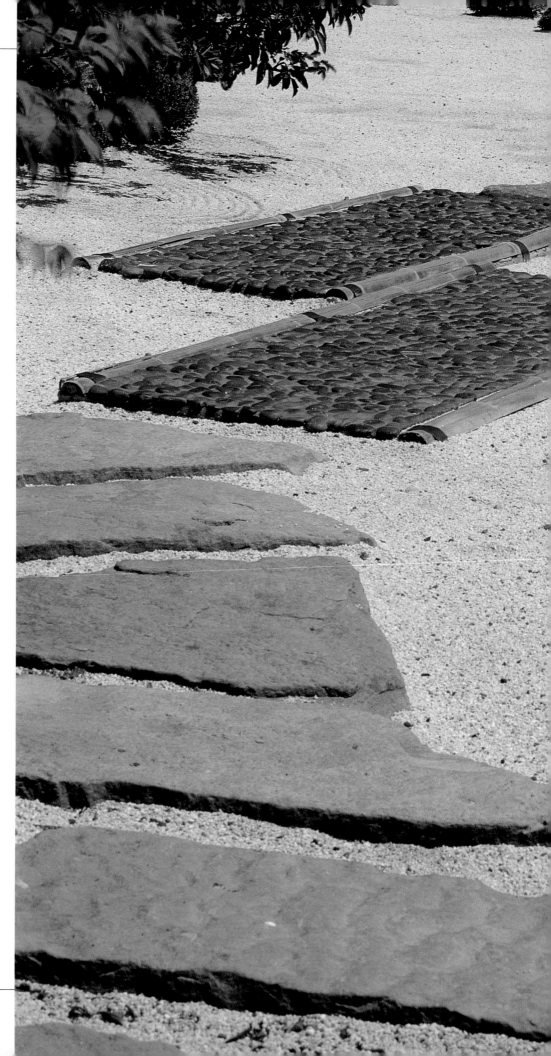

Across a sea of white gravel in a dry landscape garden, large paving stones set closely together encourage contemplation. Two areas of rounded stones set in concrete and banded by large bamboo logs suggest a bridge and provide the essential contrast. Chicago Botanic Garden, Glencoe, Illinois.

Of utmost importance, both for visual stability and safety is the proper setting of rocks. At least a third but preferably half of a rock should be buried. Another criterion is to bury it at the point where the circumference is greatest. Dig a hole and pack the earth well or line it with concrete. Whether rocks are large or small, handle them carefully to avoid scarring them. (A rock for a Japanese general was once delivered wrapped in silk!) For large rocks, a crane or hoist will be necessary. After placing the rock, check its position, then fill in around it with soil, packing it tightly. Stones placed in water are usually set on a platform or on a base of other stones.

There are also perceptual values to be considered in order to create visual harmony, with scale between the garden site and rocks the first priority.

The most important force in generating the unity in a Japanese garden is the aforementioned series of interlocking scalene triangles. Over and over, the triangle is the common denominator in organizing space, whether one is using two, three, five or more rocks or other elements. It provides stability and movement and embodies the three directional forces of vertical, horizontal and diagonal. Culturally, these correspond to heaven, earth and man. The best proportional relationship of rocks within the triangular form, both in terms of height and spacing between them, is the same classic Golden Mean the Greeks espoused—a proportion of 3:1 or 3:2.

The *Illustrations for Designing Mountain, Water, and Hillside Field Landscapes* offers a rule for setting rocks, "…first set the largest rock, and then set each succeeding rock in proportion to it." Determining how to follow this rule can only be learned partially from diagrams and directions; ultimately the skill and artistry comes with patience, training, practice and the elusive element of vision.

Besides the sculptural rocks used in the garden, stone also takes the form of pavement for paths and gravel that implies water.

The tea and stroll garden styles established the dominant role of the path in the Japanese garden. Although the path's basic function is to provide a comfortable walking surface that keeps the feet from becoming muddy, it also controls the speed at which one travels through the garden and what one is encouraged to see. Finally, the path is a significant aesthetic element.

The artistry possible with something so mundane as a path is remarkable. There are infinite combinations of surfaces, sizes, shapes and patterns of stepping stones and stone pavement. Even concrete can become a canvas.

The use of opposing elements, such as wood rounds set side by side with jigsaw-puzzle pieces of paving stone, is a meaningful part of Japanese garden design. Paving is often designed to be an abstraction of nature. Row after row of smooth stones may imply small ripples, wave upon wave of a large sea or simply a shoreline. Cast concrete rounds, echoing the shape of the water lily leaves, allow close observation. Important to success are boundaries, such as flat rocks laid on edge with an occasional larger rock. Top left: Atlanta Botanical Garden, Atlanta, Georgia. Top right: Missouri Botanical Garden, St. Louis, Missouri. Bottom left: Bloomington, Indiana, designed by Kenneth Yasuda. Bottom right: Birmingham Botanical Gardens, Birmingham, Alabama.

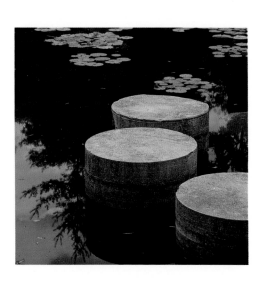

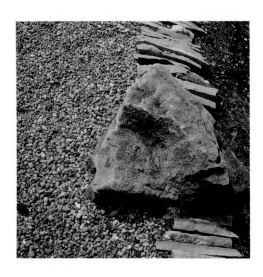

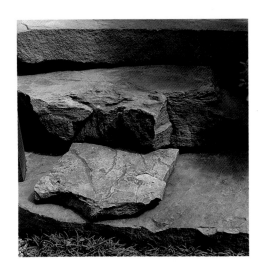

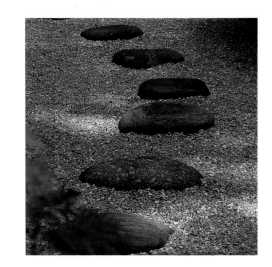

The placement of steps prescribe the speed and the perspective of how a garden is observed. The twists and turns they take can imply imaginary water coursing along its chosen path or a still and tranquil pond, as well as man's search for inner peace. The closer the stones are to one another, the more slowly a person walks and views the garden and life. Steps and stepping stones should offer a firm surface for walking and contribute to the aesthetics of the garden. Use materials that uphold the naturalistic feeling of the garden. Take time to observe and move stones around before deciding on final placement.

Top left: Private garden, Dallas, Texas, designed by Raymond T. Entenmann. Top right: The John P. Humes Japanese Stroll Garden, Mill Neck, New York. Bottom left: Dow Gardens, Midland, Michigan. Bottom right: Missouri Botanical Garden, St. Louis, Missouri.

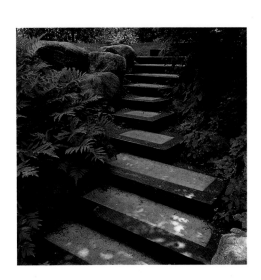

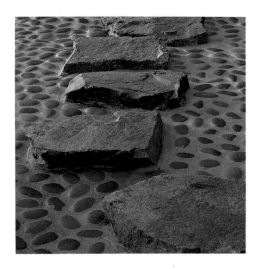

Stepping stones, or *tobi-ishi*, are usually natural rocks that are flat or slightly convex, with an average dimension of 18 inches (45 cm.) in diameter. In keeping with the principle of asymmetry, both large and small stones are placed in rhythmic groupings, or patterns, with meandering curves and angles. Larger stones are particularly useful at intersections or sharp turns in paths and to encourage a person to stop and look. Place the length of the stone perpendicular rather than parallel to the axis of the path. Geometrically shaped man-made paving stones can be used with ingenuity by setting them in irregular patterns or interspersing them with natural stones.

Stepping stones may be set directly into sod, among gravel or pebbles, or even in water. For stability, several inches to a foot (30 cm.) of the stone is buried, with the base set on 2 inches (5 cm.) of sand. Keeping them level, place all stones at the same height, which is usually about 1.5 to 3 inches (3.7 to 7.5 cm.) above the ground.

A wide, paved stone pathway, or *nobedan*, often with parallel sides, fuses geometry with natural shapes. With an architectural formality, they are useful near buildings. Made by laying long strips of cut stone in patterns with natural stepping stones, the *nobedan* avoids four-point intersections.

Another way of using stone in the garden is in bridges. Natural or cut, arching or straight, massive stone slabs are used singly or in overlapping parallel pieces. The ends are supported both structurally and visually by other rocks.

Sometimes referred to as sand, the material used in the abstract stone landscape to imply water is actually fine, sharp-edged gravel. A recommendation from Brooklyn Botanic Garden is two parts of "grower" poultry grit, one part "turkey" grit and one part "turkey finisher" grit available from agricultural stores. To minimize maintenance, use a porous-fabric weed barrier beneath 4 inches (10 cm.) of gravel. Carefully raked patterns make the "water" flow into stylized ripples, waves or whirlpools.

In all the ways stone is used in the Japanese garden—be it rock groupings, stepping stones or a gravel sea—there seems to be certain magic that comes with thoughtful use. Perhaps this is what was meant in the *Illustrations for Designing Mountain, Water, and Hillside Field Landscapes*: 'Complying with the illustrations for these rocks, you must set them with great care...Recollecting the subtle seasonal moods of *waka* poetry from ancient times up to the present, you must re-create with a quiet, graceful charm those moods that speak to your innermost heart."

The texture and color of the rock and moss have a similarity that provokes an interrogation into the essential universality of materials. The John P. Humes Japanese Stroll Garden, Mill Neck, New York.

THE way of things, the balance of *in* and *yo*, gives us the fluidity of water and the stability of rock, the concave pond and the convex hillside. As an island country with frequent rainfall and fog, mountain brooks, languorous rivers and broad expansive rice fields, Japan has literally put water at the heart of the garden. Our countryside may not be as dominated by water, but even so the landscape is filled with rich water features.

Imagine for a moment the cascading torrents of the Alps, or the mountain streams of Scotland and Wales; a rocky Atlantic shore; the sweeping vistas and pines of a Mediterranean coast; the lakes and forests of Scandinavia; and the rippling brooks of English woodlands and meadows. Quickly the wealth of natural scenery from which to draw inspiration becomes apparent.

Japanese-influenced gardens around the world translate these places into the magical sights and sounds that water brings with its motion, reflection and stillness. The mossy rill running into the pond of the Moon-Viewing Pavilion at Strybing Arboretum in San Francisco, the sunny meadow stream surrounded by clumps of balloon flowers at the St. Louis Botanical Garden and the winding shoreline and feathery waterfalls of Innisfree in Millbrook, New York, are but a few examples of the diversity of ways to use water in the Western garden landscape.

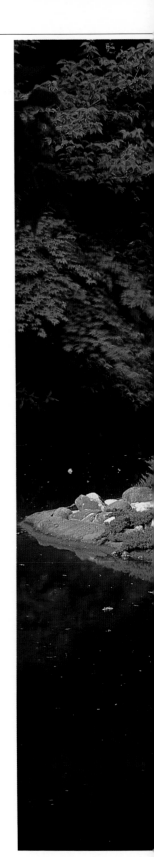

The size, shape and plantings of this low island draw the eyes across it to the broad rock ledge and the wispy waterfall that feeds the pond. Fort Worth Botanic Garden Center, Fort Worth, Texas.

On a smaller scale, numerous water basins and bamboo flumes show the ways to blend water with rocks and plants concisely in the garden. The waterless stone and gravel gardens communicate the timelessness of never-ending waves lapping at the shores of islands.

The basic natural water features, abbreviated or grand, are waterfall, stream and pond. These three elements alone and combined with stones and plants, offer an infinite number of garden variations. Over the years, the Japanese use of water has been strongly influenced by the eleventh-century gardening manual *Sakuteiki*, which contains descriptions of different water landscapes and waterfalls. These ways, esoteric though they may appear to the Western eye, have credence because they rely greatly on observations of nature and aesthetic principles. They are meant to be guidelines, not immutable rules. Within this framework there is much room for innovation in design for taking our landscape, our perceptions of water and the other elements and using them in ways that synchronize with and enhance our garden landscapes.

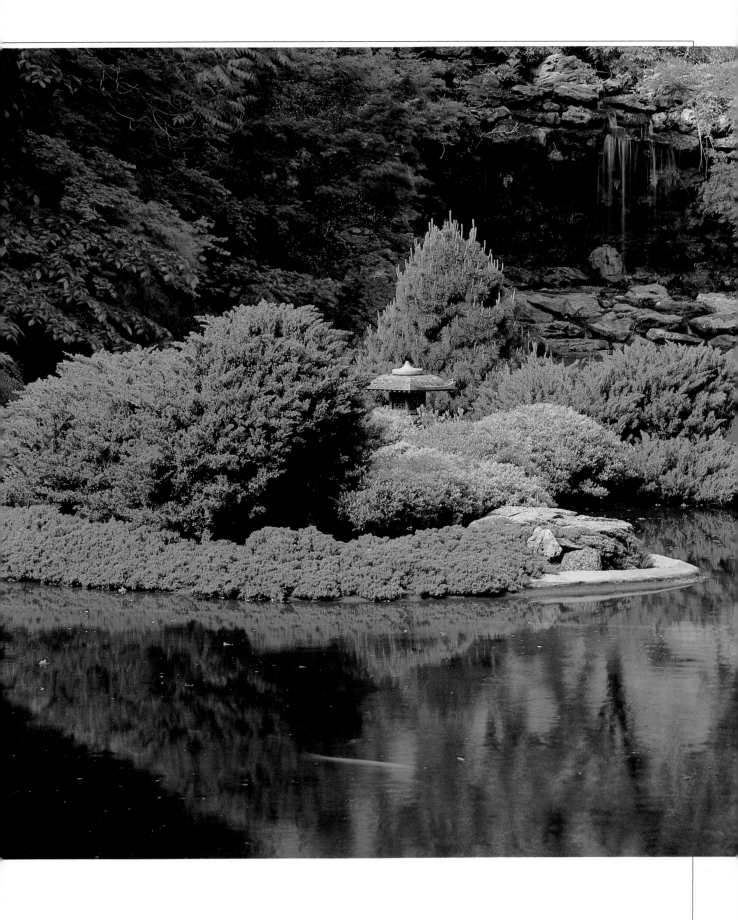

The bridge and lantern signify the point at which a stream enters the pond, providing the focal point for this garden. Although a large expanse of water is visible, the winding shoreline creates a sense of mystery. Brooklyn Botanic Garden, Brooklyn, New York.

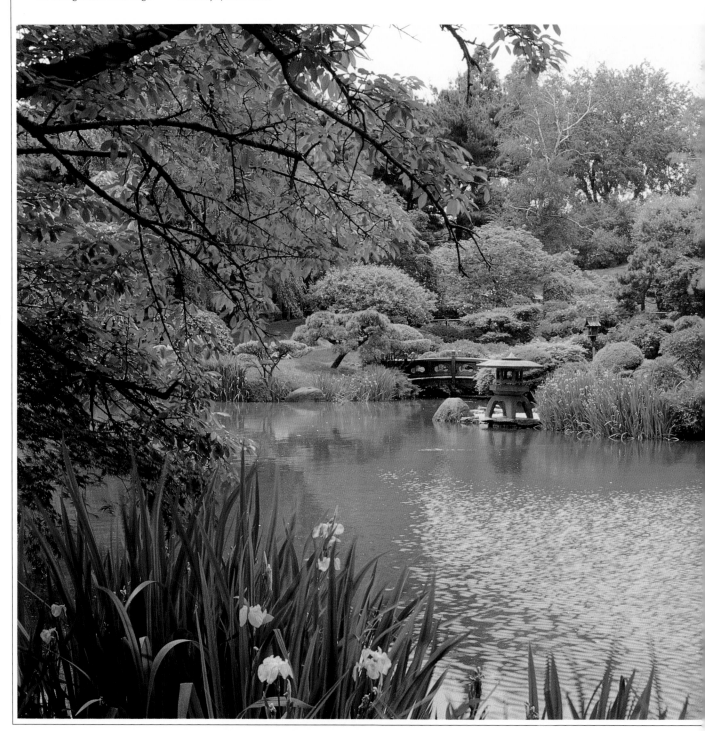

As Teiji Itoh writes in *Space & Illusion in the Japanese Garden*, "Too strict an adherence to forms is equivalent, in the words of an old Japanese proverb, to straightening the horns and killing the cow. In a word, the formalist loses flexibility of mind and heart, and the garden loses its life. For this reason, a good gardener has always tried to refine and enrich his concepts and imaginative ideas, maintaining a flexible attitude to stand him in good stead whenever the occasion arises."

In stroll or hill and pond gardens, the pond is the dominant feature of the landscape, strongly influencing other aspects of the design. Its power resides in its horizontal nature and the sense of space offsetting the plants, stones and structures of the garden. The pond's character is determined by the site and by one's own desires. For some it is the sea, while for others the pond may be a tidal pool or mountain lake. Each style determines the types of rocks and plants used in the garden.

Although the early Heian garden ponds were broad, open expanses of water, the classical Japanese pond has come to be one of mystery with hidden views and a series of perspectives retreating into the distance. This quality derives from the highly irregular shoreline consisting of inlets, bays and jutting points of land with islands, stones or plantings that further interrupt the view. At some point along the shore at least one of the inlets will force the path somehow to cross the water, either by bridge or stepping stones.

The Japanese consider a simple dammed pond to have no life, so give considerable import to including an obvious source of water, usually a stream, waterfall or spring, natural or from a recirculating system, and at least the implication of an outlet where the water disperses, such as a marshy area. The shape of the pond usually narrows as it approaches the water source, pulling the eyes further to this focal point.

In merging the water with the land at the shoreline, both structural and aesthetic demands are placed upon the design. Stones, plantings and short posts suggesting old pilings and moorings are the predominant methods of concealment and retainment. Exactly what materials are chosen and how they are installed depends on the garden.

Pond construction of this type requires conscientious attention to details, from the excavation to the construction of the watertight substrata, installation of the recirculating drainage and filtering systems and the development of the shore. Finding a designer and contractor with the necessary skills and vision may not seem much easier than doing it yourself, but it will be worth the effort.

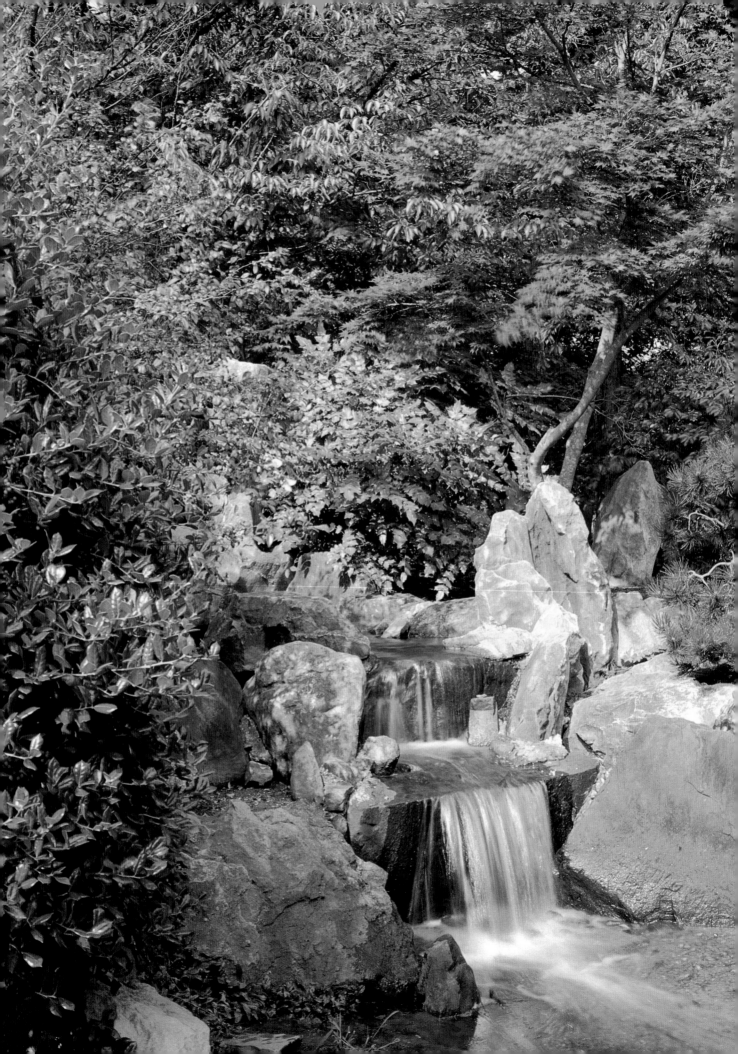

For limited space, a reflecting pool with a diminutive waterfall and trickling stream is no less soothing and effective as a source of reflection. For a pool of less than twelve feet (3.6 m.), consider the preformed ones in irregular shapes or the use of flexible liners. Both are relatively easy to install. In either case, choose materials that are dark grey or black, as they convey the illusion of depth. Large garden centers and mail-order suppliers have a wide selection of water gardening supplies as well as instructions. Although pools of this size are usually no more than two feet (60 cm.) deep, they can still accommodate water, plants and fish.

Goldfish are the prudent choice for smaller pools, but most fitting for a larger pool or pond is the spectacular koi, a type of carp the Japanese have bred for their red, gold, white, blue or black colors and patterned backs. Associated with strength, wisdom and courage, koi live for many decades given clean, cool, well-aerated water, partial shade and water four to five feet (1.2 to 1.5 m.) deep.

The mirror stone, over which the water falls, affects the shape and texture of the cascade. Vertical flanking stones provide a frame to the falls. Birmingham Botanical Gardens, Birmingham, Alabama.

Since the early gardens with their isles of paradise, the turtle and the crane, islands have been one with the pond in the Japanese garden. Size, shape and plantings harmonize with the rest of the landscape. Classical forms include a hilly island planted with evergreens; a low, wooded island with short grasses; a craggy, bleak island of cliffs and contorted pines and low, sandy islands planted either with reeds and grasses or young beach pines.

In a large garden, make at least one of the islands accessible by a bridge, and set another off in the distance, the unattainable paradise. Regardless of the size of the pond and garden, the use of rocks symbolizing islands is a time-honored tradition.

Representing the endless cycle of renewing the spirit, the waterfall in the Japanese garden literally brings life to the garden pond with its functional effect of aeration. But it is the waterfall's sensory effects that touch the quality of our day-to-day existence so profoundly. Who does not respond to the mesmerizing sound and movement of a waterfall? Or derive pleasure from the cool air that surrounds it and the refreshing feeling when it lightly splashes on fingers or toes? Diminishing the sounds of the outside world, a waterfall in the garden transforms time and space, creating a world of your choosing.

The reference in Japan to the waterfall as the stone pathway for falling water indicates the role of rock formation in creating a waterfall of stunning effect. Although the amount and speed of the water affects the fall's appearance, the rocks determine its height and path as well as its shape and texture.

The water may be a broad curtain or a thin ribbon, may cascade down one or more steps of either uniform or jagged nature, may overhang a cliff or may gently glide down the face of the rock. The style, height and width of the waterfall should be chosen and determined in reference to the garden and what will bring visual and personal satisfaction.

In the basic conformations devised centuries ago, certain stones are repeatedly used in constructing the waterfall. All have the quality of mountain stones, and any one waterfall is usually made all of the same type of stone. The rock or rocks over which the water flows is called the mirror stone. Its form determines the pattern of the water as it falls. Two pairs of stones stand on either side, but they are never symmetrical. Taller than the mirror stone, slightly in front and leaning inward, the vertical flanking rocks frame the mirror stone. Balancing and anchoring these are short, rounded base stones. In the broad basin below the falls, there may be a number of scattered stones, but most important is the triangular water-dividing stone, which causes the water to reverberate and "boil." In Japan, this stone may be somewhat extended and pointed, signifying the golden carp courageously fighting to go upstream, where it becomes a dragon, a parable of man's own struggles to attain and accomplish.

A tall cascade descends onto a large water-dividing stone, creating a lovely splashing effect before the stream quickly courses through the rough, narrow rapids. Private garden, Bloomington, Indiana, designed by Kenneth Yasuda.

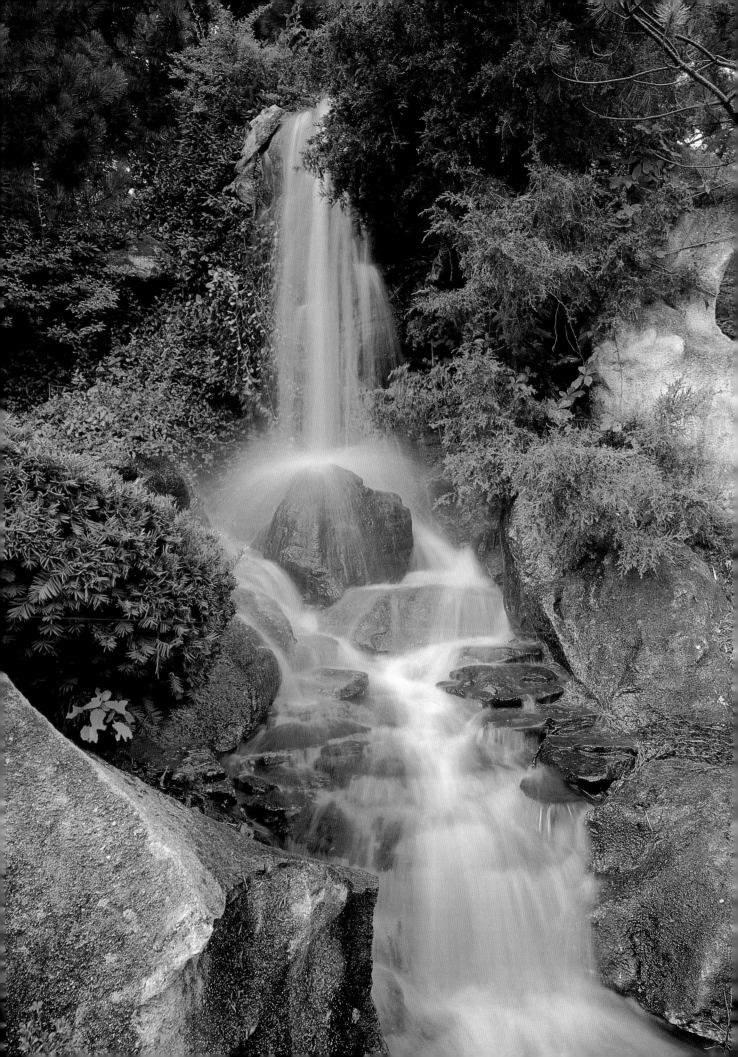

A series of small cascades,
partially obscured from
view, is in sharp contrast to
the tranquil surface of the
pond. Japanese Garden,
Portland, Oregon.

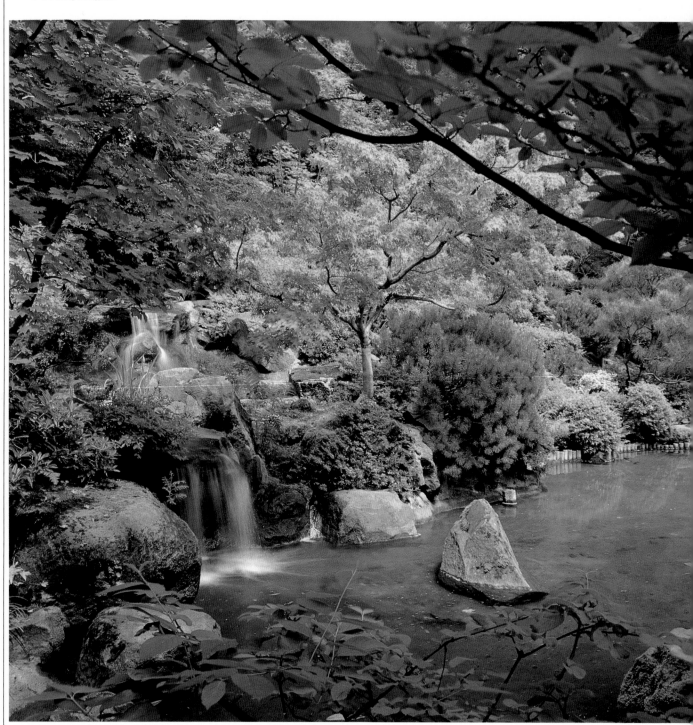

At the top of the waterfall, a small reservoir allows the water to build up volume before its journey downward begins. A variety of stones, flat and tall, dot the water and the banks of this collecting pool. Other stones throughout the composition enrich and expand it.

When building the waterfall stones are put in place, and the course of the water is checked before the stones are mortared and waterproofed with liquid sealer. As with ponds, successful, effective construction takes skill, patience and practice.

Following design principles, the waterfall is usually placed to one side of the garden, blended into the landscape with overhanging trees, surrounded with evergreens and maples, and set at an oblique angle to the main viewpoint.

Filled with vitality and energy, the stream can connect the water elements of a garden or be an entity in itself. Whether a meadowbrook or a mountain stream, the path of water is designed in scale with the garden and other features and in accordance with the available water. Waterproof construction is a necessity with a recirculating system. A dry stream and waterfall are less expensive and require less maintenance, yet they can equally assuage the heart and glorify the landscape.

If a waterfall is the stream's source, the natural progression of the stream is at first steep and through a narrow channel with rapids leading to a broader, smoother channel meandering and gently sloping down to a pond. A series of stones placed in the narrow stream flowing away from the waterfall creates the white-water rapids. Here the plants are of a mountainous nature.

Farther along, on curves, turning stones of considerable size protect the outer bank from erosion or project inward, justifying the curve. Clusters of water and meadow plants establish a sense of place and balance. As written in the *Sakuteiki*, "Other rocks and stones should be laid here and there as if forgotten." When the water approaches the pond, a row of stones creates a dam-like effect, emphasizing the sound and movement.

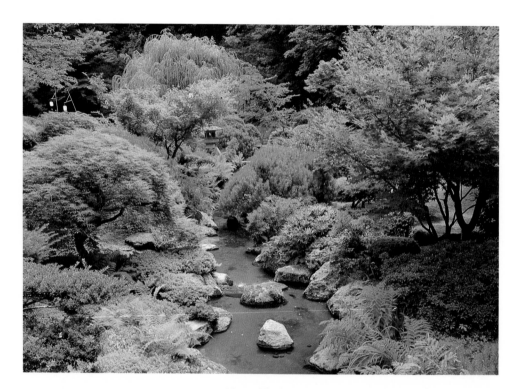

Above: The banks and bed of this gently flowing stream have been naturalized with mossy rocks of various sizes and softened with over-hanging plants. Japanese Garden, Portland, Oregon.

Right: A dynamic inter-play of light and shadow is heightened by the rapidly swirling and thundering water. Missouri Botanical Garden, St. Louis, Missouri.

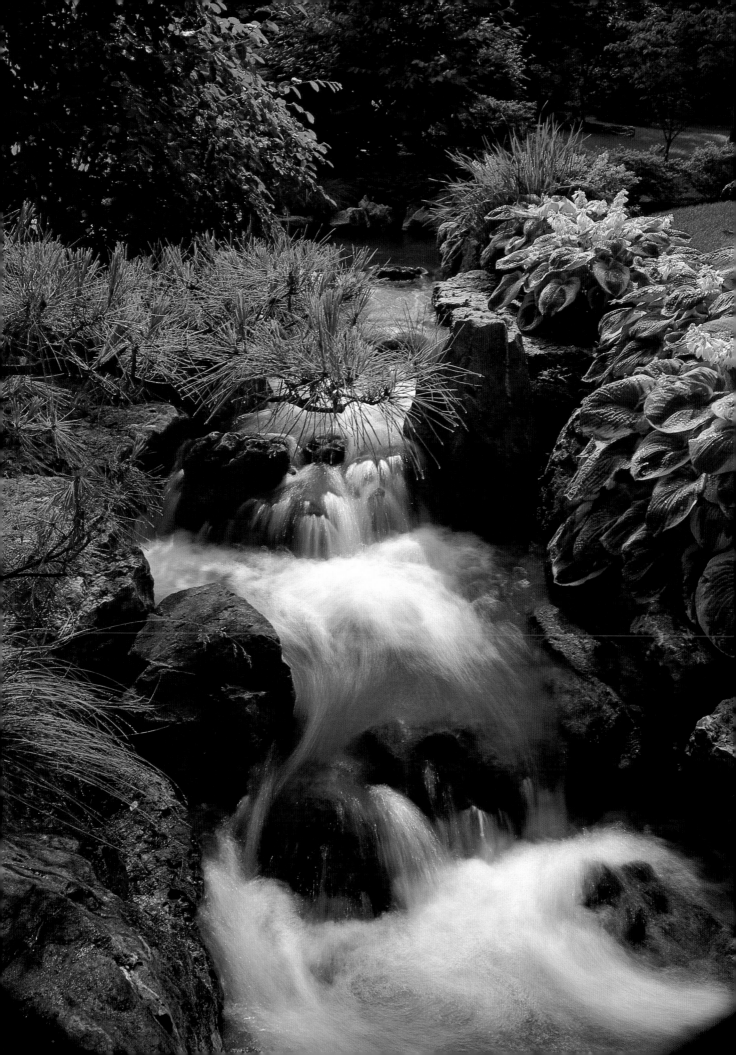

Providing a visual, practical and spiritual link, bridges in the Japanese garden illustrate the many roles and forms a mundane object can take, whether they traverse water or a dry stream bed. Made sleek and refined or left rough and natural, bridges repeat the style and character of the garden and maintain its scale.

It is important to relate the form of the bridge to the water and the span. The longer the area to be traversed or the more turbulent the water, the more substantial the bridge should be. A placid lake or gentle rivulet requests a much lighter touch, but never miniaturization. The bridge is set to be viewed advantageously from an oblique angle. Large bridges in stroll gardens are intended to be glanced at in the distance before they come into full view.

Wood and stone are the predominant materials used for bridges in the Japanese garden, both of which lend themselves to many different appearances. Stone may be hewn or as found in nature. Quarried pieces, especially, are readily available and easily installed. Simple wooden bridges made from logs or planks running parallel or perpendicular to the path and attached to rails are best made from cedar, locust, redwood or pressure-treated lumber and allowed to weather naturally or stained a subtle color.

A steep wooden drum bridge is a powerful man-made element that represents the difficult path between this world and paradise. Japanese Tea Garden, Golden Gate Park, San Francisco.

Whether made of wood or stone in a large or small garden, most bridges lie low in the landscape and are either straight or only slightly arched and seldom have handrails. They may be a single span or be composed of two or more that, most frequently, are parallel units overlapping in the middle. The structural support for all bridges must be substantial, but lending visual weight are anchor rocks at each of the four corners. Wooden bridges are usually held with wooden posts or pilings set in the ground, while stone supports are mortared in.

Another type of bridge is made of wood covered with soil and planted with sod. The eight-span wooden zigzag, or *yatsuhashi*, bridge is used over still water among plantings of iris, lotus or water lilies. Fable has it that evil spirits can only follow a straight line; hence they are thwarted on these spans, while visitors can pause to contemplate the flowers.

The high arched bridge seen in large elaborate gardens forms a circle with its reflection, symbolizing perfection. The arch also symbolizes the ordeal of reaching paradise. As much as possible of the foundation is to be camouflaged. In early Japanese gardens, these bridges were painted Chinese red, but later versions were left to darken naturally.

In whatever form, bridges allow us another perspective of the garden, a place to pause, consider the water, the fish and the earth in all its splendor.

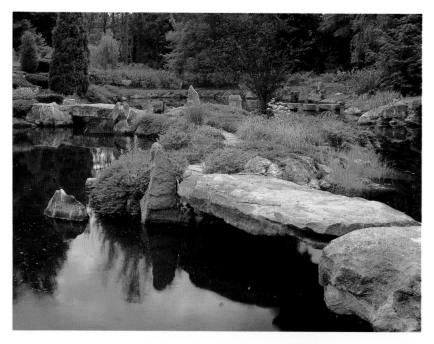

Stone slab bridges, either rough hewn or cut, are chosen when rock is a strong garden element and anchored at each end with vertical rocks. An arched wooden bridge blends in well with deciduous plantings. Top: Private garden, Bloomington, Indiana, designed by Kenneth Yasuda. Bottom: Missouri Botanical Garden, St. Louis, Missouri.

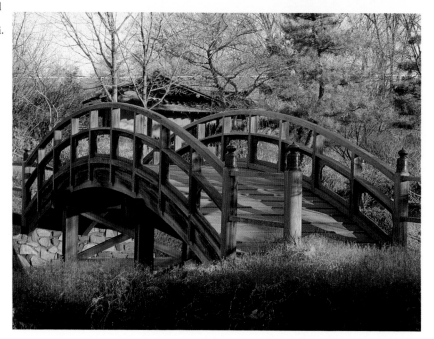

A rustic wooden bridge
of planks with low, arching
side rails is ornamented
with lotus-bud finials called
giboshi, or sacred gems.
Swiss Pines, Malvern,
Pennsylvania.

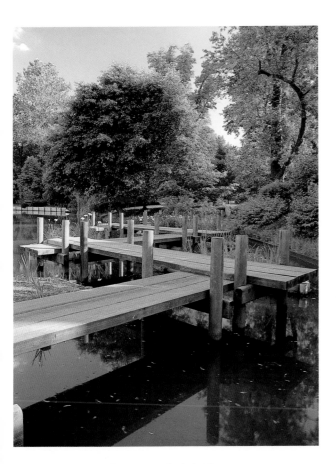

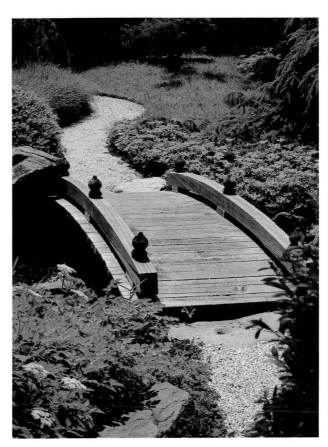

A zigzag *yatsuhashi* bridge
is traditionally used to
wander among beds of
Japanese iris (*Iris kaempferi*),
reflecting on their beauty
from different angles. Leg-
end has it that crooked
bridges also help one thwart
evil spirits, whose path is
a straight line. Missouri
Botanical Garden, St. Louis,
Missouri.

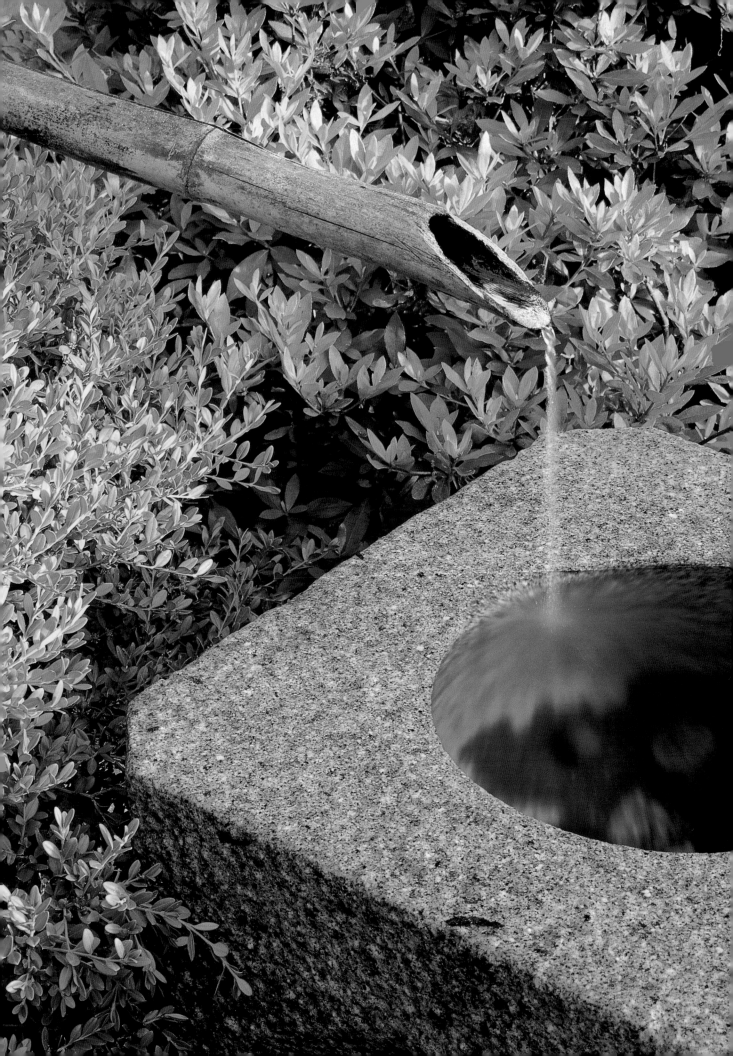

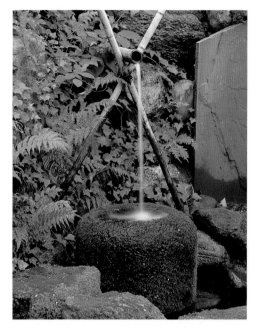

Water basins bring the cooling, cleansing sight and sound of water to the garden in a somewhat abstract and highly ritualistic form. The basin's style should be simple and natural, and they are most often fed through a simple bamboo flume. Left: Missouri Botanical Garden, St. Louis, Missouri. Right: The John P. Humes Japanese Stroll Garden, Mill Neck, New York.

Ablution is endemic to many cultures. The heritage of Shinto rites of purification that was adapted to the ritual cleansing at the water basin before the tea ceremony is not alien to Western ways or beliefs. In its refined simplicity, the water basin in the retreat of the garden is emblematic of our need to be there. Consider the water basin not only as a lovely element of water in the garden but also a highly functional one. Use it to rinse your muddy hands, letting the water touch you with its cool sweetness.

Tea masters of the sixteenth century appropriated containers of wood, ceramic, metal or stone to hold water for the prescribed rite. Over time, the stone basin has become ubiquitous, with some being rough stone with a natural or cut depression. Finely carved basins in traditional styles have poetic names. Other vessels and materials may be more personally meaningful. The practice of recycling found objects can be carried on today, honoring past ways and deepening the awareness of inevitability, passage and cycles.

A stone basin in the shape of a Chinese coin symbolizes *in* and *yo*, or the wholeness of the universe. Missouri Botanical Garden, St. Louis, Missouri.

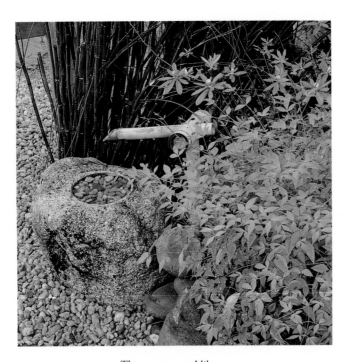

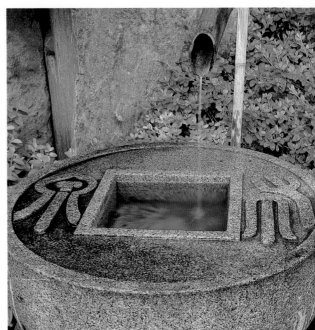

The narrow, reed-like stems of sedge (*Equisetum hyemale*) are sometimes planted near a water basin, because the silica content makes it a natural scrubbing abrasive. Atlanta Botanical Garden, Atlanta, Georgia.

A boat is one of the traditional shapes of the carved style of water basin. Japanese Tea Garden, Golden Gate Park, San Francisco, California.

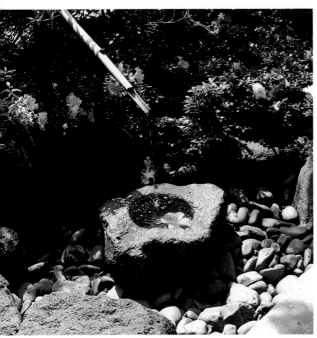

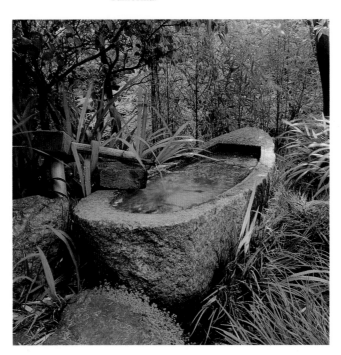

A low, roughly cut stone basin requires a stooping position as a gesture of humility for the ritual cleansing before the tea ceremony. Japanese Garden, Portland, Oregon.

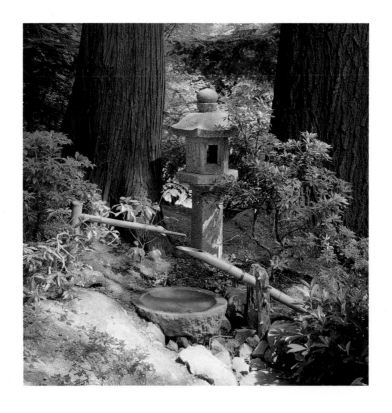

The rhythmic sounds of a deer scare, called a *sozu* or *shishi odoshi*, come from a hollow bamboo pipe filling with water, tipping downward, then swinging up when empty to strike a rock or piece of wood with a "clack." Japanese Garden, Portland, Oregon.

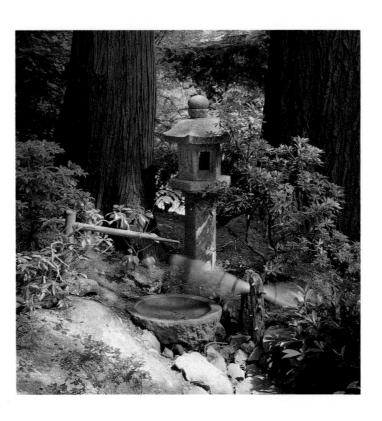

One type of water basin is placed near a porch or veranda, with the basin tall enough to reach the edge. The form most often seen in the tea garden is usually twelve to twenty-four inches (30 to 60 cm.) tall. Set with a specified grouping of stones, it is called the *tsukubai*, meaning to crouch or squat, which is a gesture of humility. Used in courtyards, small gardens or an intimate corner, this arrangement becomes a source of sensory satisfaction.

The water basin is placed either in the center or to the rear of a pebbled area. In front is a low, flat stone for kneeling, to the left is a higher flat stone for setting down a candle or belongings and to the right is another for a teakettle of hot water in the winter. Smaller stones are mortared in between. A bamboo dipper lies across the top. Fresh water may be carried to the basin or piped in through a bamboo flume with a recirculation and drainage system. The area is planted with ferns, hostas, short bamboo, small shrubs or a tree and lit by a lantern.

In considering the garden as a sensory experience, the element of sound comes to us from wind, water, insects and birds. The pleasure the Japanese derive from the clacking sound of wood upon wood has given rise to the *sozu* or *shishi odoshi*, the deer-frightening noisemaker. A system of pivoting bamboo pipes filling and emptying with water causes one pipe to strike a block of wood repeatedly. This haunting, rhythmic sound is another message of the infinite extent of the universe.

飾

ORNAMENTS

in a Japanese garden, whether original, reproductions or new, represent artifacts that held different uses in Japanese cultural history, sometimes physical, at other times spiritual. At the most intrinsic level, these man-made objects serve to symbolize man's presence in the natural world and humanize the garden. As such, they are only one small part of the garden, not its focus but a component of the whole. Ideally, they are well-integrated into the landscape, with their substance and placement befitting the original function yet also with due attention to their aesthetic qualities. To become part of the unified composition of plants, stones, water and other elements effectively, the ornaments included must be used in accordance with the design principles.

Most important are the applications of asymmetrical balance and the scalene triangle, which govern not only a grouping's structure but also how it is incorporated into the rest of the garden.

Miegakure, or the principle of hide and reveal, is an essential part of placing ornaments. In a large stroll garden, an ornament may be entirely hidden from view or only glimpsed at in the distance before finally being revealed along the path. Even then, the entire ornament may not be visible. In this case, and in a garden where all parts are viewed at once as a picture, portions of the ornament can best be hidden partially by plants at the base and a branch above. Objects in the Japanese garden are viewed advantageously at an oblique angle rather than from straight on.

Another factor to consider is keeping the ornaments in scale and character with the site, buildings and other elements of the garden. Choose those that are simple, of good design and of materials that harmonize with the rest of the garden and embody a sense of elegant rusticity.

If the aspect of *sabi,* or age, is absent from an ornament, it can more or less be fostered. English architect Josiah Conder, in his 1893 book *Landscape Gardening in Japan,* graphically suggests ways to produce lichen, moss and other effects: "A ficticious [sic] age is given to new Lanterns by attaching, with a gummy solution, patches of green moss, and by fixing to them decayed leaves by means of birdlime, or by smearing them with the slime of snails; after either of which processes they are kept in the shade and frequently wetted." Through the years inventive gardeners will continue to develop variations on this theme. Fortunately, ornaments will weather and age naturally, albeit slowly. They will do so faster in a damp, shady place.

Well-integrated with the stones and plants, this lantern is strategically placed at two intersecting paths near a gate. The John P. Humes Japanese Stroll Garden, Mill Neck, New York.

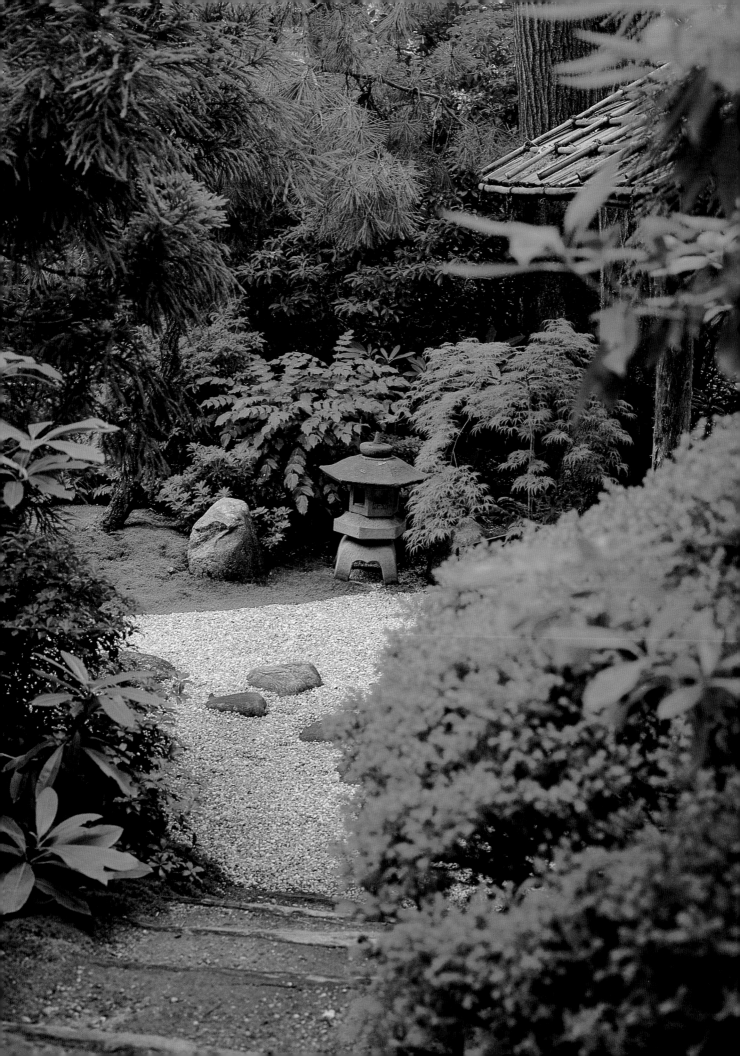

In addition to the bridges and water basins discussed in the chapter on water, lanterns, towers, sculptures of deities, signposts and animal effigies are the principal man-made objects used in the Japanese-influenced landscape garden. The finest of these are of carved stone, but those made of other materials should not be dismissed if of good quality and design. With skill and artistry, materials such as bronze, iron, wood or ceramic can be employed to good effect. In keeping with the Zen philosophy of using materials close at hand, we can attempt to use artifacts of our own culture, create traditional forms with new materials, new forms with traditional materials or any other propitious combination.

Lanterns were introduced to the garden landscape with the elaboration in the 1500s of the tea garden by tea masters partial to finding alternate uses for discarded objects. Due to the civil wars of the time, many temples and shrines were abandoned, leaving an abundance of carved stone votive-offering lanterns. The tea masters combined the desire for subtle, mysterious tea garden lighting and an appreciation of beautiful objects with this ready source. Most of these lanterns were at least six feet (1.8 m.) tall but today the height varies considerably, with many being two or three feet (60–90 cm.). The original aged, moss-covered forms from the holy places lent the requisite air of tranquil timelessness, stability and continuity, so important to the tea ceremony.

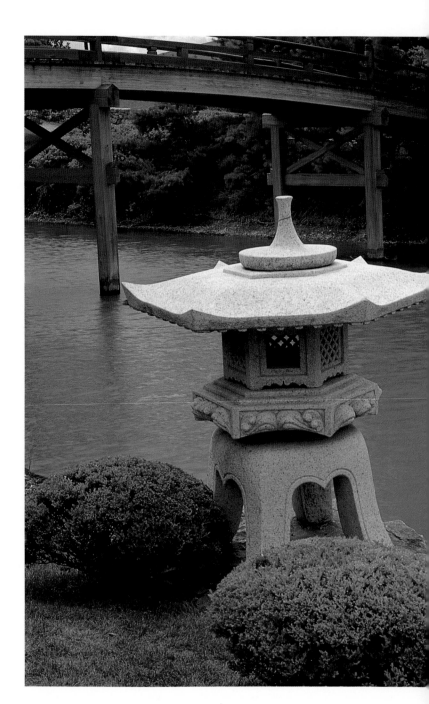

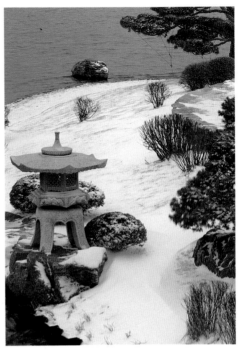

A *Yukimi-doro*, or snow-
viewing lantern, is often
placed close to water,
because it is most beautiful
when snow covers the wide
top and its light reflects on
the water. Chicago Botanic
Garden, Glencoe, Illinois.

From the time Japanese lanterns were first mentioned in the seventh century, they have been constructed in many shapes and sizes, with names reflecting the temple, shrine, designer or style. Most retain the basic components of a rounded or pointed cap depicting the lotus bud of purity; a roof of infinite configuration; a firebox that may be globular, square, or six- or eight-sided; and a flat firebox support with the same geometry. Depending on the style some lanterns have legs, while others are upheld by a shaft with or without a base pedestal.

Descriptions of the most commonly seen types of lanterns follow.

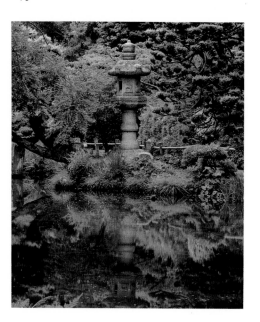

Right: Lanterns are used to light the way to an evening tea ceremony or to draw attention to a scene, such as this island shore. Brooklyn Botanic Garden, Brooklyn, New York.

Left: Kasuga-style lanterns with their pagoda-shaped tops are named for a shrine in Nara, Japan, famous for its deer park—hence the deer panels that appear on the sides. Japanese Tea Garden, Golden Gate Park, San Francisco, California.

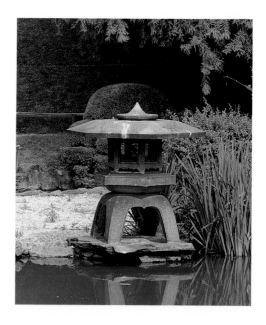

The pedestal lantern (*tachi-doro*) stands appropriately on the pedestal base; it is usually large and formal with the ornate, six-sided pagoda-roofed *kasuga* shape often copied. The buried lantern (*ikekomi-doro*) has a shaft buried directly in the soil rather than resting on a pedestal; a well-known style designed by the tea master Oribe has a thick roof, square firebox and a circular area at the top of the shaft. Both the pedestal and buried lanterns have a tall, slim appearance.

Small lanterns, set directly on the ground or a rock, are called *oki-doro*. Low and broad, the snow-viewing lantern, *yukimi-doro*, has a large roof mirroring a Japanese farmer's rush hat; it may have two legs resembling a tuning fork or three or four low, curved legs. Another leg style is an arched shape, usually placed to extend out over water. Other lantern styles are made by combining either natural stones or stone art objects.

Lanterns are placed in the garden with an eye to logic and beauty, with the firebox preferably facing the area to be illuminated. Three-legged lanterns are set so two legs face the viewer. In keeping with the precedent of the tea garden, lanterns may be set near a gate, waiting bench, well, water basin or teahouse entrance. Stroll gardens enlarge their use to include placing them at a bend in a path, at the base of a hill, on an island, at the bank of a pond or stream or even in the water, near a bridge, steps or boat landing or by a tree to highlight its branching pattern or translucent leaves.

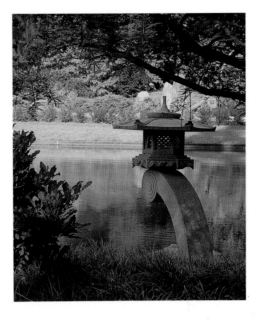

Right: A *rankei*-style lantern is set on an arching pedestal that extends out over the water so its image is reflected. Missouri Botanical Gardens, St. Louis, Missouri.

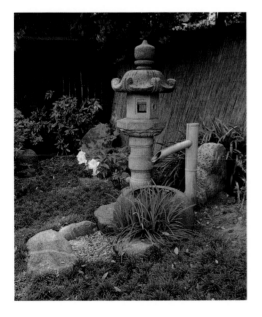

Left: A lantern can literally or symbolically illuminate the ritual water basin near a teahouse. Huntington Botanical Garden, San Marino, California.

Although the lantern is the dominant element in a grouping, small stones are included to offset the height of taller lanterns. A tall, flat stepping stone is set near the firebox for lamplighting. Plants serve to soften the stone, with a nearby tree trunk repeating the vertical line of the pedestal.

Although it is possible to wire a lantern for electricity, how much more in keeping with the spirit to use a candle or lamp oil and cover the opening with rice paper on a small wooden frame or a piece of frosted glass.

Small lanterns of bronze, iron, bamboo, wood or ceramic are hung from the eaves of buildings or set on a rock beside a path, at the water's edge or in a courtyard or entryway.

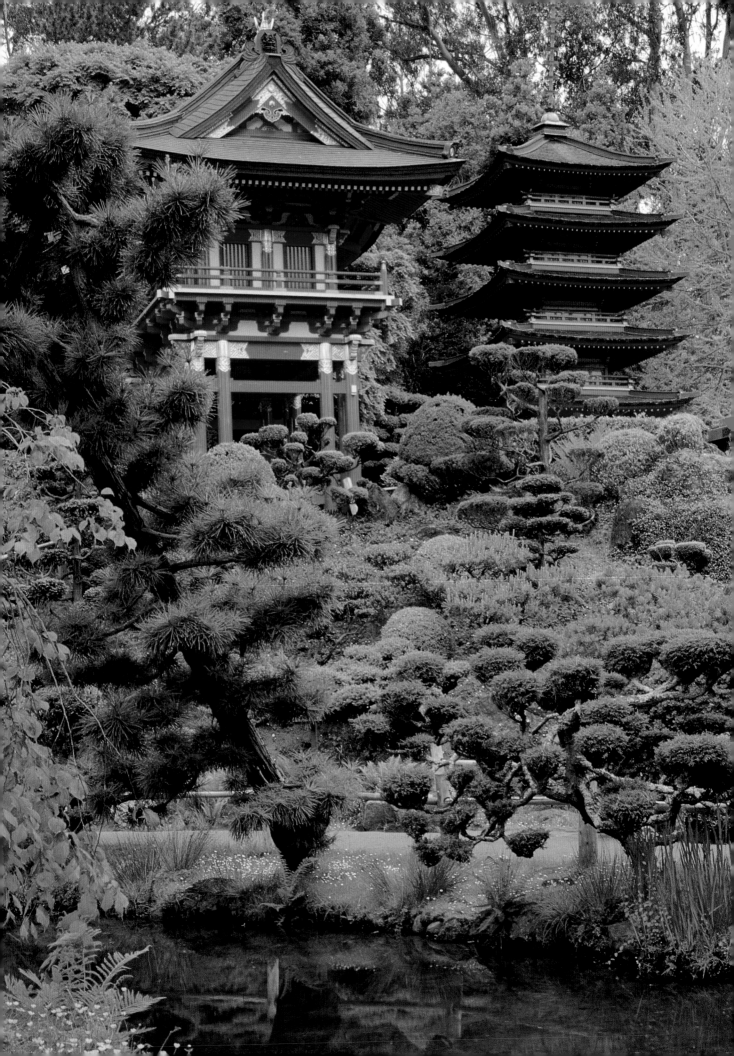

Stone towers or pagodas usually are composed of an uneven number of progressively smaller curved roofs. Because of their small size, they add to the diminished perspective in a garden. Left: Japanese Tea Garden, Golden Gate Park, San Francisco, California. Above: The John P. Humes Japanese Stroll Garden, Mill Neck, New York. Right: Evil is unbeknownst to these carved stone monkeys who bring a note of humor to the garden. Fort Worth Botanic Garden Center, Fort Worth, Texas.

Stone towers, also called stupas or pagodas, are reminiscent of Buddhist elements and represent temples of the deities. Their rooflike plates are always in odd numbers. Three signify heaven, earth and man, while five convey the earth, water, fire, wind and sky. The nine rings at the top stand for the nine heavens in the Buddhist pantheon, and the lotus blossom finial represents Buddha. Providing a strong vertical element, towers of nine or thirteen stories placed on a hill in the garden accentuate the height. Those of three or five plates set near water offer contrast to the water's horizontal lines and reflection. Perspective and intrigue are augmented when a portion of the tower is obscured with branches or low plantings.

Small stone carvings of various Buddhist deities, whether freestanding statues or bas reliefs, have a significance and substance that bring strength and spirit to the garden. The strong geometric lines of stone or wooden signposts with carved Japanese characters provide linear contrast.

Bronze or iron sculptures of natural creatures like cranes, turtles, frogs or rabbits each have a symbolic meaning. The graceful shape of cranes and the pleasure they bring when reflected in water have made them favored through the years.

Figures of Buddhist deities strengthen the spiritual connotation of the garden and are usually set in a sheltered place. Left: Swiss Pines, Malvern, Pennsylvania. Right: Cheekwood, Tennessee Botanical Gardens and Fine Arts Center, Nashville, Tennessee.

構造

A NUMBER

of structures in the Japanese garden beckon us to it, surround us with their security and provide a place of rest and well-being. The gates, fences, walls, arbors and shelters chosen should reflect a sense of respect and regard for the materials. Finely crafted elements, whether of rustic or refined design, show a thoughtfulness and appreciation for their innate nature. The resulting harmony and order is one more element in the integration of architecture and landscape that is the Japanese garden, wherever it is built.

The hundreds of knots patiently tied in a bamboo fence, the rough texture of a stucco wall, the polished grain of arbor posts, the precision of an umbrella ceiling, the plum blossom of bamboo in a fence window—each of these details manifests a sensibility to all aspects of the environment. Materials used in structures need not duplicate those of Japan, nor must the designs themselves, but at the core must be that affinity of spirit.

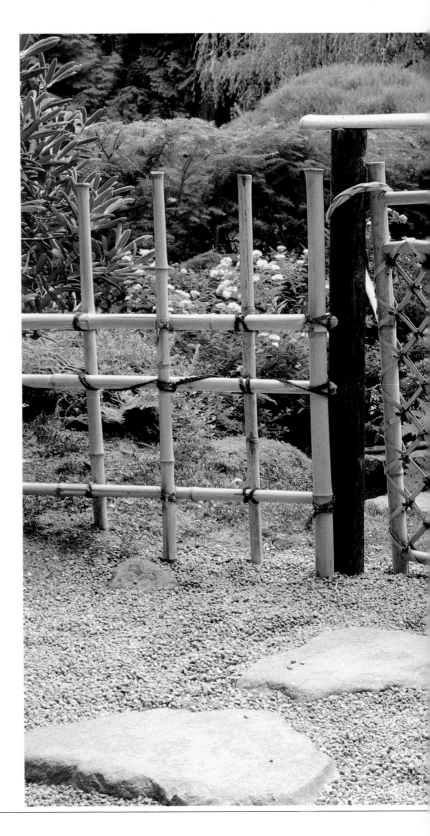

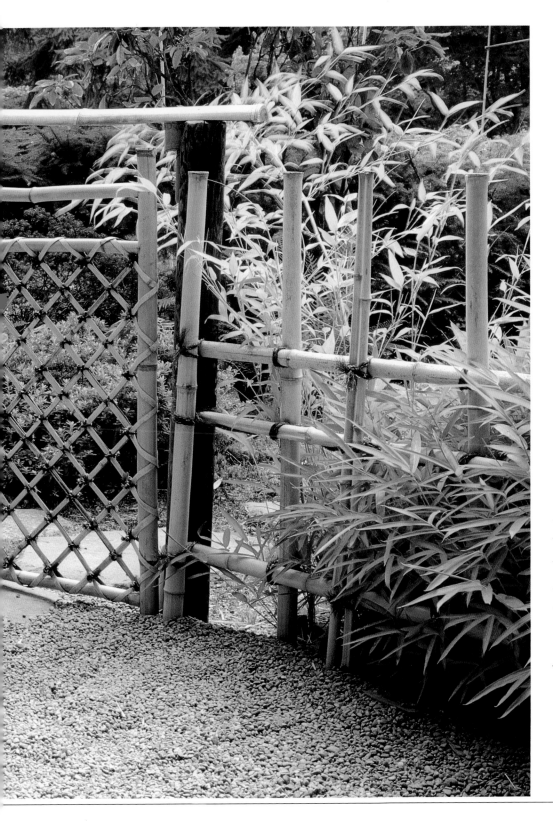

Simple and elegant, a bamboo fence and split, woven bamboo gate are tied with traditional black cord. With time, the bamboo will weather to a softer color. Japanese Garden, Portland, Oregon.

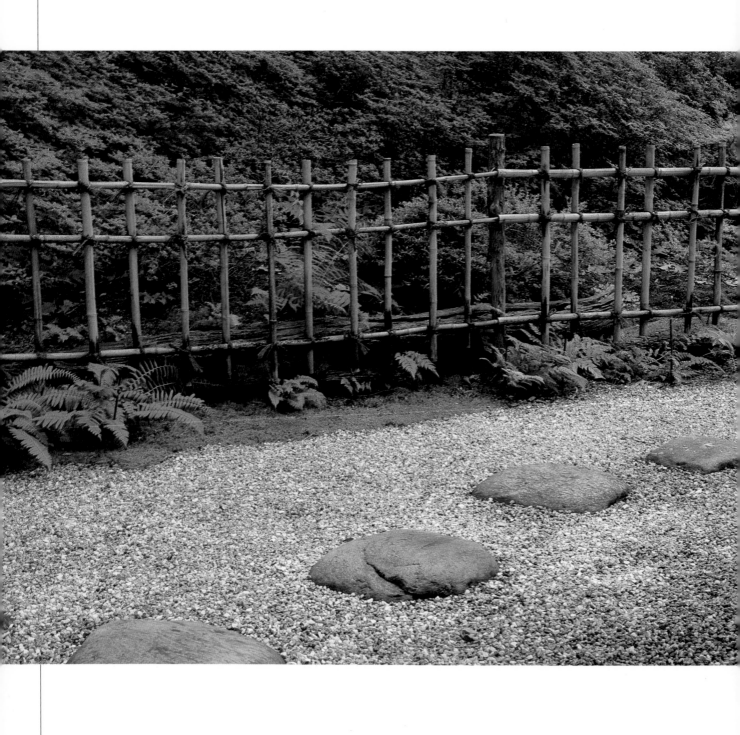

It is the fence or wall that defines the space of the Japanese garden, determining which portion of the outside world is kept out and which is invited in. This space is not separate from the home but at one with it. Most important is choosing a form and character that integrates house and setting.

A boundary fence or wall also baffles noise and wind and offers some shade. Although tall, it never shuts out the rest of the world completely, allowing that quality of mystery, the unknown, the implied, to remain.

As a backdrop to the garden, the fence or wall neither calls attention to itself nor is so unobtrusive as to be lost. Low key colors, such as warm beiges, soft grays, and browns serve well. Materials from nature suit the fence of wall best, be they bamboo, wood and/or stone. The Japanese are not afraid to mix or use "overlooked" materials, such as branches or brushwood. They know that materials need not be grand to be beautiful.

Left: A low, open bamboo fence gives definition to an area while also adding texture and design interest. The John P. Humes Japanese Stroll Garden, Mill Neck, New York.

Right: Bamboo poles, spaced closely together, form a solid boundary wall, yet the effect is that of lightness. Atlanta Botanical Garden, Atlanta, Georgia.

Although bamboo is available, it is not a natural part of the Western landscape. Often more appropriate is using bamboo as trim or for a small divider fence within the garden. When working with bamboo, be sure to cut it just above a joint so that the end is solid and water won't collect inside resulting in rot.

Simple wooden fences, such as the style with boards nailed alternately on opposite sides of a frame, are in keeping with the nature of Japanese design. This style looks good from both sides and provides privacy while allowing air to circulate. Other types of plain wooden fences are also readily available. Let time weather them naturally or apply a subtle, dark stain. Redwood, cedar, cypress or pressure-treated wood make the longest lasting fences. Most boundary fences are five or six feet (1.5 or 1.8 m.) tall. To ensure stability, set posts three feet (90 cm.) deep in the ground, with a drainage layer of gravel beneath and the holes filled in with gravel and soil or mortar.

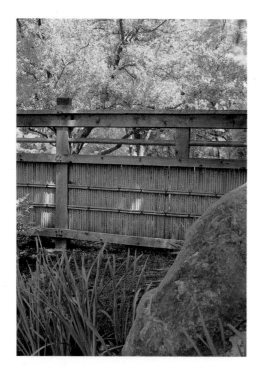

Feel free to vary the height of the fence if the situation demands it. For example, to hide something ugly, a taller panel may help. Conversely, if a beautiful scene is available, leave a panel of the fence out or frame the view in an opening.

Solid walls are expensive but ones of stucco or stone offer a sense of stability and immutability. Their rough textures and natural colors blend with the garden. A traditional Japanese touch is to work in a pattern of broken tile or interesting rocks.

Tall fences and walls may have a narrow gabled roof shingled with cedar bark, thatch or tile. Their value is both aesthetic and practical, as they are attractive and protect the structure from the ravages of rain.

Where to site the boundary fence or wall may seem obvious, but consider setting it in from the property line to allow the planting of tall trees and shrubs on the outside, extending the sense of the garden.

Within the garden itself, low, open divider fences serve to define portions gracefully. Classic for the entrance garden, often running parallel to a broad path, is a divider fence twelve to twenty-four inches (30 to 60 cm.) tall. The main parts of the garden are divided by fences three to four feet (90 to 120 cm.) tall. These are traditionally made of bamboo canes or bundles of bush clover twigs but other materials can be used. For example, a classic pattern can be paired with lengths of one-inch (2.5 cm.) wood instead. These are nailed together, then tied with black jute in the customary way, blending East and West.

The sleeve fence, or *sode-gaki*, is named for its resemblance to a kimono sleeve. Essentially, it is a short length of high fencing placed at right angles to a building. It shields, screens or provide a backdrop. The average size is six feet (1.8 m.) tall and three feet (90 cm.) wide, but it can be employed in any other size.

Left: This bamboo and wood boundary fence encloses the garden, yet its partial openness fully maximizes the borrowed scenery. Fort Worth Botanic Garden Center, Fort Worth, Texas.

Right: Short segments of fence, extending like a kimono sleeve from a house, are called sleeve fences. Usually twice as high as wide, they form a transition from house to garden, hide a utility area or provide a backdrop. The John P. Humes Japanese Stroll Garden, Mill Neck, New York.

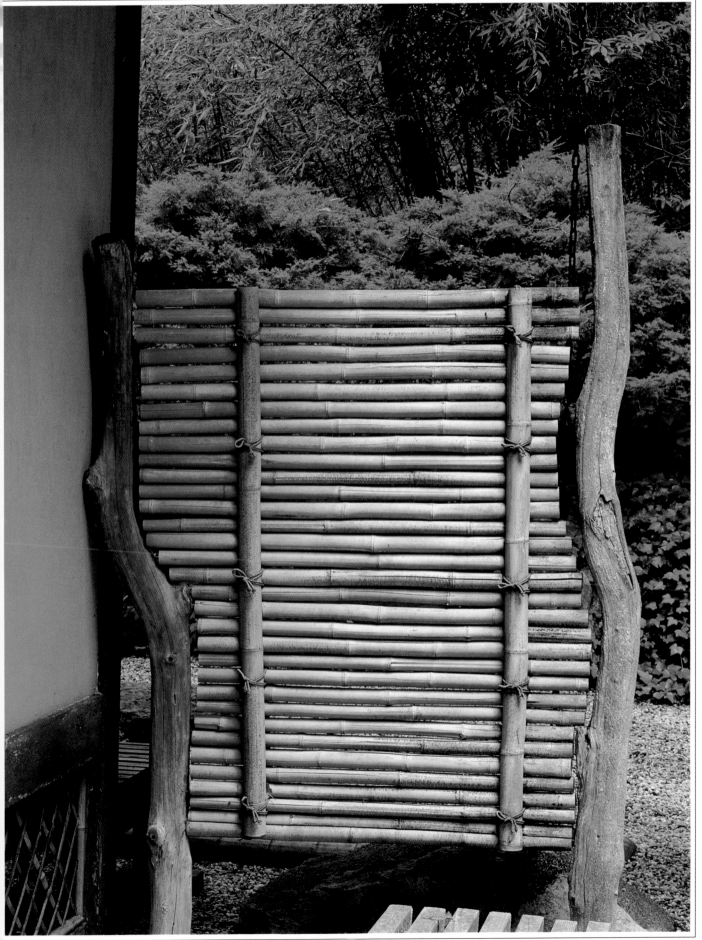

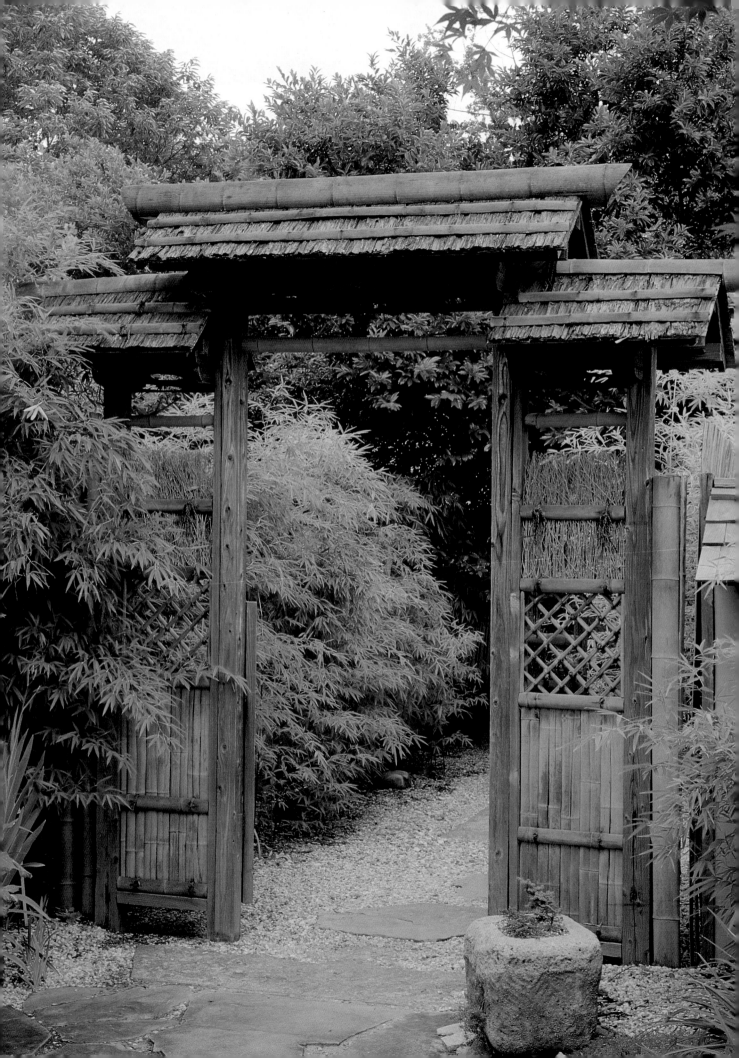

Roofed gateways with decorative flanking wings serve to welcome visitors to the garden. The design is in keeping with the fence, plantings and garden. Atlanta Botanical Garden, Atlanta, Georgia.

Large entrance gates are usually placed between the front, or entrance garden and the main garden. A single or double wooden door is hung between two gateposts with a simple gabled roof. The gate should be fitting in style and scale with the fence, garden and dwelling. At its simplest, a gate might consist only of two gateposts and a top crosspiece.

Hardware on a main gate is generally a sliding wooden bolt, but consider using a special piece of art, perhaps something in iron or brass. If the doors are to be kept open, add an unobtrusive latch to keep them from swinging wildly.

Small gates of open weave, whether of bamboo, wood or metal, work with the low fences delineating sections of the garden inside.

Because the *torii* gateway carries a religious connotation, marking the entrance to a Shinto shrine, it should not be duplicated in a garden as an ornament.

A finely constructed teahouse, complete with sliding *shoji* walls and an alcove for flowers or art, may be the ultimate structure in a garden, but a small open shelter can be no less inviting and pleasant. Sometimes referred to as a summerhouse or arbor, such structures are naturally simple and open on all sides or with two or three walls. They may be big enough for friends or just for one. Keep them in scale and character with the garden, use natural materials, such as logs or planed posts, plaster, wood or bamboo walls and a roof of shingles, boards or thatch. Maintain the rustic quality by leaving them unpainted or subtly stained. Add a bench, stools, or table and chairs.

Go to the shelter at the end of a stepping-stone path winding among ferns and evergreens. Stop for a moment to hear the trickle of water into the basin. Watch the pattern of light and shadow among the branches of the Japanese maple. Stoop down and feel the velvet moss. Smell the jasmine tea in your cup. In solitary meditation, the harmony of nature and your inner self is achieved.

Tree and stones,
Just as they are,—
The summer drawing-room.

Tōrin

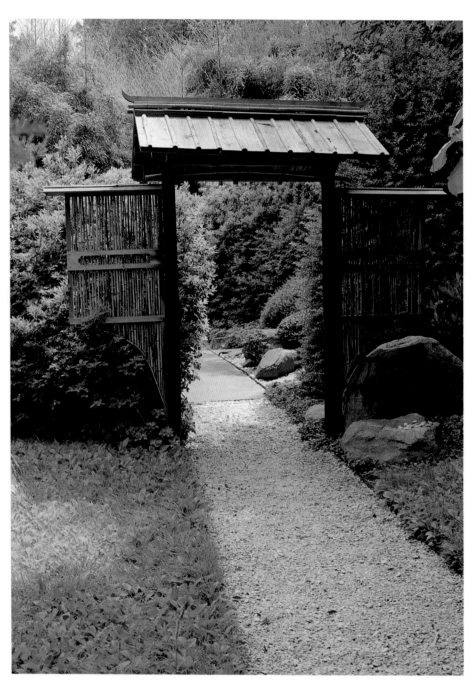

Gates are an essential part
of Japanese gardens, sym-
bolically representing
passage. Swiss Pines,
Malvern, Pennsylvania.

A circular opening in one
wall of a garden shelter
coaxes the visitor along
the path with its glimpse
of the garden ahead.
Atlanta Botanical Garden,
Atlanta, Georgia.

花木

T H E comfort and contentment offered by a Japanese garden, even when filled with people, may seem at first inexplicable. The alchemy at work renders a unique garden from ordinary elements. To achieve such peaceful accord in your garden, try to see the space you have chosen with new eyes, to feel it with a part of yourself that may be unfamiliar. To create a landscape that embodies the harmonious balance of nature's essence, you will need more than a new perspective on the garden. An understanding of plants on the practical level as well as the artistic is also fundamental.

The choice of plants in Japanese gardens tends to be constrained and subtle; they frequently contain only a few different kinds of plants. To choose well, you must have a basic knowledge of the plants being considered, such as their mature size and shape, their ability to withstand pruning and shaping, the color and texture of leaves and stems and their appearance during different seasons. Of course, the plants you select must also match the soil, light, moisture and hardiness requirements dictated by your garden.

Plants indigenous to Japan as well as plants from other countries can all be used effectively in designing a Japanese garden outside Japan. Using local plants actually authenticates a garden by accurately blending it with its surroundings. The key is to choose and place plants in accord with the principles and aesthetics of Japanese garden design.

Many plants we take for granted in Western gardens are actually native to Japan or the Asian mainland. The United States and Japan are in nearly the same latitudes, but the Japanese climate is humid with fog and mist and over 5 feet (1.5 m.) of annual rainfall. Winter temperatures seldom fall to 0°F. (−17.8°C.). Some Japanese plants acclimatize well to less accommodating Western climates, but at times other plants must be used.

Many parts of the west coast of the United States closely approximate the Japanese climate, and dramatic examples of Japanese gardens that use many Japanese plants are located in this region. Japanese-style gardens in other parts of the United States also offer excellent examples of the integration of plants from all parts of the world. What makes these adaptive gardens effective is that the plants chosen have qualities similar to Japanese plants and also reflect the natural world surrounding the gardens.

Above and beyond selecting plants that will survive the temperatures, wind, moisture, soil and light conditions in your garden, try to strike a balance between the scale of the garden, the natural size and shape of the plants and the amount of maintenance you are willing to undertake.

Evergreen trees and shrubs, a Japanese maple (*Acer palmatum*), iris and moss are traditional plants providing year-round beauty with their shapes and form. Atlanta Botanical Garden, Atlanta, Georgia.

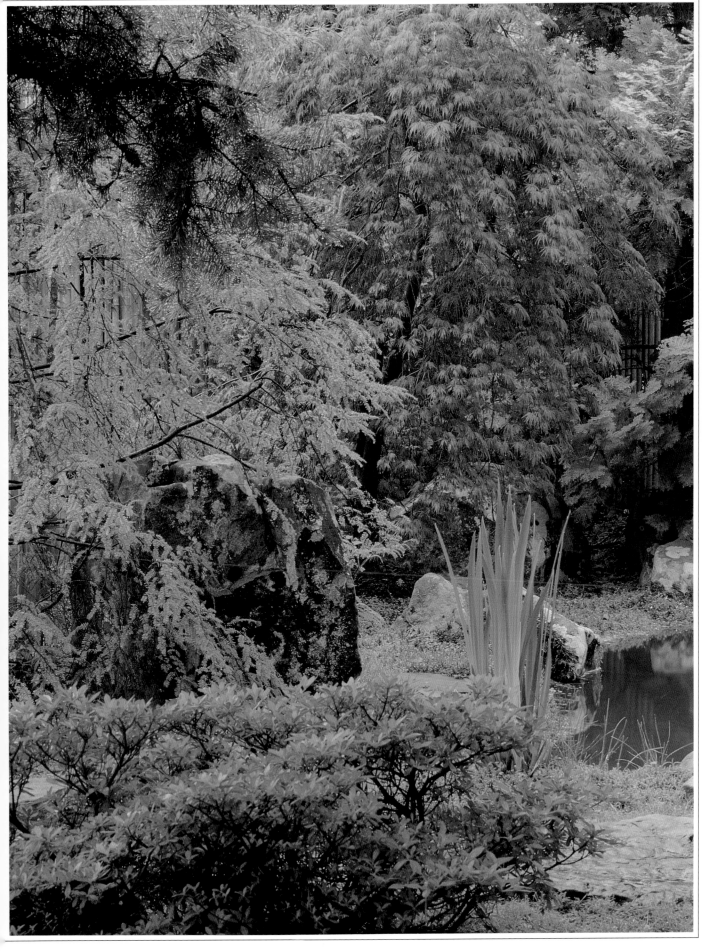

The simplicity of a Japanese garden belies the amount of effort involved in maintaining it. To avoid extra work, select plants that are naturally within the scale of your garden to minimize the need for pruning. For example, do not plant a tree with a mature height of 40 feet (12 m.) if a 20-foot (6 m.) tree would be in better proportion to the garden.

Another element of caring for plants in a Japanese garden is to pare them down to their essence in an aesthetic manner, removing distractions and accentuating strengths (the "personality" of the plant). Plants can represent clouds, rocks or mountains, and much as a sculptor chips away at the extraneous marble, so the gardener clips, shears, pinches, prunes or plucks a plant to clarify the lines and reveal the symbolic intention he or she has attributed to the plant. The plants you choose must be able to withstand such treatment.

Color in the Japanese garden is a study in the possibilities of green and the interplay of light and textures. Even when a Japanese garden contains only foliage plants, it never appears to be just green. With practice, you will become sensitive to the shades of green and the power of textures and will use them to complement and contrast with each other.

The other colors used in the Japanese garden are often derived from foliage, usually in shades of red, purple or yellow. Autumn

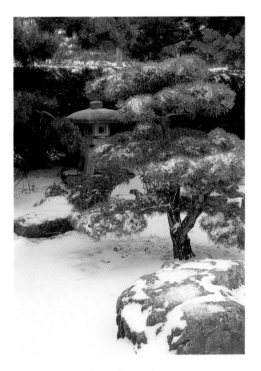

colors, especially with maples, are sometimes added judiciously to the garden plan. Flowers, whether those of trees, shrubs, perennials, bulbs or annuals, are an adjunct to the garden to be used sparingly. Plants are primarily chosen because their growth is best suited to the position they occupy in the garden. Blooms are viewed as a fortunate accident.

Seasonal qualities—including flowers, autumn color, unusual bark, berries or the way the branches of a plant hold the snow—are also considered. Much of a Japanese garden's timeless, serene quality derives from the careful artistry of using plants that contribute to the composition year-round. There is a saying that a garden blooms twice, the second time when snow swathes the plants.

Several plant types are essential for the Japanese garden. Evergreen trees and shrubs, both needled and broad-leaved, form the core of the plantings, often constituting as much as seventy-five percent of the plants. The eternal, ageless effect of evergreens provides the framework on which the rest of the garden builds its strength year-round. Evergreens serve as a background to flowering plants and autumn color, as well as light-colored stone, bamboo and other garden features.

Evergreen plants range in color from pale chartreuse to blue-gray to black-green and come in countless shapes, forms and textures. Many have interesting bark, cones, flowers or berries; hence, there is no want for variety. Besides the ubiquitous Japanese black pines (*Pinus thunbergiana*) and red pines (*P. densiflora*), consider the unusual flat-topped Tanyosho pine (*P. densiflora* 'Umbra-culifera'), or the strangely variegated dragon's eye pine (*P. thunbergiana* 'Oculus-draconis').

If the large, elegant Japanese pines are not amenable to your climate, consider native pines, spruces or junipers. These two diverse genera offer a large number of plants—from ground-hugging types to large trees—from which to choose. False cypress is another genus with a number of species of different growth habits.

Rhododendrons, including azaleas, are the best known broad-leaved evergreens. Azaleas in particular are widely used in Japan because they tolerate pruning so well. From the hundreds of cultivars available, be sure to choose ones that are hardy in your climate. Many of the broad-leaved evergreens used in Japan, such as camellia, gardenia, pittosporum and aucuba, are hardy only to 0°F (−17.8°C.). Gardeners in colder climates must rely on the hardier rhododendrons, plus species of abelia, pieris, mahonia and ilex, among others.

Evergreen trees and shrubs provide the backbone of the Japanese garden, giving it a timeless quality from season to season. Missouri Botanical Garden, St. Louis, Missouri.

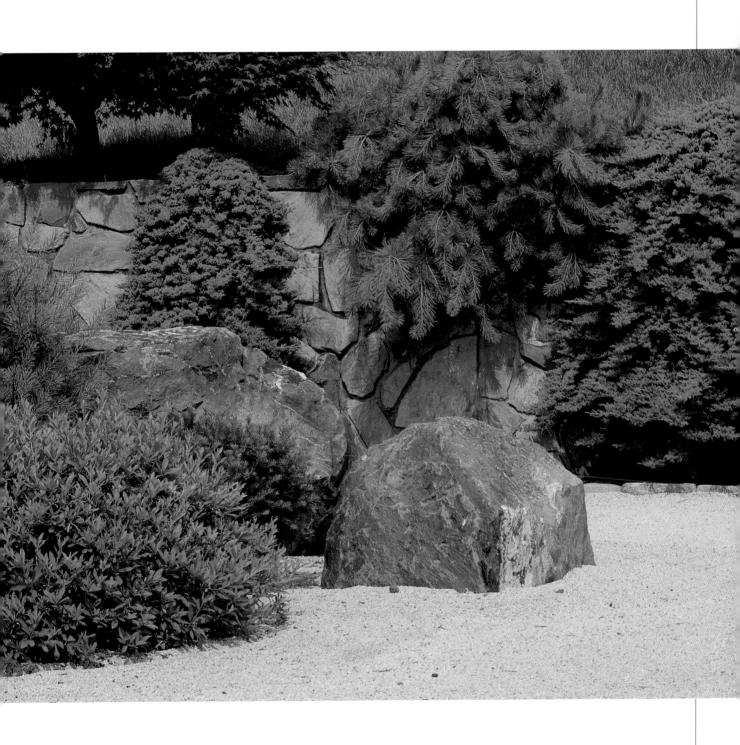

The flowers of these tender broadleaf evergreen plants add color and scent to the garden. Left: azalea (*Rhododendron indicum*). Right: *Gardenia jasminoides.* Brooklyn Botanic Garden, Brooklyn, New York.

Deciduous trees and shrubs, which shed their leaves each winter, offer the Japanese garden foliage texture, brilliant autumn color, distinctive bark or branching patterns, burnished berries and ephemeral flowers. From the subtle catkins of the witch hazels in late winter, to the breathtaking plum, cherry, peach and tree peony (*Paeonia suffruticosa*) flowers in the spring, to the luminescent gold leaves of *Ginkgo biloba* in the autumn, deciduous plants provide contrasts and add elements of wonder to the more staid evergreen plantings.

Maples, particularly Japanese maples (*Acer palmatum*), are synonymous with Japanese gardens. The delicate tracery of their arching branches, their translucent lacy leaves, and their hundreds of forms have caused them to be admired and glorified for centuries. There are also a number of other commendable small maples, including the trident (*A. buergeranum*), vine (*A. circinatum*), Amur (*A. ginnala*), paper-bark (*A. griseum*), full-moon (*A. japonicum*) and Nikko (*A. maximowiczianum*).

The Japanese give the name of *ko haru,* or "little spring," to what Americans call Indian summer. The red and gold tapestry of leaves, so strongly represented by the maples, the limpid air and clear blue sky of the dying year do indeed have the same glowing, unspoiled quality as spring. It is a time of picnicking, of sitting and contemplating the beauty of the all-too-quickly passing moment. Soon the first snowfall or a strong windstorm will scatter the glorious leaves to the earth, leaving the lovely tracery of the tree and shrub branches to sustain us until spring returns.

Deciduous trees, such as weeping willow (*Salix babylonica*) or Japanese flowering crabapple (*Malus floribunda*), are integral to the Japanese garden. Top: Private garden, Long Island, New York. Bottom: Missouri Botanical, St. Louis, Missouri.

Even though plants are not chosen for their flowers, their beauty can still be enjoyed. From top to bottom: Japanese flowering cherry (*Prunus serrulata* 'Shirotae'), loebner magnolia (*Magnolia* x *loebneri* 'Leonard Messel') and flowering quince (*Chaenomeles speciosa* 'Moerloosei').

The transitory nature of spring flowers heightens our appreciation. From top to bottom: weeping Higan cherry (*Prunus subhirtella* 'Pendula Rosea'), flowering quince (*Chaenomeles* 'Knapp Hill Scarlet'), and Japanese flowering crabapple (*Malus floribunda*).

Bamboos and ornamental grasses add sound and movement to a garden. Japanese writings refer to the pleasures of standing in a bamboo grove and listening to the sound of snow and wind. The dancing leaves of bamboos and grasses, catching light, casting shadows and rustling gently, bring joy to those who take the time to see and hear at any time of the year. Dwarf forms serve as ground covers, compact hedges, edging for paths or mounds imitating or softening rocks. Larger types are useful as accents, mass plantings or screens. In the spring, many bamboos provide edible young shoots and, in the fall, canes for useful purposes such as fences, gates, plant stakes and fishing poles. Most of the bamboos and grasses provide fall color and remain attractive through the winter. The flowers of many ornamental grasses can be brought indoors for dried bouquets or left for their beauty in the garden until the following spring. Some bamboos spread rapidly and must be planted either where they can run with impunity or contained with a metal or plastic shield sunk in the ground to 2 feet (61 cm.) deep.

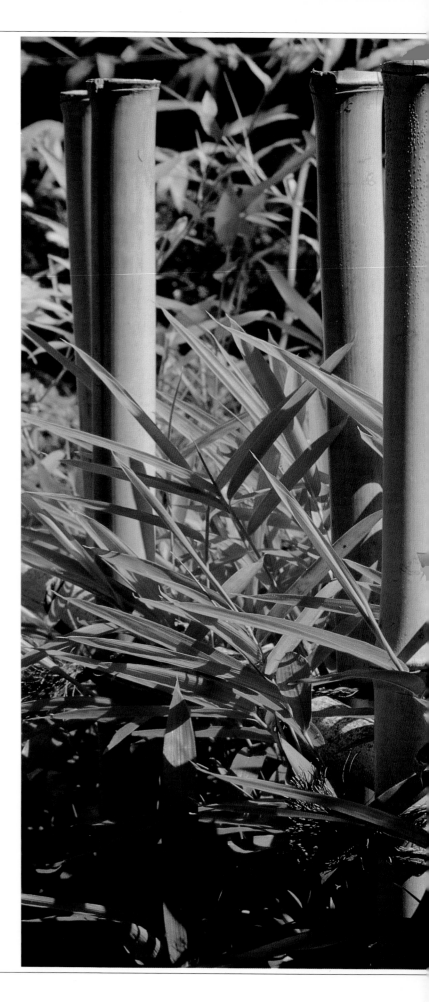

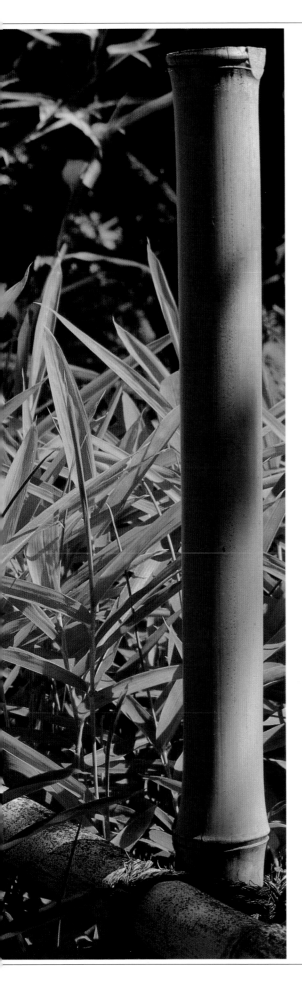

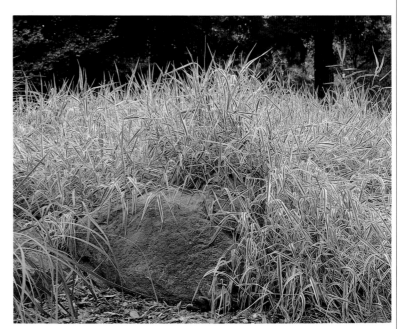

Dozens of different bamboo varieties, as well as ornamental grasses, such as variegated ribbon grass (*Phalaris arundinacea* 'Picta'), contribute graceful shape and movement to the garden. Left: Japanese Garden, Portland, Oregon. Above: Planting Fields, Oyster Bay, New York.

Ferns have long been significant elements in Japanese gardens, recalling images of primordial forests. They can be used in many places, singly or in masses. They provide a striking contrast in texture and feeling when growing on or near rocks. Allow them to reflect in water, or add their spirit to plantings of shrubs or perennials. A number of ferns, most native to North America, harmonize with the concepts of the Japanese garden.

Ground covers in a Japanese garden soften the passage from the ground level to the height of shrubs and trees. Western gardeners tend to use them in larger expanses than the Japanese do, but either way their textures and colors serve to unify a garden.

Any number of other low-growing plants, including bamboos, ornamental grasses, perennials and shrubs, can function as ground covers in a Japanese garden. In addition, a number of evergreen and deciduous plants can serve this purpose, and lawn grass is useful as well.

Ground cover plants, whether only inches tall or several feet, add texture and shades of green to the landscape. Among the plants to consider are the low-growing ferns, lily-turf, below and pachysandra, right.

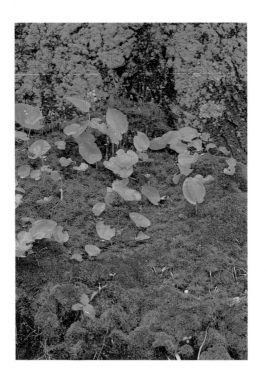

The velvety texture of moss truly softens the landscape. To grow them in most climates, they must be misted and watered frequently, especially when first planted, but less later. Remove fallen leaves from moss as these can smother it. A light mulch may be necessary in winter. Left: The John P. Humes Japanese Stroll Garden. Right: Bloedel Reserve, Bainbridge Island, Washington.

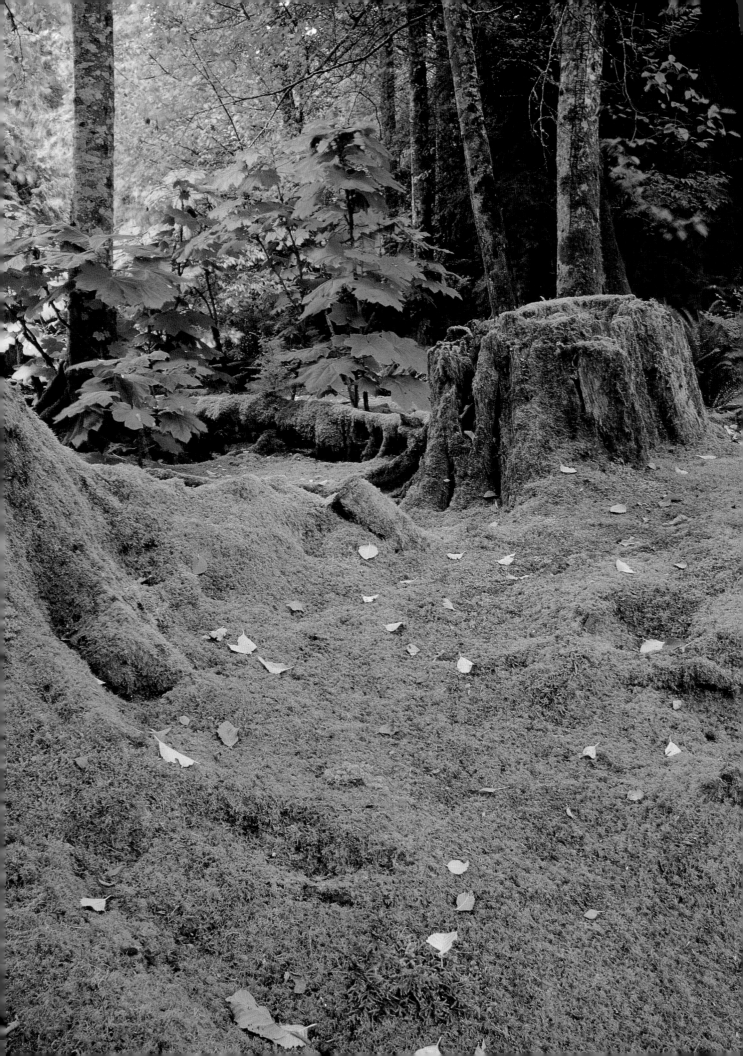

The long purple trails of wisteria are a feast for the senses in spring when large trellises are covered with the pendant flowers. Atlanta Botanical Garden, Atlanta, Georgia.

Because of the damp, humid climate in Japan, moss is widely used and taken to a high level of artistry. Some gardens in Japan have dozens of different kinds and colors of mosses, creating the illusion of clouds or other elements. In the United States, the Pacific Northwest most closely approximates the Japanese environment, and the Japanese garden at the Bloedel Reserve on Bainbridge Island near Seattle illustrates well the sensual qualities of moss carpeting a woodland.

In the rest of the U.S., moss should probably be used only sparingly or else constantly misted and watered. Several moss substitutes, such as Irish moss (*Sagina subulata*) or flowering moss (*Pyxidanthera barbatula*), are available commercially. True mosses must be transplanted from other areas of the garden or gathered from the wild. If doing the latter, be sure to collect with the landowner's permission (if necessary), take a small amount and be willing to commit the time to care for it properly. (You will need to water it several times a day until it is established.)

Vines blunt the impact of any sharp architectural edge, such as a fence, wall, gate, arbor, pergola or trellis. There are a few evergreen vines, but most are deciduous woody plants or tender annuals. They are chosen for the Japanese garden in much the same way as other plants, siting them to appreciate the transitory qualities of flowers, berries or other special features. Climbing hydrangea, bittersweet, clematis, honeysuckle, jasmine, trumpet creeper and morning glory are among the favored choices.

The purple haze of a pergola roofed with Japanese wisteria (*Wisteria floribunda*), ground thickly carpeted with fallen violet blossoms, air heavily scented—all this is painfully transient but glorious enough to be toasted with sake, which the wisteria is supposed to desire greatly. Although regarded by the Japanese as an emblem of gentleness and obedience, wisteria in the garden can be quite vigorous and needs strong supports.

Whether embellishing a pond, pool, water basin or dry stream, plants characteristic of the water's edge lend their own singular charm, particularly when reflected, smudging the line between shore and water. Most effective planted in clusters, sweet flag (*Acorus calamus*) or any of the water-loving irises add a strong vertical contrast to the water's horizontal plane with their sword-like leaves. Japanese iris (*Iris kaempferi*) is the undisputed star of this scene in June, with plate-sized flowers of white, lavender, purple, pink or blue.

For the water itself, the spectacular sacred lotus (*Nelumbo nucifera*), the Buddhist symbol of life, radiantly transforms ponds in August. Growing to 6 feet (1.8 m.) tall, with 3-foot (91 cm.) leaves and fragrant 1-foot (30.5 cm.) flowers of pink, rose or white, this is a plant for larger gardens. Dwarf forms, such as 'Momo Botan,' which reaches only 1 foot (30.5 cm.) tall, lend themselves to smaller gardens. Large and small, tender and hardy, the many water lily species and hybrids (*Nymphaea* spp.) are equally at home in pools and ponds in Japanese gardens.

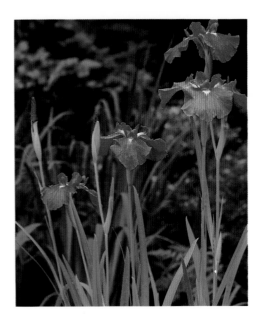

Most annual and perennial flowers and bulbs grown in Japan are raised in cutting gardens for the expressive, linear *ikebana* arrangements. Flowers, especially the revered chrysanthemums, may also be grown in pots and brought to the garden for their moment of glory. Still, a few judiciously chosen flowers may be the perfect grace note to the permanent garden planting. Never used in beds or mass plantings as in Western gardens, flowers nestle among the trees and shrubs, gently surprising visitors with their elegance.

In early spring, the diminutive bulbs and woodland wildflowers subtly and appropriately adorn lightly shaded areas of the Japanese garden. As summer progresses, consider flowers either native to the Japanese landscape or ones that evoke the feeling of these gardens. Some of the most frequently used perennials include astilbes, peonies, lilies, daylilies, hostas, asters, platycodons, Japanese anemones and hellebores. Besides Japanese iris (*Iris kaempferi*) for planting near water, most other iris species, except the German bearded types, work well in Japanese gardens.

During the days of June Japanese irises (*Iris kaempferi*) hold center stage along the edges of lakes and ponds with their large flowers reflected in the water.

There are water lily varieties of different sizes, hardiness and types, including some that bloom during the day and others at night.

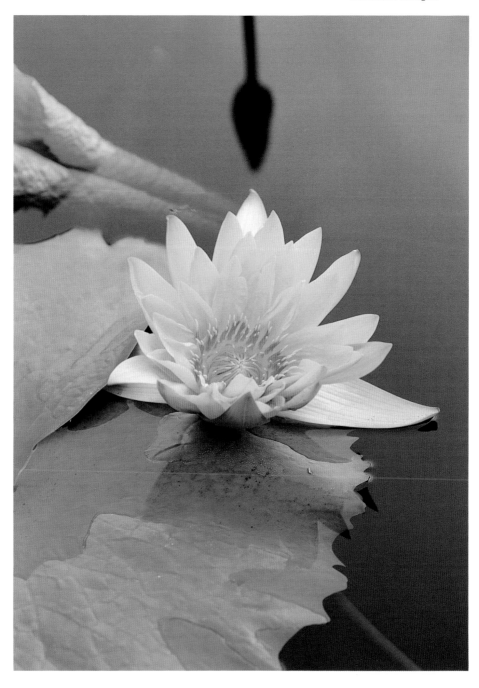

Left: Peonies, such as this
Paeonia 'Mons. Jules Elie',
have been honored flowers
in Japan for hundreds
of years.
Right: Forming neat
clumps, the balloon flower
(*Platycodon grandiflorus*)
fascinates us with its
balloon-like buds.

Clematis integrifolia 'Coerula'

To create a calm oasis of studied elegance, the designer of a Japanese garden leaves nothing to chance. Each vista, each plant, each stone is an integral part of a carefully envisioned whole. This unity is achieved by studying the garden space, the house and the natural surroundings, then using plants in ways that reflect the perception of nature in that milieu. Sometimes a single carefully grown tree will suffice, but most often a combination of plants works best. To appear aesthetically appealing, the arrangement must adhere to the basic Japanese garden principles.

Using odd numbers of plants—most often threes—in triangular compositions with uneven sides re-creates the natural randomness found in nature. Plants with fine textures and ones that adapt readily to pruning evoke a more precise appearance and are most useful in formal areas at entrances or close to the house. The tea garden is traditionally wilder in character and contains plants with more informal growth.

Syringa vulgaris

Campanula glomeráta

Muscari botryoides

Lilium hybrid

Other ways to create illusions with plants involve drawing the eye to certain areas or away from others. Tall, dense plantings provide a background, hiding the outside world and keeping the viewer's focus in the garden. Conversely, plantings in corners, at far walls or just outside of fences can make the garden seem larger than it is. Using large plants with bold texture or dark green color in the foreground and smaller, finer textured, lighter green in the background can give the illu-

sion of depth and distance. Space is also significant in Japanese gardens. Empty space has weight and should balance the mass of the plants. It also has shape. To achieve asymmetrical balance, a composition of plants and space might include a gracefully shaped cut-leaved maple, empty space and a group of three or five small rounded evergreens.

Aster novae-angliae 'Alma Potschke'

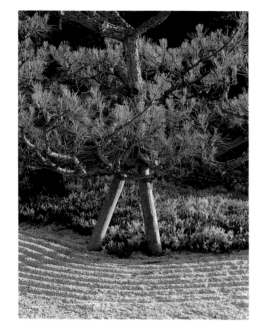

A Japanese garden is far from low maintenance. Florence Du Cane, writing in *The Flowers and Gardens of Japan*, describes wondering why an evidently well cared-for garden was allowed to be carpeted thickly with pine needles. On closer observation, she realized that each pine needle was in perfect place, following the same direction to depict water flowing through the garden; if a rock interrupted the "water," the needles were turned and twisted to represent the current!

Such painstaking care is not likely in a Western Japanese-style garden today, but a certain amount of care is essential to main-tain the simple grace and dignity that make these gardens a place of repose. Plan on regular weeding, watering, removal of faded flowers and dropped leaves and pest control. The use of mulches reduces weeding and watering chores. Since rampant growth is not the goal, fertilizing is usually a matter of maintaining health; feeding in the spring with a complete, balanced fertilizer will usually be adequate.

Long, horizontal branching is extremely important in a Japanese garden, and, with age, branches may become quite heavy and susceptible to damage from wind, snow and ice. Ever conscious of aesthetics, the Japanese will make well-crafted T-supports from naturally weathered wood to hold up sagging branches.

In Japanese gardens, special braces that hold up branches are a natural part of the landscape, not something to be hidden. It's important that these be well-constructed. They are particularly crucial where horizontal branches might be damaged with heavy snows. Above left: Missouri Botanical Garden, St. Louis, Missouri. Bottom left: Japanese Garden, Portland, Oregon. Right: Chicago Botanic Garden, Glencoe, Illinois.

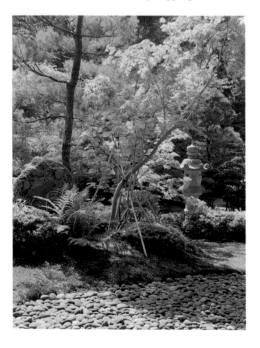

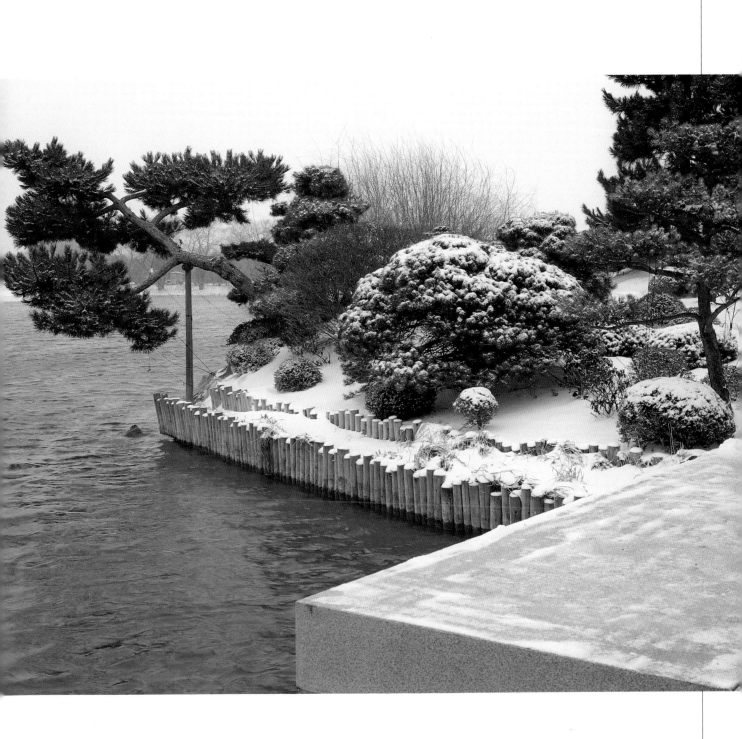

The most important attention given to plants in a Japanese garden is pruning and shaping. Its primary goal is to keep plants in proportion to—and thus in harmony with—the garden itself, the house and all other elements in the garden. If size cannot be maintained with pruning, a plant should be replaced. Pruning also shapes plants, either to emphasize their inherent character or to sculpt them to blend with the garden's design. Finally, pruning opens up plants, allowing light to reach lower branches and plants below.

Pruning in all its various forms—including clipping, shearing, pinching and plucking—is conducted at different times of year, depending on the plant. Late spring and again in late summer is best for needled evergreens. The structure of deciduous trees and shrubs is more evident when the leaves are off; hence, autumn to mid-winter is the ideal time to prune. Deciduous trees that produce a lot of sap, such as maples, birches and dogwoods, are best pruned in the autumn. Spring-blooming shrubs that flower on the previous season's growth, such as forsythia, quince or rhododendron, are pruned immediately after flowers have faded. There may also be horticultural reasons for pruning, such as removing sucker growth, which can be done at any time of year. Dead or diseased wood should likewise be removed immediately. Some plants will rejuvenate if periodically cut to within several inches of the ground.

The pruning style called *tamazukuri*, or making round, results in powerful formal shapes. Plants pruned in this manner provide foils to the natural shapes and forms in the garden and offer feelings of sanctuary and orderliness. These low, smooth mounds resembling rounded cushions may symbolize clouds or receding mountains, mimic nearby rocks or contrast with jagged stones. *Tamazukuri* works best with fine-textured broadleafed evergreens, such as azaleas or privets, or with naturally rounded plants, such as dwarf Japanese holly, boxwood and dwarf Mugo pine. To prune in the *tamazukuri* style, cut the shrub back to half its height in early spring or just after it flowers. Each cut should be just above a node, or the point where a leaf joins the stem. Each following spring, prune new growth back to one or two new buds. If summer growth is especially vigorous, a second pruning may be done in late autumn. With age, the bush may develop so many tiny branches that air circulation and light penetration will become poor. When this occurs, thin out about a third of the oldest branches. Another formal method of pruning is the *kuruma-zukashi* style, in which branches are made to resemble a series of wagon wheels with space in between each layer. No limb is ever directly above another. This method works well with podocarpus, camellia and hemlock.

Meticulous pruning, both in relatively natural and highly stylized forms, is necessary in maintaining harmony of size, scale, and form in a Japanese garden. Brooklyn Botanic Garden, Brooklyn, New York.

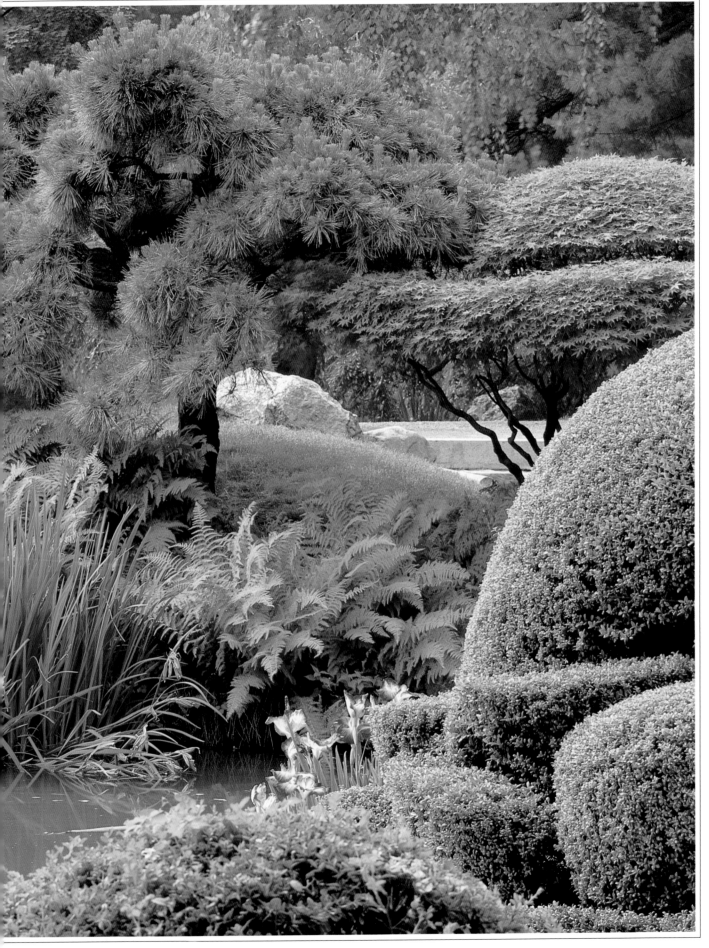

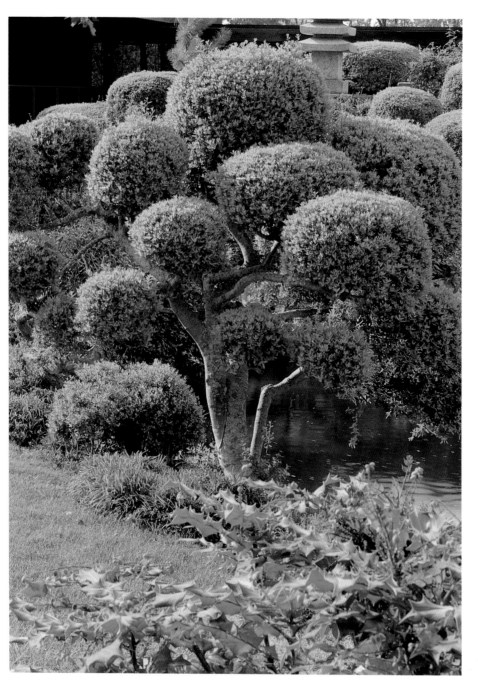

Pruning shrubs into
rounded cushion shape
technique called *tamazu*
and creates plants that
semble clouds or hills.
Gently bending the bra
with braces and rope e
phasizes horizontal gro
Left: Gulf States Paper
Corporation, Tuscaloos
Alabama. Right: Chica
Botanic Garden, Glenc
Illinois.

A twisted, windswept-looking pine tree with long, low branches is almost as synonymous with a Japanese garden as a lantern and stone basin. Because of the natural environment, aged pine trees are a familiar part of the Japanese landscape. Although rarer in the West, the Monterey cypresses, (*Cupressus macrocarpa*) are well known, and in hilly or mountainous regions, examples of gnarled pines abound. To the Japanese, a venerable pine tree, asymmetrically pruned over years by the gardener, adds strength and character to a garden, giving it a sense of permanence. The low spreading shape best expresses the tree's character. Often this tree will be a garden's focal point, whether on an "island" in a dry garden, reflected in a pond, or overhanging a waterfall. The art is in making this very controlled manipulation appear natural. Japanese black pine (*Pinus thunbergiana*) is the most popular species for this kind of pruning in Japan, with Japanese red pine (*P. densiflora*) a strong second choice. In other places, many other pine trees can be used, as well as other evergreens such as yews and hollies.

To begin developing your aged, windswept pine, plant a young, flexible-stemmed tree about 6 feet (1.8 m.) tall, angling it in the ground. Trim off the branches alternately from side to side. Make an S-shaped curve in the main trunk, using two strong poles driven into the ground in an X shape next to the trunk, and tie the trunk to the poles with rope. Use short lengths of rubber hose with the rope to prevent it from cutting into the bark. Keep these poles in place until the tree naturally holds its shape, or about one to two years. To further shape the tree, pull the main branches to a horizontal or downward-sloping angle using the poles or ropes.

Each following spring, when the new growth is about 5 inches (12.5 cm.) long, break off half of the main candle, a third of the length of each of the upward-pointing side candles, and all of the downward-facing candles. Trim off any other needles or branches that interfere with the balance and clean lines of the tree. In the fall, trim off the needles on the previous year's growth, as well as some from the new growth.

Bent, twisted and curving lines play a predominant role in Japanese gardens. Perhaps a branch is allowed to trail in front of a lantern, or an entire planting softens major architectural features such as walls and fences. You can learn to do this only with practice. Be willing to imagine what effects might result from trimming here, training there. Cutting a branch back, allowing it to grow, then cutting it again alters the growth so that it twists and curves rather than grows straight. Unless a plant naturally has all vertical growth, pruning to emphasize layers of hori-

zontal growth is practiced. One method called *sashide* imitates feathery layers of mist. The main tips of branches are removed and any small branches pointing downward are cut out. Consider using this method with Japanese black pines and red pines, maples, arborvitae, hemlock, and podocarpus. The Japanese practice of amply pruning to admit light and air benefits the plant by improving air circulation—thus reducing disease, encouraging strong, durable branching and causing flowers to be larger. In pruning to open up a plant, first remove those branches not growing in the direction wanted as well as those that crisscross, overcrowd or shade other branches.

Diverse as the plants that constitute the Japanese-style garden may be, they share the qualities of outstanding form and magnificent texture. The plants discussed in this chapter are only a sampling of the possiblities open to the Westerner, who not only has the luxury of drawing upon an ancient gardening tradition, but also has the freedom to experiment with American and European plants that harmonize with the remarkable Japanese style.

Bamboo Plants

A Bamboo Shoot Nursery
1462 Darby Road
Sebastopol, CA 95472
Catalogue $1.00

David C. Andrews
P.O. Box 358
Oxon Hill, MD 20750-0358
List for SASE

Bamboo Sourcery
666 Wagnon Road
Sebastol, CA 95472
List for SASE,
Catalogue $2.00

Burt Associates
P.O. Box 719
Westford, MA 01886
Catalogue $2.00

Endangered Species
P.O. Box 1830
Tustin, CA 92681
Catalogue $5.00

Gardens of the Blue Ridge
P.O. Box 10
Pineola, NC 28662

Louisiana Nursery
Route 7, Box 43
Opelousas, LA 70570

New England Bamboo Company
P.O. Box 358
Rockport, MA 01966

Northern Groves
P.O. Box 86291
Portland, OR 97292

Steve Ray's Bamboo Gardens
909 29th Place, South
Birmingham, AL 35206
Catalogue $2.00

Tornello Landscape Corporation
115 12th Avenue S.E.
Ruskin, FL 33570

Tradewinds Bamboo Nursery
P.O. Box 70
Calpella, CA 95418
List for SASE

Tripple Brook Farm
37 Middle Road
Southampton, MA 01073

Upper Bank Nurseries
P.O. Box 486
Media, PA 19063

Tom Wood, Nurseryman
P.O. Box 100
Archer, FL 32618

For more information on bamboo:

American Bamboo Society
P.O. Box 640
Springville, CA 93265
$15.00 annual membership; society
provides a free list of commercial
sources for many types of bamboo;
send a #10 SASE.

Bamboos of China. Wang, Dajun
and Shen Shap-Jin. Timber Press,
999 S.W. Wilshire, Portland, OR
97225. $21.95, hardcover; plus
$3.00 shipping. Describes most of
the bamboo species of China and
gives a brief overview of their use
in gardens.

The Book of Bamboo. David Farrelly.
Sierra Club Books, c/o J.V. West,
P.O. Box 11950, Reno, NV 89510.
$25.00 hardcover; $14.95, paper-
back; plus $4.50 shipping per order.
This is the best single book about
bamboo; start with it.

Chinese Bamboos. Chen Shou-liang
and Chia Liangpchi. Timber Press,
999 S.W. Wilshire, Portland, OR
97225. $29.95, hardcover; plus
$3.00 shipping. Good color photos
of dozens of bamboos.

**Unusual trees and shrubs,
Japanese maples, conifers,
broadleaf evergreens, ground
covers, perennials, Japanese iris,
aquatic plants and supplies, fish
and herbaceous and tree peonies**

Appalachian Gardens
P.O. Box 82
Waynesboro, PA 18268
Wide selection of ornamental trees
and shrubs

Beaver Creek Nursery
7526 Pelleaux Road
Knoxville, TN 37938
Catalogue $1.00; unusual trees
and shrubs

Kurt Bluemel, Inc.
2740 Greene Lane
Baldwin, MD 21013-9523
Catalogue $2.00; ornamental
grasses, bamboos, sedges and
rushes, perennials, ferns and
aquatic plants

Bluestone Perennials
7211 Middle Ridge Road
Madison, OH 44057
Wide selection of perennials

The Bovees Nursery
1737 S.W. Coronado
Portland, OR 97219
Catalogue $2.00; unusual rhodo-
dendrons, Japanese maples and
other trees and shrubs

Broken Arrow Nursery
13 Broken Arrow Road
Hamden, CT 06518
Unusual broadleaf evergreens and
other trees and shrubs

Busse Gardens
Route 2, Box 238
Cokato, MN 55321
Catalogue $2.00; wide selection
of perennials

Camellia Forest Nursery
125 Carolina Forest
Chapel Hill, NC 27516
Catalogue for two first-class
stamps; camellias and unusual
trees and shrubs

Caprice Farm
15425 S.W. Pleasant Hill Road
Sherwood, OR 97140
Catalogue $1.00; Japanese iris,
hostas, daylilies and herbaceous
and tree peonies

Carlson's Gardens
P.O. Box 305
South Salem, NY 10590
Catalogue $2.00; broadleaf
evergreens

Carroll Gardens
444 East Main Street
Westminster, MD 21157
Catalogue $2.00; wide selection
of perennials, vines, conifers, trees
and shrubs

Clifford's Perennial & Vine
Route 2, Box 320
East Troy, WI 53120
Catalogue $1.00; perennials, vines,
rhododendrons and azaleas

Coastal Gardens
4611 Socastee Boulevard
Myrtle Beach, SC 29575
Catalogue $2.00; Japanese iris,
hostas, daylilies, ground covers,
perennials and aquatic plants

Coenosium Gardens
6642 S. Lone Elder Road
Aurora, OR 97022
Catalogue $3.00; unusual conifers,
Japanese maples and other trees
and shrubs

Colvos Creek Nursery &
 Landscaping
1931 2nd Avenue #215
Seattle, WA 98101
Unusual trees and shrubs

Crownsville Nursery
P.O. Box 797
Crownsville, MD 21032
Catalogue $2.00; wide selection
of perennials, ornamental grasses,
ferns and some azaleas

The Cummins Garden
22 Robertsville Road
Marlboro, NJ 07746
Broadleaf evergreens and
dwarf conifers

Del's Japanese Maples
4691 River Road
Eugene, OR 97404
Catalogue $1.00; collector's
Japanese maples

Eastern Plant Specialties
P.O. Box 226
Georgetown, ME 04548
Catalogue $2.00; unusual trees
and shrubs

Englerth Gardens
2461 22nd Street
Hopkins, MI 49328
Catalogue $.50; Japanese iris,
daylilies and hostas

Ensata Gardens
9823 East Michigan Avenue
Galesburg, MI 49053
Catalogue $2.00; Japanese iris

Fieldstone Gardens, Inc.
620 Quaker Lane
Vasselboro, ME 04989-9713
Catalogue $2.00; Japanese iris,
perennials and tree peonies

Flora Lan Nursery
Route 1, Box 357
Forest Grove, OR 97116
Unusual trees and shrubs

Forestfarm
930 Tetherow Road
Williams, OR 97544
Catalogue $3.00; wide selection of
unusual trees, shrubs and perennials

Foxborough Nursery
3611 Miller Road
Street, MD 21154
Catalogue $1.00; dwarf and
unusual conifers, trees and shrubs

Girard Nurseries
P.O. Box 426
Geneva, OH 44041
Wide selection of conifers,
broadleaf evergreens and other
trees and shrubs

Gossler Farms Nursery
1200 Weaver Road
Springfield, OR 97578-9663
Catalogue $1.00; unusual trees
and shrubs

Greer Gardens
1280 Goodpasture Island Road
Eugene, OR 97401-1794
Catalogue $3.00; unusual trees
and shrubs with many broadleaf
evergreens

Hatfield Gardens
22799 Ringgold Southern Blvd.
Stoutsville, OH 43154
Catalogue $2.00; wide selection of
perennials and ornamental grasses

Heritage Gardens
1 Meadow Ridge Road
Shenandoah, IA 51602
Perennials, trees and shrubs

Holbrook Farm & Nursery
Route 2, Box 223B
Fletcher, NC 28732
Catalogue $2.00; wide selection
of perennials, trees and shrubs

Holly Hills, Inc.
1216 Hillsdale Road
Evansville, IN 47711
Broadleaf evergreens and
dwarf conifers

Hughes Nursery
1305 Wynooche West
Montesano, WA 98563
Catalogue $1.50; Japanese maples
and unusual trees

The Iris Pond
7311 Churchill Road
McLean, VA 22101
Catalogue $1.00; Japanese iris

Klehm Nursery
Route 5, Box 197
South Barrington, IL 60010-9555
Perennials and tree peonies

Michael & Janet Kristick
155 Mockingbird Road
Wellsville, PA 17365
Unusual conifers and Japanese
and species maples

Laurie's Garden
41886 McKenzie Highway
Springfield, OR 97478
Catalogue for long SASE;
Japanese iris

Lilypons Water Gardens
P.O. Box 10
Buckeystown, MD 21717-0010
Catalogue $5.00; water plants,
supplies and fish

Limerock Ornamental Grasses
Route 1, Box 111C
Port Matilda, PA 16870
Catalogue $1.00; ornamental
grasses

Loucks Nursery
P.O. Box 102
Cloverdale, OR 97112
Catalogue $1.00; Japanese maples

Magnolia Nursery & Display
 Garden
12615 Roberts Road
Chunchula, AL 36521
Catalogue $1; broadleaf evergreens,
Japanese irises, native magnolias,
hollies and camellias

Maple Leaf Nursery
4236 Greenstone Road
Placerville, CA 95667
Catalogue $1.50; unusual trees
and shrubs

Maryland Aquatic Nurseries
3427 North Furnace Road
Jarrettsville, MD 21084
Catalogue $2.00; aquatic plants,
Japanese iris and ornamental
grasses

Mary's Plant Farm
2410 Lanes Mill Road
Hamilton, OH 45013
Catalogue $1.00; trees, shrubs
and perennials

Matsu-Momiji Nursery
P.O. Box 1114
Philadelphia, PA 19111
Catalogue $2.00; unusual Japanese
black pines, maples and spruces

Maxim's Greenwood Gardens
2157 Sonoma Street
Redding, CA 96001
Catalogue $1.00; Japanese iris

Meadowlake Garden
Route 4, Box 709
Walterboro, SC 29488
Catalogue $3.00; Japanese iris

Mellinger's, Inc.
2310 West South Range Road
North Lima, OH 44452
Wide assortment of plants
and supplies

Mileager's Gardens
4838 Douglas Avenue
Racine, WI 53402-2498
Catalogue $1.00; wide selection
of perennials

Moore Water Gardens
P.O. Box 340
Port Stanley, Ontario
Canada N0L 2A0
Aquatic plants and supplies

Mowbray Gardens
3318 Mowbray Lane
Cincinnati, OH 45226
Unusual rhododendrons and
other trees and shrubs

E.B. Nauman, Nurseryman
688 Saint David's Lane
Schenectady, NY 12309
Hardy broadleaf evergreens

Nicholas Gardens
4724 Angus Drive
Gainesville, VA 22065
Catalogue $1.00; Japanese iris

Owen Farms
Route 3, Box 158-A
Ripley, TN 38063
Catalogue $3.00
Broad selection of trees, shrubs
and perennials

Paradise Water Garden
62 May Street
Whitman, MA 02382
Catalogue $3.00; aquatic plants
and supplies

Perry's Water Gardens
191 Leatherman Gap Road
Franklin, NC 28734
Catalogue $2.00; aquatic plants,
supplies and fish

Pleasure Iris Gardens
425 East Luna
Chaparral, NM 88021
Catalogue $1.00; Japanese iris.

Powell's Gardens
Route 3, Box 21
Princeton, NC 27569
Catalogue $2.50; wide selection
of perennials, dwarf conifers, trees
and shrubs

Reath's Nursery
P.O. Box 521
Vulcan, MI 49892
Catalogue $1.00; herbaceous and
tree peonies and hostas

Roslyn Nursery
211 Burrs Lane
Dix Hills, NY 11746
Catalogue $2.00; broadleaf
evergreens, dwarf conifers, trees,
shrubs and perennials

Santa Barbara Water Gardens
P.O. Box 4353
Santa Barbara, CA 93140
Catalogue $1.50; aquatic plants
and supplies

S. Scherer & Sons
104 Waterside Road
Northport, NY 11768
Aquatic plants and supplies

F.W. Schumacher Company
36 Spring Hill Road
Sandwich, MA 02563-1023
Catalogue $1.00; wide selection
of trees, shrubs, conifers and
broadleaf evergreens

Shady Oaks Nursery
700 19th Avenue N.E.
Waseca, MN 56093
Catalogue $1.00; wide selection
of plants for shade

Slocum Water Gardens
1101 Cypress Gardens Boulevard
Winter Haven, FL 33880-6099
Catalogue $2.00; aquatic plants
and supplies

Springvale Farm Nursery
Mozier Hollow Road
Hamburg, IL 62045
Catalogue $2.00; dwarf conifers
and small shrubs, ground covers
and perennials

Stoecklin's Nursery
135 Critchlow Road
Renfrew, PA 16053
Catalogue $2.00; ground covers
and perennials for shade

Tilley's Nursery/The WaterWorks
111 East Fairmount Street
Coopersburg, PA 18036
Catalogue $1.00; aquatic plants,
supplies and fish

Tranquil Lake Nursery
45 River Street
Rehoboth, MA 02769-1395
Catalogue for first-class stamp;
Japanese iris

Trans Pacific Nursery
16065 Oldsville Road
McMinnville, OR 97128
Catalogue $1.00; wide selection of
unusual trees, shrubs and perennials,
including Japanese maples

Transplant Nursery
Parkertown Road
Lavonia, GA 30553
Rare and unusual broadleaf
evergreens

William Tricker, Inc.
P.O. Box 31267
Independence, OH 44131
Catalogue $2.00; aquatic plants,
supplies and fish

Twombly Nursery
163 Barn Hill Road
Monroe, CT 06468
Catalogue $2.00; wide selection of
dwarf conifers, ornamental grasses,
trees, shrubs and perennials

Van Ness Water Gardens
2460 North Euclid
Upland, CA 91786-1199
Catalogue $2.00; aquatic plants,
supplies and fish

Andre Viette Farm & Nursery
Route 1, Box 16
Fisherville, VA 22939
Catalogue $2.00; wide selection
of perennials

Water Ways Nursery
Route 2, Box 247
Lovettsville, VA 22080
Catalogue for long SASE;
aquatic plants

Waterford Gardens
74 East Allendale Road
Saddle River, NJ 07458
Catalogue $4.00; aquatic plants,
supplies and fish

Wavecrest Nursery & Landscaping
 Company
2509 Lakeshore Drive
Fennville, MI 49403
Wide selection of trees and shrubs,
including Japanese maples

Wayside Gardens
P.O. Box 1
Hodges, SC 29695-0001
Wide selection of trees, shrubs
and perennials

We-Du Nurseries
Route 5, Box 724
Marion, NC 28752
Catalogue $1.00; unusual selection
of American and Asian woodland
plants

Westgate Garden Nursery
751 Westgate Drive
Eureka, CA 95501
Catalogue $4.00; choice selection
of broadleaf evergreens and
unusual trees and shrubs

White Flower Farm
Route 63
Litchfield, CT 06759-0050
Wide selection of trees, shrubs
and perennials

Wicklein's Aquatic Farm &
 Nursery, Inc.
1820 Cromwell Bridge Road
Baltimore, MD 21234
Catalogue $1.00; aquatic plants,
supplies and fish

Woodlands, Inc.
1128 Colleton Avenue
Aiken, SC 29801
Catalogue for long SASE with two
first-class stamps; unusual selection
of Southeastern native plants and
other trees

Yucca Do Nursery
P.O. Box 655
Waller, TX 77484
Catalogue $2.00; unusual trees,
shrubs and perennials for zones
8 and 9

Ornaments, bamboo fencing and other items

Bamboo & Rattan Works
470 Oberlin Avenue South
Lakewood, NJ 08701
Custom bamboo and reed fencing

Bamboo Fencer
31 Germainia Street
Jamaica Plain, MA 02130
Catalogue $2.00; bamboo fences
and structures

East/West Bookshop
1170 El Camino Real
Menlo Park, CA 94025
Catalogue free; Asian-style garden
ornaments in ceramic, bronze,
marble and terra cotta

Phillip Hawk & Company
159 East College Avenue
Pleasant Gap, PA 16823
Catalogue $3.00; hand-carved
stone lanterns

Hermitage Gardens
P.O. Box 361
Canastota, NY 13032
Catalogue $1.00; water garden
equipment and bridges

Nampara Gardens
2004 Golfcourse Road
Bayside, CA 95524
Redwood bridges, gates, benches
and lanterns

Orion Trading Company
1508 Posen Avenue
Albany, CA 94706
Bamboo stakes, poles and fencing,
tropical roof thatching and other
decorative Japanese items

Sun Garden Specialties
P.O. Box 52382
Tulsa, OK 74152
Source of garden plaque with your
name in Japanese

Sun Designs
P.O. Box 206
Delafield, WI 53018-0206
Books of garden structure designs;
gazebo book is $9.45 postpaid
and garden structures book is
$10.45 postpaid.

Stone Forest
P.O. Box 2840
Santa Fe, NM 87504
Japanese lanterns and water basins

Public Gardens in the U.S.A.

Alabama

Birmingham Botanical Gardens
2612 Lane Park Road
Birmingham, AL 35223

Bellingrath Gardens
Route 1, Box 60
Theodore, AL 36582

Gulf States Paper Corporation
1400 River Road
Tuscaloosa, AL 35401

California

Sherman Foundation Library
 and Gardens
2647 East Coast Highway
Corona Del Mar, CA 92625

Descanso Gardens
1418 Descanso Drive
La Canada, CA 91011

Micke Grove Park and Zoo
Micke Grove Road
Lodi, CA 95240

University of California at
 Los Angeles Hanna Carter
 Japanese Garden
10619 Bellagio Road
Los Angeles, CA 90024-1606
(Open by reservation only)

Oakland-East Bay Garden Center
666 Bellevue Avenue
Oakland, CA 94602

Chinese Temple Garden
1500 Broderick Street
Oroville, CA 95965

Sea World
1720 South Shores Drive
San Diego, CA 92109

Japan Center
1790 Post Street
San Francisco, CA 94115

Japanese Tea Garden
Golden Gate Park
San Francisco, CA 94117

Strybing Arboretum and
 Botanical Gardens
Golden Gate Park
San Francisco, CA 94117

Japanese Friendship Garden
1490 Senter Road
San Jose, CA 95100

Buddhist Temple
640 North Fifth Street
San Jose, CA 95100

Huntington Botanical Gardens
1151 Oxford Road
San Marino, CA 91108

San Mateo Japanese Garden
 and Arboretum
El Camino Road and Fifth Avenue
San Mateo, CA 94402

Hakone Gardens
21000 Big Basin Way
Saratoga, CA 95070

Colorado

Denver Botanic Gardens
909 York Street
Denver, CO 80206

District of Columbia

Ippakutei, The Ceremonial
 Teahouse and Garden at the
 Embassy of Japan
2520 Massachussetts Avenue, N.W.
Washington, DC 20008
(Open by reservation only)

U.S. National Arboretum
24th and R Streets, N.E.
Washington, DC 20002

Florida

The Morikami
Museum and Japanese Gardens
4000 Morikami Park Road
Delray Beach, FL 33446

San-Ai-An Garden
MacArthur Causeway, Watson
 Island
Miami, FL 33100

The Society of the Four Arts
Royal Palm Way
Palm Beach, FL 33480

Georgia

Atlanta Botanical Garden
Piedmont Road at The Prado
Box 77246
Atlanta, GA 30357

Hawaii

Liliuokalani Gardens Park
Banyan Drive and Lihiwai Streets
Hilo, HI 96720

Kepaniwai Heritage Gardens
Highway 32
Wailuku, HI 96793

East-West Center, University
 of Hawaii
1777 East-West Road
Honolulu, HI 96822

Soto Mission of Hawaii
1708 Nuuanu Avenue
Honolulu, HI 96817

Honolulu Memorial Park
22 Craigside Place
Honolulu, HI 96817

Alice Cooke Spalding House
2411 Makiki Drive
Honolulu, HI 96822

Byodo-in Temple
47-200 Kahekili Highway
Kaneohe, HI 96744

Illinois

Scovill Gardens Park
71 South Country Club Road
Decatur, IL 62521

Chicago Botanic Garden
775 Dundee Road
Glencoe, IL 60022

Louisiana

Live Oak Gardens
Jefferson Island
New Iberia, LA 70560

Maine

Asticou Azalea Gardens
Asticou Way, Mount Desert Island
Northeast Harbor, ME 04662

Maryland

Brookside Garden
Glenallen Avenue
Wheaton, MD 20902

Ladew Topiary Gardens
3535 Jarrettsville Pike
Monkton, MD 21111

Breezewood Japanese Garden
 and Museum
3722 Hess Road
Monkton, MD 21111

Massachussetts

Mytoi Japanese Garden
Chappaquiddick Island
Edgartown, MA 02539

Peabody Museum of Salem
161 Essex Street
Salem, MA 01970

Stanley Park
P.O. Box 1191
400 Western Avenue
Westfield, MA 01086

Michigan

Cranbrook House and Gardens
 Auxiliary
P.O. Box 801
380 Lone Pine Road
Bloomfield Hills, MI 48303

Dow Gardens
1018 West Main Street
Midland, MI 48640

Fernwood Botanic Garden and
 Nature Center
13988 Range Line Road
Niles, MI 49120

Tokushima Saginaw Friendship
 Garden
Ezra Rust Drive and
 Washington Avenue
Saginaw, MI 48601

Mississippi

Mynelle Gardens
4738 Clinton Boulevard
Jackson, MS 39216

Missouri

Missouri Botanical Garden
2315 Tower Grove Avenue
St. Louis, MO 63110

New Jersey

Georgian Court College
Lakewood Avenue
Lakewood, NJ 08701

Duke Gardens Foundation
Route 206
Somerville, NJ 08876
(Open by reservation only)

New York

Brooklyn Botanic Garden
1000 Washington Avenue
Brooklyn, NY 11225

Delaware Park
Elmwood Avenue
Buffalo, NY 14202

Sonnenberg Gardens
151 Charlotte Street
Canandaigua, NY 14424

Innisfree Garden
Tyrrel Road
Millbrook, NY 12545

The John P. Humes Japanese
 Stroll Garden
Dogwood Lane
Mill Neck, NY 11765

Hammond Museum
Deveau Road
North Salem, NY 10560

Old Westbury Gardens
71 Old Westbury Road
Old Westbury, NY 11568

Ohio

Stan Hywet Hall
714 North Portage Path
Akron, OH 44303

Cleveland Cultural Gardens
Rockefeller Park
750 East 88th Street
Cleveland, OH 44108

Garden Center of Greater
 Cleveland
11030 East Boulevard
Cleveland, OH 44106

Dawes Arboretum
Route 5, Box 270
Newark, OH 43055

Oberlin College
West College and South
 Professor Streets
Oberlin, OH 44074

Oregon

Japanese Garden
Southwest Kingston Avenue
Portland, OR 97208

Pennsylvania

Serenity Garden
Sakon Plaza, City Center Complex
Bethlehem, PA 18018

Swiss Pines
The Arnold Bartschi Foundation
Charleston Road
Malvern, PA 19355

Japanese House and Gardens
P.O. Box 2224
Fairmount Park Horticultural
 Center
North Horticultural Drive
Philadelphia, PA 19103

Rhode Island

Roger Williams Park
Elmwood Avenue
Providence, RI 02905

South Carolina

The Japanese Garden
Furman University
3300 Poinsett Highway
Greenville, SC 29613

Tennessee

Memphis Botanic Garden
750 Cherry Road
Memphis, TN 38117

Cheekwood
Tennessee Botanical Gardens
 and Fine Arts Center
Forrest Park Drive
Nashville, TN 37205

Texas

Austin Area Garden Center
2220 Barton Springs Road
Austin, TX 78746

Fort Worth Botanic Garden Center
3220 Botanic Garden Drive
Fort Worth, TX 76107

Utah

International Peace Gardens
10th South and 8th West Streets
Salt Lake City, UT 84109

Virginia

Norfolk Botanical Gardens
Airport Road
Norfolk, VA 23518

Maymount
1700 Hampton Street
Richmond, VA 23220

Washington

Bloedel Reserve
Bainbridge Island, WA 98110

Yao Park
13204 S.E. 8th Street
Bellevue, WA 98009

University of Washington
 Arboretum
East Madison and Lake Washington
 Boulevard East
Seattle, WA 98105

Manito Park
Bernard and 21st Streets
Spokane, WA 99201

Point Defiance Park
Tacoma, WA 98409

BIBLIOGRAPHY

Bartels, Andreas. *Gardening With Dwarf Trees and Shrubs*. Portland, OR. Timber Press, 1986.

Germain Basin. *Paradeisos: The Art of the Garden*. Boston, MA: Little Brown and Company, 1990.

Berrall, Julia S. *The Garden: An Illustrated History*. New York: The Viking Press, 1966.

Bring, Mitchell and Josse Wayembergh. *Japanese Gardens: Design and Meaning*. New York: McGraw-Hill Book Company, 1981.

Conder, Josiah. *Landscape Gardening In Japan*. New York: Dover Publications, 1964.

Crocker, Cedric. *Creating Japanese Gardens*. San Ramon, CA: Ortho Books, Chevron Chemical Company, 1987.

Davidson, A.K. *The Art of Zen Gardens—A Guide To Their Creation and Enjoyment*. Los Angeles: Jeremy P. Tarcher, 1983.

deWeese, R.W., revised by W.C. Robinson. *Symbolism in the Japanese Garden*. Portland, OR: The Japanese Garden Society of Oregon, 1989.

Douglas, William Lake, Susan R. Frey, Norman K. Johnson, Susan Littlefield, and Michael Van Valkenburgh. *Garden Design*. New York: Simon & Schuster, 1984.

Du Cane, Florence. *The Flowers and Gardens of Japan*. London: Adam and Charles Black, 1908.

Engel, David. *Japanese Gardens for Today*. Rutland, VT: Charles E. Tuttle Company, Publishers, 1959.

Hyams, Edward. *A History of Gardens and Gardening*. New York: Praeger Publishers, 1971.

Itoh, Teiji. *Space & Illusions in the Japanese Garden*. New York: Weatherhill/Tankosha, 1988.

Johnson, Sylvia A. *Mosses*. Minneapolis: Lerner Publications Company, 1983.

Kuck, Loraine. *The World of the Japanese Garden*. New York: Weatherhill, 1968.

McFadden, Dorothy Loa. *Oriental Gardens in America—A Visitor's Guide*. Los Angeles: Douglas-West Publishers, 1976.

Murk, Alfreda and Wen Fong. *A Chinese Garden Court*. New York: Metropolitan Museum of Art, 1980.

Murphy, Wendy. *Japanese Gardens*. Alexandria, VA: Time-Life Books, 1979.

Okamoto, Toyo and Gisei Takakuwa. *Gardens of Japan*. Tokyo: Mitsumura Suiko Shoin Company, Ltd., 1962.

Reynolds, Phyllis, Bill Robinson, and Pat Morrison. *Plant Material in the Japanese Garden*. Portland, OR: The Japanese Garden Society of Oregon, 1988.

Richards, Betty W. and Ann Kaneko. *Japanese Plants: Know Them & Use Them*. Tokyo: Shufunotomo Company, 1988.

Saito, Katsuo. *Quick and Easy Japanese Gardens*. Tokyo: Shufunotomo Company, 1971.

Sansho-En. Chicago: Chicago Botanic Garden, 1982.

Sawyers, Claire, Editor. *Japanese Gardens*. Brooklyn, NY: Brooklyn Botanic Garden, 1985.

Seike, Kiyoshi, and Masanobu Kudo with David H. Engel, ed. consultant. *A Japanese Touch for Your Garden*. New York: Kodansha International, 1980.

Shaku, Soyen. Translated by Daisetz Teitaro Suzuki. *Zen for Americans*. Peru, IL: Open Court Publishing Company, 1906, 1913. Reprinted by Dorset Press in 1987.

Slawson, David A. *Secret Teachings in the Art of Japanese Gardens*. Tokyo: Kodansha International/USA Ltd., 1987.

Stevens, David. *Creative Gardens*. London: Hamlyn, 1986.

Tatsui, Matsunosuke. *Japanese Gardens*. Tokyo: Japan Travel Bureau, 1962.

Vertrees, J.D. *Japanese Maples*. Portland, OR: Timber Press, 1978.

Watts, Alan. *Tao: The Watercourse Way*. New York: Pantheon Books, 1975.

Wilson, Andrew. *Garden Style Source Book: Design Themes For Every Type of Garden*. Secaucus, NJ: Chartwell Books, 1989.

Yoshikawa, Isao. *Elements of Japanese Gardens*. Tokyo: Graphic-Sha Publishing Co., 1990.

Page numbers in italic indicate illustrations.